Wayne M. Bryant

Bisexual Characters in Film: From Anaïs to Zee

*Pre-publication
REVIEWS,
COMMENTARIES,
EVALUATIONS . . .*

"**B**ryant's book is a long-awaited roll call of the bisexual characters in film who have been labeled anything but bisexual. Academics will love this book for its extensive survey of the topic; the popular audience will love it because it's more fun than popcorn. If the Hays Code applied to Queer scholarship, Bryant's book on bisexuals would have them in an uproar–it's hot stuff for film fans!"

Elise Matthesen
Keynote speaker,
International Conference
Celebrating Bisexuality
1994; bisexual writer,
activist, journalist

"In *Bisexual Characters in Film* Wayne Bryant perceptively surveys the various ways in which bisexually behavioral characters have been represented in films over a period of 80 years. His research, based on over 200 films from 25 countries, reveals common themes that tell us much about the ways screenwriters, directors, producers, actors, censors, and audiences have felt about people who—in the words of the Scarecrow in *The Wizard of Oz*—'go both ways,' and about cultural attitudes toward gay men, lesbians, and heterosexuals as well. Bryant deftly isolates and identifies the intended and effectual functions of bisexual characters by observing not only how they appear and what they do on screen but also, in some cases, how decisions about their appearances and actions were arrived at. The author also discusses thematic uses of bisexuality in camp and comedy, and surveys the contributions to film of bisexual actors, directors, screenwriters, and others. Of particular interest are Bryant's chapters on particular classes of representations: the 'killers and psychos,' the victims, the stereotypes of married sexuals, 'anything-that-moves' satyrs and sluts, bisexual male hustlers, and exemplary positive and non-judgmental depictions. *Bisexual Characters in Film* is an important contribution to the study of twentieth-century sexual culture."

Michael S. Montgomery, MA, MS
Humanities Reference Librarian
and Selector for philosophy
and gay, lesbian, and bisexual
studies, Princeton University

"I can see a line around the block for a bisexual film festival that any creative programmer would be proud of, especially if he/she used as a source this amazing new book that covers more than 200 films. Bryant lets the facts speak for themselves without analysis, theory, or criticism. This is the first book on bisexual characters in film and is an important beginning to a rich and deep source of study for future film historians."

Barbara Hammer
Filmmaker;
Visiting Professor,
Rutgers University

"**B**isexuals have largely been sealed into a movieland closet. In those relatively rare instances when they have been seen in films, they are often the subjects of jokes and abuse, and represented as killers and psychos, as deceitful husbands or conniving wives, as children trapped in the bodies of adults, as victims of extortion, as self-loathing and suicidal. Sexually they are likely seen as prostitutes and hustlers, insatiable animals perpetually in heat, or as vectors of transmission of deadly infectious disease.

From silent days, to the Motion Picture Production Code, and into modern times, Wayne M. Bryant projects a focused beam of light through a bisexual lens, illuminating our understanding of the place of bisexuals both behind and in front of the silver screen."

Warren J. Blumenfeld
Editor, *Journal of Gay,
Lesbian, and Bisexual Identity*
and *Homophobia: How We All
Pay the Price*; Co-Author,
Looking at Gay and Lesbian Life

"**I**nformative, provocative, a *must* for anyone who loves film, writes about film, or reads about film, no matter what your orientation is.

This book is put together in a fun, light way, chock-full of historic detail that puts the whole gay/bi civil rights movement in perspective, and shows how it is reflected in what we choose to entertain ourselves with.

The book is a no-holds-barred analysis of some of the most popular, and some of the most obscure films of all time. Bryant pulls no punches and you will never be able to look at some of these movies in the same way ever again.

I will be using this as a primer for videos to rent for years to come."

Michael Szymanski
journalist, activist,
film critic, and reporter;
Instructor of journalism,
UCLA

The Harrington Park Press
An Imprint of The Haworth Press, Inc.

Bisexual Characters in Film
From Anaïs to Zee

HAWORTH Gay & Lesbian Studies
John P. De Cecco, PhD
Editor in Chief

Bisexual Characters
in Film
From Anaïs to Zee

Wayne M. Bryant

Harrington Park Press
An Imprint of The Haworth Press, Inc.
New York • London

Published by

Harrington Park Press, an imprint of The Haworth Press, Inc., 10 Alice Street, Binghamton, NY 13904-1580

Cover design by Donna M. Brooks.
Cover graphic design by David Reiffel and Mary-Ann Greanier.

Library of Congress Cataloging-in-Publication Data

Bryant, Wayne M.
 Bisexual characters in film : from Anaïs to Zee / Wayne M. Bryant.
 p. cm.
 Includes bibliographical references and index.
 ISBN 1-56023-894-1
 1. Bisexuality in motion pictures. I. Title.
PN1995.9.B57B78 1997
791.43'6538–dc20 96-25868
 CIP

In memory of *Tequila Sunrise Serval* –
dedicated writing and viewing companion.

ABOUT THE AUTHOR

Wayne Bryant, Co-Founder of Biversity Boston, serves on the Board of Directors for the Bisexual Resource Center in Boston and is Film Editor for the *Bisexual Resource Guide*. He has programmed bisexual films for a number of conferences and festivals and has been writing about bisexuality, films, and politics for more than a decade.

CONTENTS

Preface

Anyone with a passing interest in the subject can probably name a dozen or more movies with gay and lesbian characters. The same is not true for bisexual characters in film. Experts may be hard pressed to cite more than two or three examples, even though many films with homosexuality as a central theme have bisexual protagonists.

The invisibility of bisexual characters in film is compounded by the dearth of writing on the topic. While there are a number of books on homosexuality in the cinema, there has never been anything written—until now—about bisexual characters in film. The relatively small number of bisexual characters is certainly due to a variety of factors, which are discussed in this book. These include a total ban on same-sex relationships in U.S. films for decades, the lack of "out" bisexual film producers and directors, the absence of a cohesive bisexual movement until the early 1980s, and the popular myth that bisexual people do not actually exist.

Just as famous bisexual people in history have been "claimed" by the lesbian and gay community (Sappho, Alexander the Great, Virginia Woolf, Simone de Beauvoir, Langston Hughes, etc.), so have films with bisexual characters been categorized as lesbian or gay films. This is true even in cases where there are no strictly homosexual characters in the film.

Another factor contributing to the invisibility of bisexual characters is the personal prejudices of those who write movie reviews. Many film critics automatically pan films with lesbian, gay, or bisexual characters. In other cases, they conveniently ignore them. When beginning my research, I purchased a copy of *Halliwell's Film Guide*—a venerable name in film criticism—which contains a wealth of information on thousands of films, *as long as they are not about bisexual or homosexual characters*. Notably absent from this book, which claims that "no other guide has the same breadth or scope," are such classics as *Mädchen in Uniform, Women in Love,*

The Rainbow, Torch Song Trilogy, The Fourth Man, Entre Nous, and *The Rocky Horror Picture Show.* For gay, lesbian, and bisexual films that the Halliwell guide did review, there is rarely a kind word. He calls *Personal Best* "tedious," *The Hunger* "absurd," *The Bostonians* "sluggish," *Deathtrap* "badly fumbled," and so on.

Another mainstream source which I consulted on occasion, *The Time Out Film Guide,* though more complete, is also viciously homophobic. A synopsis of the film *Zee and Company* contains the phrase "her pet faggot." The text on *Querelle* calls its director "a drug-crazed German faggot." With this sort of commentary, it is not difficult to see why films with bisexual, lesbian, or gay characters often fare poorly at the box office. Built-in obstacles of this kind make obtaining the necessary financial backing to produce such a film much more difficult.

Also contributing to this invisibility is the fact that many lesbian and gay film festivals tend to ignore films with bisexual characters. This may be because of the myth that bisexual people do not actually exist or because many gay and lesbian people who attend these festivals feel offended if the heterosexual sex they are forced to watch, *ad nauseam,* in the mainstream media shows up in a gay and lesbian film festival. Therefore, recognizably bisexual film characters are generally not mentioned in the festival program. The same seems to be true for most existing books on homosexuality in the cinema. The fact that characters being discussed are attracted to members of the other sex is not mentioned, ostensibly because that is not the subject of the book.

The program for The Seventh Annual Boston International Gay and Lesbian Film and Video Festival (1991), for instance, does not mention any bisexual characters, although roughly one quarter of the films in the festival contained such roles. The synopsis of *Straight to the Heart* describes the bisexual protagonist as coming to "full acceptance of his homosexuality," when in fact there is no indication that he is no longer bisexual. The description for *My Father Is Coming* characterizes a bisexual woman as trying to deceive her father by living with a man in order to protect her lesbian relationship. In the plot, however, she does not yet have a female lover when this scene occurs. The bisexual role in a third

film, *Sunday, Bloody Sunday,* is central to the plot, but the festival guide does not mention it.

This book does not deal with the subject of bisexual characters in pornographic movies, with the exception of a small number of soft-core films that received general theatrical release. There are a number of reasons I have chosen this course of action; for one thing, it is difficult to keep up with all the X-rated films with bisexual characters being produced these days. The enumeration of such films would overwhelm this book and make the project unmanageable. There would be questions of whether to include 8mm films and peep show film loops as well. All that aside, this author has had to sit through an unconscionable number of bad films with marginal plots already. If he hadn't stopped, he would surely have gone blind!

Finally, a few notes about language. In an attempt to make this book accessible to all people interested in the topic, the use of gratuitously academic language has been avoided. English, while rich in words and concepts, is still relatively lacking in terms to describe genders, relationships, and sexual orientations outside the male/female, monogamous, heterosexual convention. In this book, the term "opposite sex" refers to male as opposite of female and vice versa. This is not meant to negate the existence of transsexuals, transvestites, intersexed people, and people with other chromosomal combinations as additional sexes or genders. Since male and female are not *really* opposite, you may consider "opposite sex" to be merely a colloquialism. The word "straight" is used merely as a synonym for heterosexual and does not imply that heterosexuality is any more or less normal or desirable than any other sexual orientation.

Acknowledgments

This book could not have been written without the help and support of a number of people. Many people assisted in identifying and locating films and reference books for use in this endeavor. Others provided advice, encouragement, guilt, and whatever else was necessary to keep the project moving forward. I would like to express my love and gratitude to Mary-Ann Greanier, David Reiffel, and Michael Schwartz for their unfailing assistance and encouragement. Many others helped me in a variety of ways. I would like to thank Lani Ka'ahumanu, Sharon Gonsalves, Michael Montgomery, Liam Moody, Heidi Vanderheiden, Grau Katt, Coal Train, Drew Lewis, Wouter Kaal, Kevin Hardy, Leslie Bryant, Andy Brenneman, Dr. Fritz Klein, Gilly Rosenthal, Vic De La Rosa of Frameline, Burt Blum of the Santa Monica Trading Company, Din Luboviski of the Larry Edmunds Bookshop, Jackie Hayes, Lisa Sheehy, and Aurora Nunes.

My thanks also to the dedicated organizers of lesbian, gay, and (sometimes) bisexual film festivals in Boston, Cambridge, New York, Washington, DC, Amsterdam, Hartford, San Francisco, and Copenhagen. Without their efforts, it would have been much more difficult to locate many of the more obscure films I have researched. In addition, I would like to thank the staffs of the following libraries for assisting me in locating information: Museum of Modern Art in New York, Margaret Herrick Library of the Academy of Motion Picture Arts and Sciences, Library of Congress, Boston Public Library, University of California at Berkeley, San Francisco Public Library, and the national film archives in Amsterdam and Copenhagen. I would like to extend a note of special thanks to Mary-Ann Greanier for her extraordinary work in editing, indexing, and political insight, and for teaching me so much along the way.

Chapter 1

Who Is Bisexual?

Of course, people do go both ways.

–The Scarecrow in the movie,
The Wizard of Oz

Questioning characters in film about whether they are bisexual or not is as productive as asking historical figures the same question; neither is available for comment. Were they available, there is no guarantee they would give a straight answer. Or perhaps the answer would be more "straight" than truthful. All we have to go on is the historical evidence; in this case, the film itself and anything the director, actor, or script writer may have said. Given that, we are often unable to make a determination beyond a reasonable doubt.

Opinions about bisexuality represent wide and varied beliefs. Using the broadest interpretation of the term–people who have had at least some sexual attraction to both males and females–nearly half of all American males (46 percent) would be considered bisexual according to Kinsey Institute statistics published in 1948. People rated as one through five on the Kinsey scale might be considered bisexual, whereas those who rated zero are exclusively heterosexual and six are exclusively homosexual.

Some people will use the narrowest interpretation to insist that there are no bisexual people: "bisexuals" are merely people in the process of coming out as homosexual. In his book, *Homosexuality: Disease or Way of Life?*, Edmund Berger voices this point of view. He states, "Bisexuality–a state that has no existence beyond the word itself–is an out-and-out fraud, involuntarily maintained by

some naive homosexuals, and voluntarily perpetrated by some who are not so naive."

Scientific evidence disputes Berger's claim, however, and suggests the opposite may be true. In 1985, Dr. Fritz Klein published research based on his Klein Sexual Orientation Grid. Rather than a single Kinsey digit, subjects using the Grid are asked to place themselves on each of twenty-one seven-digit scales. The scales indicate each subject's past, present, and ideal rating for sexual attraction, sexual behavior, sexual fantasies, emotional preference, social preference, self identification, and lifestyle. This results in a multidimensional grid of behavior over time. Klein's research demonstrated that there is "a significant trend in the direction of the bisexual norm with the heterosexuals moving toward a more homosexual orientation over their lifetimes, and homosexuals moving away from a homosexual orientation."

Even among bisexuals, there is no consensus about who "qualifies" as bisexual. There is general agreement among researchers that the majority of bisexuals do not have an equal attraction to females and males. However, those bisexuals who do feel an equal attraction often feel that they are attracted to men and women in different ways. Heated debates rage over why people have a particular sexual orientation and why it may change over time. A quick reading of a few essays from the landmark anthology, *Bi Any Other Name* will illustrate a diversity of feelings, experiences, and lifestyles among bisexuals.

The general belief among bisexuals is that anyone who has an attraction to males and females can be considered bisexual, whether or not they are currently engaged in relationships with both. Many bisexuals are engaged in monogamous relationships while others are celibate. Therefore, it requires more than just physical evidence of sexual relations during any period of life to determine whether or not an individual is truly bisexual. Research by Dr. Ron Fox shows that many people who have physical attractions or even regular sexual encounters with both females and males still identify themselves as gay, lesbian, or straight. In some cases, this is because the subject has had no particular emotional attractions to partners of one sex. For others, the reason is pressure from their social support network to retain a particular identification.

SIMILARITIES AND DIFFERENCES
OF REAL AND CELLULOID BISEXUALS

If one were to view film characters as real rather than fictional, it would be obvious that there exists a larger population of bisexuals than is evidenced in the films. Because a film is just a small slice of a fictional character's life, we are usually given little information about their history. For example, were Ester and Anna lovers in Ingmar Bergman's *The Silence* (1963) before we join the action? Bergman teases us with this possibility, but in the end is silent about the answer. Similarly, there is no telling what will become of any given character after the film's end, unless they die on screen. As it happens, death is the fate of an inordinate number of bisexual, lesbian, and gay film characters. *The Celluloid Closet* by Vito Russo lists an interesting "Necrology" with dozens of gay, lesbian, and bisexual characters who were killed off in Hollywood films.

Some film characters may be attracted to both males and females, but do not let us know during the time frame of the film. Perhaps they are not yet aware themselves. Given the number of characters who discover their bisexuality during the course of a film, is it reasonable to assume that others might discover it in some as-yet-unmade sequel? If Stallone had made as many sequels to *Tango and Cash* as he did to *Rocky*, we might have quite a different picture of the "Italian Stallion." Just as monogamous bisexuals are less obvious in real life, a bisexual film character in a monogamous relationship is overlooked unless overt reference is made to the fact. There have not yet been any narrative film characters wearing the overlapping blue and pink triangles–the symbol of the bisexual movement.

A film must be read in the context of the period and country in which it was made. Modern Hollywood films, such as *Henry and June* (1990), can be quite explicit about bisexuality. However, films made during the days of the Motion Picture Production Code, such as *Gilda* (1946), were strictly regulated. Therefore, references had to be much more subtle. German films, such as *Mädchen in Uniform,* were acceptable in 1931 Germany (though censored in the United States). Such a film could cost the director and actors their lives less than five years later under Nazi rule.

Just as gay, lesbian, and bisexual people are forced underground when their government starts burning books and people, so are their celluloid counterparts. The characters exist during such times, but they are much more difficult to detect. They must be clever and subtle to avoid the police (read: censors), but if you know the "code words" you can still find them.

In the 1990 documentary, *Dry Kisses Only* (directed by Jane Cottis and Kaucylia Brooke), a number of films are cited in which, despite being produced in the days of the Motion Picture Production Code (The Code), lesbian and/or bisexual characters can be spotted by "reading between the lines." None of these roles were allowed to be explicitly developed or even strongly suggested, however. Under The Code, homosexuality could be portrayed only as negative stereotypes, warped personalities, or silly comic characters used to underscore the macho qualities of the leading (always white) male. Two women could never kiss each other more passionately than a quick peck, and men had better save their lips for the opposite sex.

There are a number of recurring character types in film that are difficult to categorize as bisexual or not bisexual. The reason they defy classification is that we do not fully understand their motivations or inclinations. Because the film is merely a slice of a character's life, it generally reveals only a portion of the character's personality. Even if the character is well-developed in the script, we may not know, with certainty, whether or not he or she is truly bisexual because the character may not be sure either.

One example of such an ambiguous character is the married bisexual. Old stereotypes would have us believe that all such people are actually closeted homosexuals who marry to avoid detection. If not closeted, they must be confused, and will eventually realize that they are indeed homosexual. There are certainly some married people who fall into one or the other of these categories. However, to state that this is true for all married people who are attracted to members of the same sex is simply to deny that bisexuality could possibly exist as a legitimate sexual orientation. This stereotype denies the idea that a person could choose to acknowledge his or her bisexuality over the long term and still have a successful marriage. In fact, married couples with one or both partners being bisexual

exist in significant numbers. Many of these are quite successful long-term relationships.

This attitude toward married bisexuals is deeply ingrained in the movie industry, both in the United States and abroad. One is hard-pressed to find a single instance on film of a bisexual woman who is happily married. The implication, rather, is that women turn to other women for love because their husbands abuse them. Conversely, the stereotypical married bisexual male in film is treated as a closeted homosexual who married simply for the sake of appearance. Such films do not allow the possibility that bisexual men marry because they are attracted to women. We will return to these stereotypes later in the book.

Another negative type of bisexual character is the one who sleeps with people of the same sex in order to gain something from them. In most cases, we do not know whether that character would be attracted to someone of their own sex under normal circumstances. In *The Conformist* (1971), does Anna seduce Julia only to save her husband's life? Probably. Would she–does she–sleep with other women? Perhaps. We cannot know for sure.

In the Japanese film *Afternoon Breezes*, would Natsuko have slept with a man had it not given her a better chance at becoming lovers with her roommate? Based on the evidence, probably not. On the other hand, if we had known her better, maybe we would find that this is not so incongruous for her after all. It was certainly her first time with a man, but that is not unusual for a young working woman in Japan in the late 1970s. What *is* unusual is her open attraction to another woman during that period.

Is Elizabeth Taylor's character in *X, Y, and Zee* (1972) bisexual or did she sleep with Susannah York only to save her marriage? We are left to decide for ourselves. In *Doña Herlinda and Her Son* (1986), would the son ever sleep with women if his mother were not push-ing him and threatening to withhold her love? The implication of the film is that he would not, but who knows?

Michael York's Karl, in *Something for Everyone*, seems to be using his bisexuality to make his way to the top and fulfill his dream of living in a real castle. Is he having sex with both men and women only to achieve his goals . . . or would he choose to do so in any

event? If he is not bisexual, to which sex is he attracted? Considering the evidence, it is impossible to tell.

A third type of ambiguous film character is the hustler. Would one consider a man bisexual who sleeps with men professionally, but prefers women in his personal life? Maybe, but probably not. In most of these cases, however, we do not have all the information necessary to make an informed judgment. Examples of otherwise-straight hustlers appear in *Mala Noche* (1985) as young Roberto and *Midnight Cowboy* (1969), with Jon Voight as the homophobic Joe Buck. In Paul Morrissey's *Flesh* and its sequel *Trash* (1970), Joe Dallesandro plays a hustler who seems to enjoy both men and women.

There are numerous instances of characters who turn to members of their own sex due to long incarceration and the opportunity to be sexual with someone who may care about them and their situation. The first such film was probably the German *Geschlecht in Fesseln (Sex in Bondage)*, made in 1928. In it, the male lover of a gay convict shakes down Dieterle, a married fellow prisoner, over an affair the two had in prison. In *Kiss of the Spider Woman* (1985), Valentin, the revolutionary who has a female lover waiting for his release, eventually turns his attentions to his cellmate Molina, a flamboyant queen. Men are as affectionate as they can manage under difficult circumstances in Jean Genet's French masterpiece, *Un Chant D'Amour* (1947). Tender images of hands reaching through cell windows, flowers being passed, and cigarette smoke shared through a straw fuel the homoerotic feel of this film, set in an otherwise brutal environment.

The boarding school is another form of enforced single-sex living. The most famous of all early lesbian films is *Mädchen in Uniform* (1931). In this film, several of the girls are lovingly involved with each other, and one girl with her teacher. Early in the film, however, the school girls are seen gazing longingly at pictures of men. Jacqueline Audrey's *Olivia* (1951) depicts passion between students in a French girls' school. *Thérèse and Isabelle* (1968) is yet another girls' school film in which at least one of the young lovers has an interest in men, as well. Many European countries have produced one or more of these films. *You Are Not Alone* (1982) is Denmark's contribution. In it, a bisexual boy named Bo teaches the

headmaster's son the joys of sex. Similar scenes of "homosexuality by necessity" occur in English school films such as *Another Country* (1984), in which Guy Bennett, who is homosexual, is sexually involved with classmates who are probably not.

An interesting question about bisexuality is posed by Robert Altman's 1982 film, *Come Back to the Five and Dime, Jimmy Dean, Jimmy Dean*. Karen Black plays a transsexual who shows up at the twentieth anniversary reunion of her small town's James Dean fan club, much to the confusion of her old friends. As a young man, she had slept with women and even fathered a son. As a grown transsexual woman, she slept with a number of men. However, to the best of our knowledge, this character, having been sexual with both men and women, always did so with members of the opposite sex.

Similarly, in the film *Orlando* (1993), the title character lives the beginning of his life as a man who is attracted to women, then becomes a woman herself. Once she has made the transformation, she is apparently only attracted to men and therefore remains heterosexual.

Another curious film is Eric de Kuyper's *Pink Ulysses* (1990). A sort of cult retelling of Homer's *Odyssey*, this film is aimed at gay male audiences and projects a distinctly gay aura. The main character Ulysses, based on the evidence available, is heterosexual. In fact, there is little obvious homosexuality anywhere in the film. What gives this film its gay overtones is the treatment of Ulysses and his crew, the insertion of film clips of operas, and camp sight jokes throughout the film. Ulysses and his crew are cast as gorgeous musclemen straight out of the physique films of the 1950s. The scene of his crew lashing the beautifully oiled Ulysses to the mast is so homoerotic that it steals the show.

Those writers and directors who subscribe to the myth that lesbians need only to sleep with the right man to realize what they have been missing are another source of questionable bisexual characters. Characters based on this ignorant cliché include Pussy Galore in *Goldfinger*, the title character from *Emmanuelle*, and Ellen in *The Fox*.

Chapter 2

In the Beginning

When I think of those who will come after . . . I feel as if I were taking part in the preparations for a feast, the joys of which I shall not share.

—Dag Hammarskjöld

If one were to examine the early history of the motion picture without a sense of the historical changes in language and culture, there would seem something very queer indeed about William Kennedy Laurie Dickson. Dickson was only nineteen when he wrote a letter to Thomas Edison from his home in England asking for a job. Edison turned him down, but Dickson sailed to the United States anyway and presented himself to the famous inventor. After a brief interview, an impressed Edison told him, "Well, since you have come, you'd better get to work."

Over the next five years, they worked together on various projects. In 1886, Edison assigned Dickson the job of combining Edison's phonograph with "a practical zoetropic moving figure device." By 1889, Dickson had developed both the kinetoscope, a peep show device which Edison subsequently marketed, and the film projector. Edison promptly buried the projector idea, believing it would ruin the market for kinetoscopes. Edison was correct, but unfortunately he had not bothered to patent the projector.

Edison provided both the hardware and the films for kinetoscopes. These films could be no longer than fifty feet and consequently lasted only a few seconds. All the early kinetoscope films were directed by Dickson. *A Gaiety Girl* (1894) was among the first commercial films. It featured Mae Lucas, one of three women re-

cruited from Daly's Theater in New York, where they performed a show called *The Gaiety Girls*. The stage version featured Edison's star and other women dancing together. The following year Dickson directed an experimental sound film called *The Gay Brothers*, which featured two men dancing a waltz. When Dickson left the Edison shops later that year, he went to work for the Lambda Company. There he developed equipment used in the first commercial showing of a projected movie. Before the year was over, he left Lambda to help found the American Mutoscope Company, later known as Biograph.

A SURVEY OF BISEXUAL REPRESENTATION IN SILENT FILM

A disturbingly large percentage of movies made during the silent era are now lost. For example, French director Alice Guy made the first scripted fiction film in 1896. She directed more than 700 films, of which only a handful have survived. We know from reviews and diary accounts that among the many lost films by other directors are ones which contained homosexuality and possibly included bisexual characters.

The earliest surviving films with bisexual characters appeared just before the outbreak of World War I. These films featured cross dressing, with incidental bisexual behavior. With only one exception, all the bisexual characters from this time until the advent of talkies came from the United States and Germany.

The first arguably bisexual characters appear in Sidney Drew's *A Florida Enchantment*, released by the General Film Company in 1914. The story was adapted from a successful and highly controversial 1896 Broadway play by the same name. Typical for the period, all the servants are played by white actors in blackface.

In the film, Lillian Travers is a young heiress from New York City visiting her aunt in Florida. In her aunt's house, she discovers an old chest containing seeds from an African "tree of sexual change." When consumed, the seeds turn a person into the opposite sex. In a fit of jealousy over the local doctor, Lillian swallows one and awakens the next morning with a mustache. She promptly shaves it off. However, she is now possessed of male instincts, but

continues to dress as a woman. Edith Storey does an excellent and humorous job in the role of Lillian. For the remainder of the film, whether in male or female garb, she is able to convey her new found "maleness" in subtle and convincing ways.

Lillian causes quite a commotion at her aunt's stately southern home by coming-on to several women, all of whom seem attracted to her. One of the women even wants to sleep with her. Deciding that she needs a valet, Lillian gives a seed to her maid, who becomes decidedly butch. The two travel to New York to get outfitted as men, and return south. Apparently there were no good tailors in Florida at that time.

In the meantime, the doctor (played by director Sidney Drew) follows them. When they change into men's clothing and disappear, he assumes they have been murdered. Later he catches up with them and Lillian has to let him in on the secret. The skeptical doctor tries one of the seeds himself. He becomes a particularly unconvincing female, actively pursuing men. Unlike Lillian, whose unusual behavior is generally tolerated, the doctor is chased off the end of a pier by an angry mob.

Released the same year, Germany's first contribution to bisexuality on the screen was *Zapatas Bande*. A film company is on location in Italy for a movie about a famous gang of bandits. The cast mistakenly attacks the carriage of a countess who believes that they are the real outlaws of the Zapata Gang. The countess' daughter develops a crush on the gang's leader, Elena (Asta Nielsen). In the meantime, the actual Zapata gang has stolen the actors' clothing, leaving them with only their bandit costumes, while the Countess has sent villagers and the police to capture them.

After being shot at by the villagers, the cast breaks into the Countess' house, where Elena sees the daughter again, asleep. The daughter awakens, lustily kisses her, and gathers food for the whole company. Elena and the daughter join up with the company, where the daughter also hugs and kisses one of the men. When the police do catch up with them, the acting troupe is finally able to explain what happened by getting the cameraman, the only one left with his own clothing, to vouch for them.

The film's star, Danish-born Asta Nielsen, is considered by many to be the first great actress in film history. Beginning in 1910, she

made more than seventy films in a career that spanned twenty-two years. Her acting style was natural, in contrast to the exaggerated gesticulations common to the silent film era. She is also credited with introducing the "hosenrolle" (women in masculine roles) to cinema with two films in 1912: *Wenn die Maske fallt*, where she is dressed as a page; and *Jungend und Tollheit*, in which she disguises herself as a male student. With *Zapatas Bande* she evolves the craft further by playing a masculine romantic lead. Perhaps her greatest contribution to the art of gender bending was in the 1920 version of *Hamlet*, where she plays the Prince himself. This was one of the first films to come out of the production company she formed that year. In 1925, she appeared with Greta Garbo and an unbilled Marlene Dietrich in G. W. Pabst's classic melodrama *Die freudlose Gasse (The Joyless Street)*.

A pair of films were adapted from the Danish novel, *Mikaël* written by gay writer Herman Bang. The story is said to be based on the life of French sculptor Auguste Rodin. Basically, it is a melodrama about a homoerotic relationship between a master and his student, who ultimately leaves his teacher for the love of a woman.

The first version, released in 1916, is called *Vingarne (The Wings)*. The title refers to a nude, winged, male sculpture which provides the central image in the film. Swedish director Mauritz Stiller was a particular fan of gay artists Magnus Enckell (whose most famous painting is called *The Wings*) and Carl Milles (who provided the sculptures for the film).

Carl Theodor Dreyer directed the German version, called *Mikaël*, in 1924. In it a famous artist named Zoret falls in love with his young model, Mikaël. He paints the boy's nude portrait as Siegfried. Despite losing the boy's affections to a wealthy princess, Zoret says on his death bed, "Now I may die content, for I have known great love." When the film opened in New York, the name was changed to *Chained: The Story of the Third Sex*.

Following the First World War, censorship efforts around the United States were on the rise. A number of movies made during this period attempted to evade the censors by using Biblical themes. Three such films with gay themes were *Salome* (1923), *The Sign of the Cross* (1932), and *Lot in Sodom* (1933). Based on the banned play by Oscar Wilde, *Salome* was allegedly made with an all gay,

lesbian, and bisexual cast. The sets and costumes were developed by designer Natasha Rambova, and were based on sketches by Aubrey Beardsley. Rambova was wife of the film's director and lover of its star, Alla Nazimova who, in turn, was married to Rudolph Valentino.

In the film, Herod has taken his brother's wife as his own and lusts after her daughter, Salome. Herod also holds the prophet Jokaanan captive in a cage. Salome spurns Herod's advances and is drawn to the sweet voice of Jokaanan. Salome easily seduces the guard, Narraboth, who has otherwise spent most of his time in the arms of another guard. When he unlocks the cage, Jokaanan appears. Salome is transfixed with desire. She praises his body, his hair, and his mouth, but he will give her none of these. Her desire prompts the jealous Narraboth to kill himself at her feet. Frustrated at her rejection by Jokaanan she orders him locked up again.

When Herod arrives, she accepts his offer of "anything, up to half my kingdom" to dance for him. Salome performs the Dance of the Seven Veils, then demands the head of Jokaanan so that she can gratify her desire to kiss him on the mouth. Herod is horrified at the request, but keeps his half of the bargain—then orders her killed as well. Insisting that the film be banned, the examining censor from New York concluded, "This picture is in no way religious in theme or interpretation . . . it is a story of depravity and immorality made worse because of its biblical background." Needless to say, the film is a must-see.

In the 1927 film, *Der Geiger von Florenz* (*The Violinist from Florence*), Elisabeth Bergner plays the tomboyish Renée. She dresses as a boy in order to escape from boarding school and is picked up by a brother and sister. The brother is an artist who find himself attracted to Renée, his new 'male' model. Renée reveals to the sister that she is a woman by placing the sister's hand on her breast. It is only then that the sister gives her a full kiss on the lips. Later, at the end of the film, the brother is also seen kissing Renée who is still dressed in her male garb.

The 1928 German film, *Geschlecht in Fesseln* (*Sex in Bondage*) was probably the first film to depict homosexual relationships in prison. Director William Dieterle plays the part of a young man who is sent to prison for an accidental killing. The man enters into a

tender and loving relationship with a prisoner who has a male lover on the outside. When the young man is released from prison, he leaves his lover behind and returns to his wife. The homosexual prisoner later extorts the wife for money, leading to a double suicide.

German G. W. Pabst directed the silent era's best-known bisexual character in 1929's *Die Büchse der Pandora* (*Pandora's Box*). The story for this film comes from a pair of plays: *Pandora's Box* and *Earth Spirit*, written by Frank Wedekind.

American actress Louise Brooks gives an excellent performance as the character Lulu, a beautiful and talented German equivalent of the 1920s "flapper." Everyone desires Lulu and she flirts with them all. She eventually marries Ludwig, a newspaper tycoon, whose son Alwa runs a cabaret show in which they plan to make her a star.

At the wedding, Lulu approaches the Countess Geschwitz, who asks her to dance. When the groom interrupts them, the Countess stares daggers. Before Lulu retires for the evening, the Countess gives her an intimate good night hug. More than that was not allowed, even by the relatively liberal censors of the time. The marriage is short-lived, as is the husband. When Lulu is brought up on murder charges, she chooses to flee the country with Alwa, her dead husband's son who has become her lover.

The Countess tracks down Lulu in exile. She attempts to help Lulu by giving her cash and seducing a bounty hunter who has been trailing her. Alwa leaves her destitute. Lulu escapes to London where she meets her fate at the hands of Jack the Ripper.

In the 1985 documentary, *Lulu in Berlin*, actress Brooks recalls that although, "Lulu and the Countess were having an affair on the side" at the time of the wedding, Alice Roberts accepted the part without knowing that she was to play a lesbian character. When she revolted against kissing a woman, Pabst said he would play opposite her himself on all the close-up shots, just out of camera range. In that way, Roberts could act out her love for a man even though the Countess was a lesbian. Brooks said that she had no such inhibitions, since her best friend was a lesbian and together they frequented lesbian bars.

The Wild Party (1929) is the only film directed by Dorothy Arzner in which she touches on lesbian relationships. Always a

pioneer in the world of film, Arzner produced this movie as a "talkie," using a microphone attached to a fishing pole to create the first boom.

The film is set at a girls' school, starring Clara Bow as one of the students. Bow's character is in love with the professor, played by Frederic March. Due to its setting and Arzner's subtle direction, the film has a persistent undercurrent of lesbianism. This is most apparent when Bow jumps on the lap of another student and embraces her.

Also set in a girls' school, the German film *Mädchen in Uniform* (1931) is more explicit about lesbian attractions–this time between a student and her female teacher. The story takes place in a Potsdam boarding school where a young student named Manuela (Hertha Thiele) falls in love with her teacher, Fräulein von Bernbourg (Dorothea Wieck). The gentle von Bernbourg is continually in conflict with the cruel headmistress, who declares that tenderness is inappropriate. "Discipline is what the girls need in order to grow up to be the proud mothers of Prussian soldiers," says the headmistress.

The teacher is in the habit of kissing each of the girls in her section on the forehead before "lights out." Nearly all the girls have a serious crush on her, but Manuela takes the initiative, throwing her arms around the teacher and kissing her squarely on the lips. Later, the teacher gives Manuela one of her slips to wear. The young girl takes this as a sure sign of von Bernbourg's love. After the school play Manuela, who has imbibed a bit too much punch, openly declares her love for the teacher. The principal overhears and declares it a scandal, banishing Manuela to the infirmary. In the original ending for the German market, the girl climbs to the stop of the school's spiral staircase and throws herself off. However, in most countries the film was shown with an alternate ending in which her classmates prevent the suicide.

The bisexuality in this film is only implicit, since no men appear anywhere in it. However, at two points in the action, some of the same girls who have an attraction to their teacher are seen looking lovingly at photographs of male actors and athletes.

When the film was submitted to the U.S. censors in 1932, their pronouncement was, "The definite story of Manuela's affinity for her teacher make this picture totally unsuitable for showing in any

theater." All scenes portraying Manuela's affection for the older woman were deleted, as was Fräulein von Bernbourg's defense of lesbianism to the principal.

Mädchens was based on the antiauthoritarian play, *Gestern und Heute* (*Yesterday and Today*), by German writer Christa Winsloe. That story in turn was adapted from an earlier play of hers that did not have the lesbian theme.

Acht Mädels im Boot (*Eight Lasses in a Boat*), made in 1932, is the story of eight women in a rowing team. The women spend most of their days and nights together at the clubhouse near the river. There are shots of women caressing each other and rubbing cheeks together as lovers might.

When the protagonist, Christa, discovers that she is pregnant, the women implore her to stay with them so they can raise the baby. Her father, her fiancé, and her doctor have other plans, insisting on an abortion. The film's focus is on the struggle between the nurturing women, represented by Hanna, the club's charismatic leader; and the controlling men, led by Hans, Christa's fiancé. In the end, the men are victorious, though the film's sympathy does not lie with them. Hanna tells Christa, "I nearly forgot what fathers are like. They want to be tyrants. They are all the same."

In 1933, the eve of the Nazi takeover in Germany, *Anna und Elisabeth* was released using the same stars as *Mädchens in Uniform*. Elisabeth is the lady of the manor, who is unable to walk. She hears of a girl in the village who possesses healing powers and has Anna brought to her. Elisabeth persuades Anna to leave her fiancé and stay with her. With Anna there, Elisabeth begins to walk again.

The emotional intensity between the two women makes it clear that they have become lovers, as well. This is most obvious in the scene which begins the night before Anna is to be interrogated about her powers by a group of priests. In an extreme close-up, the two women are positively glowing. This dissolves into a stylized fade and, as morning breaks, their positions on the screen have reversed. The implication is that they have spent the night in loving embrace.

The movie ends in a scene reminiscent of *Mädchens*, with Elisabeth jumping from a cliff to her death. The film was banned within two weeks of its release.

EARLY ACTIVISM

The silent film era was a relatively active time for gays, lesbians, and bisexuals. Gay bars and sex clubs existed, though for the most part they had to remain well-hidden. Many were in private homes, like the "buffet flats" mentioned in in the song *Soft Pedal Blues* by bisexual singer Bessie Smith. The term "buffet" referred to great variety of sex available on the premises.

Same-sex organizing was very limited compared to today, but a small number of groups did exist. The Scientific Humanitarian Committee, founded in Berlin in 1897 was one of the most active and best-known. Dr. Magnus Hirschfeld, the group's director, worked tirelessly for the repeal of Paragraph 175 of the German penal code, which outlawed male homosexuality.

Hirschfeld's Institute for Sexual Science produced a film in 1919 called *Anders als die Anderen* (*Different from the Others*) which continued the repeal campaign. The role of Paul was played by Conrad Veidt, best known at that time as the somnambulist in *The Cabinet of Dr. Caligari*. Paul is a violinist who falls in love with one of his students. They begin appearing in concert together, but their happiness is short-lived. A man whom Paul had brought home from a dance begins extorting them. When Paul goes to the authorities for help, both he and the extortionist go to prison. Once Paul is released, his friends, lover, and work are all gone, so he poisons himself. At the funeral, the former lover vows to become an activist fighting against Paragraph 175.

Hitler's storm troopers attempted to destroy all prints of this film and very nearly succeeded. It was thought to be lost until a partial copy was discovered in East Germany bearing Ukranian subtitles. Existing fragments imply that one of the gay characters was also married.

One attempt at organizing for gay rights in the United States was a Chicago group calling themselves the Society for Human Rights. Named after a gay group in Germany, they received a state charter in 1924. Within a year, however, the president, vice president, and secretary were all arrested on trumped-up charges of lewd conduct. Although the group officially excluded bisexuals, vice president Al Meininger was bi.

Prescott Townsend was another bisexual activist who began his work during this period, having come out in 1913. The son of a Boston blue-blood family, Townsend was removed from the social register for not keeping quiet about sleeping with men. He would annually address the Massachusetts Legislature on gay rights, admonishing them for attempting to legislate morality. Townsend founded the Boston chapters of the Matachine Society and One Inc., two early national gay organizations. He also started the Boston Demophile Society, a gay group with a mailing list of more than one hundred people.

At the age of seventy-one Townsend was the subject of a black and white, pre-Stonewall documentary aptly titled *An Early Clue to a New Direction* (1965). He appears with a young cult actress named Joy Bang, talking about his life, reading from Hawthorne, and warning her not to steal his boyfriend away. When Joy is surprised that he also finds her attractive, he tells her, "Of course I like girls. I'm bisexual. There are only variants. No deviants."

One of the fun topics Townsend introduces in the documentary is his "Snowflake Theory." Using a diagram, he shows six vectors radiating from a central point. Each of the three opposing pairs is labeled: He and She; I and You; Hit and Submit; representing factors in an individual's sexual persona. Each vector has an arrowhead at the end and hash marks along its length. The length of the vector (and therefore the number of hash marks) is determined by how much of each factor is present for a given person. The resulting diagram looks like a six pointed snowflake, with no two flakes exactly alike.

Chapter 3

Breaking the Code

Morality is simply an attitude we adopt toward people whom we personally dislike.

—Oscar Wilde

In 1910, D. W. Griffith began making films in southern California for the New York-based Biograph Company. Soon other film companies followed. Before long, newspapers were reporting a steady stream of sex and drug related scandals from America's new film capital. It was rumored that Griffith had a strong attraction for young girls. Other gossip declared that two of Griffith's stars, sisters Lillian and Dorothy Gish, were lovers.

It was shortly after actress Mary Pickford's secret Nevada divorce and subsequent marriage to Douglas Fairbanks in 1920 that Hollywood's first substantiated scandal occurred. Olive Thomas–star of *The Tomboy* and *Betty Takes a Hand*–who had been promoted by Selznick Pictures as the "Ideal American Girl," was found dead in her Paris hotel room. She apparently committed suicide over her inability to purchase a quantity of heroin for her addicted husband, actor Jack Pickford, Mary's younger brother.

Not quite a year later, this scandal was eclipsed by one involving Paramount comic star Fatty Arbuckle. Already in hot water due to bribes he paid to Boston and Woburn Massachusetts officials to drop indecency charges, Arbuckle threw a party Labor Day weekend in San Francisco. According to witnesses, on the third day of the party he took actress Virginia Rappe into an adjoining suite, raped her, and beat her into a coma. Her last words, whispered to a nurse at the hospital were allegedly, "Fatty Arbuckle did this to me.

Please see that he doesn't get away with it." She died a few days later. Despite all the evidence, he was acquitted in the third trial and went free, but never appeared on film again.

Only a few months passed before Paramount was again rocked by the shooting death of executive William Desmond Taylor in his Westlake home. Hampered by a number of people who turned up ahead of the police to burn evidence, the investigation revealed that Taylor had an extensive collection of pornographic photos of himself with well-known female stars. It was also revealed that he was having simultaneous affairs with Mabel Normand (*The Slim Princess* and *Fatty's Flirtations*), Mary Miles Minter (*The Drums of Fate*), and Mary's mother, Charlotte Shelby. Further, it was discovered that in one closet he had an extensive collection of underwear he had purloined from his lovers, each identified with initials and dates. On top of all this, reporters said Taylor visited "queer meeting places" and used drugs with "effeminate men and masculine women." The now-lost film *The World's Applause* (1923) was loosely based on the Taylor affair.

By this time, the newspapers and clergy were having a field day denouncing Hollywood and the studios, organizing boycotts and demanding congressional action to clean up the "cesspool of sin." The studio magnates knew they had to do something quickly. In 1915, they had lost a key censorship battle in *Mutual Film Corporation v. Industrial Commission of Ohio*, in which the United States Supreme Court ruled that films were not entitled to protection as speech under the First Amendment. The court ruled that cinema was simply a business, and free speech had nothing to do with it. That ruling opened the door for state censorship boards all over the country to snip away at films. Each board, of course, had its own view of what was righteous and pure. There was no uniform code that filmmakers could follow, even if they had wanted to.

Professional baseball had improved its scandalous image after the World Series "fix" of 1919 by creating the Office of the Commissioner of Baseball and hiring Judge Kenesaw Mountain Landis to clean things up. He did, and baseball remained virtually scandal-free for sixty years. The powers in Hollywood saw this concept as an opportunity to reduce some of the heat from Congress and religious groups.

THE HISTORY OF THE MOTION PICTURE
PRODUCTION CODE

Self-regulation by the film industry had been implemented in England several years earlier under similar circumstances. The British Board of Film Censors was organized in 1912 in order to forestall attempts by the government to create a film censorship board. The BBFC set up a two-certificate system for films it reviewed— using the label 'U' for universal exhibition and 'A' for adult audiences. Of the 7510 films submitted for review by the BBFC the following year, 6861 were awarded a 'U,' 627 earned the 'A,' and twenty-two were rejected outright. Grounds for rejection included the ridiculing of religion, excessive violence, scenes of abduction into slavery or prostitution, sexual situations, and the ever popular "native customs in foreign lands abhorrent to British ideas." Up until this time, films were regulated under the Disorderly Houses Act of 1751, which gave local authorities control over "places of entertainment for the lower sort of people."

In March of 1922, the Hollywood moguls hastily concocted a self-policing organization called the Motion Picture Producers and Distributors of America. The purpose was to protect themselves from outside interference by censorship boards and give the movie industry a clean image. As spokesman for this new organization, they recruited an elder of the Indiana Presbyterian church by the name of Will H. Hays. Hays had made his reputation as Postmaster General under President Warren Harding. In that office he had waged a fierce and highly publicized campaign against "smut" in the mails. A press conference was called to introduce the new guardian of morality and to assure the world that things in Hollywood would now be hunky-dory.

This appointment was not Will Hays' first exposure to Hollywood. As chairman of the Republican National Committee, he met with the studio directors in 1919 to garner support for the Republican cause in the following year's election. Oddly enough, that meeting was facilitated by Charles Pettijohn, a film attorney and former secretary of the Indiana *Democratic* State Committee.

Newsreels were very influential in those days. Thanks to the support of Hollywood's studio owners, Warren Harding appeared in all of them and was swept into the White House. The Republican

party had discovered the power of film. Hays' loyalty to the party was rewarded with a job in Harding's notoriously corrupt cabinet. In 1928, it was revealed that Hays had accepted a bribe (in the form of a $75,000 gift and a $185,000 loan) for his part in tipping the 1920 Republican convention to Harding.

Hays jumped into his new $100,000 per year job with vigor, speaking out against passionate kisses on the screen, all carnality, and any off-screen activities that might lead to headlines. The studio heads followed his lead by hiring private investigators to dig up dirt on their employees. By the time their work was completed, there was a list of 117 Hollywood names who were considered unsafe to employ because of drug use, illegal activities, sexual proclivities, or sexual orientation. Among those listed in the "Doom Book" was Paramount's Wallace Reid, who was subsequently committed to a sanitarium for morphine addiction and died there the following year.

Hays promised that Hollywood's image would soon improve, saying, "I have faith that unfortunate incidents will be things safely of the past." But studios were fully aware that sex sells tickets and directors did what they could to make sure that their films had plenty. Erich von Stroheim became famous for the orgy scenes and sexual fetishes in his films *Merry-Go-Round* (1922), *The Merry Widow* (1925), and *The Wedding March* (1928). Cecil B. DeMille's *Manslaughter* (1922) shows two women passionately kissing, much to the dismay of state censorship boards. It was apparent that Mr. Hays spoke loudly, but carried a small stick.

In 1927, Hays hired a former War Department public relations man, Colonel Jason Joy, to develop self-censorship guidelines and to advise the studios on their use in film projects. Based on a survey of censorship codes around the country, Joy developed a document which became known as the "Don'ts and Be Carefuls." This list of three dozen proscriptions included nudity, pointed profanity, sex perversion (including homosexuality), sex hygiene, venereal diseases, childbirth, and ridicule of the clergy. The document was endorsed by the Motion Picture Association in October of 1927, allowing Hays to claim once again that he was cleaning up the film industry.

While this was going on, however, the Hollywood scandals continued unabated. Bad Prohibition whiskey caused the deaths of film stars Art Accord and Leo Maloney. Drugs cut short the lives of

Barbara La Marr and Alma Rubens. But it was comic genius Charlie Chaplin who made the most scandalous headlines during this era. Known to have been involved with many women, he also developed a particular interest in girls who were below the legal age of consent. The first was fourteen-year-old Mildred Harris, whom Chaplin met at a beach party in Santa Monica when he was twenty-seven. Two years later, Chaplin married her when she became pregnant with their child. During their brief marriage, Mildred became the lover of Alla Nazimova.

Next in line was Lillita McMurray. She was only seven years old when Chaplin met her at the restaurant where her mother worked. Soon she was working for The Little Tramp in various films as an extra and in more substantial roles in *The Kid* and *The Idle Class*. In 1924, when she was fifteen, Chaplin signed her to a major part in *The Gold Rush*. Shortly thereafter she became his lover. Later that year, young Lita became pregnant. Chaplin, now thirty-five, married her in order to avoid statutory rape charges. Within the next sixteen months, she had two sons and in January of 1927 sued for divorce, settling for $625,000 out of Chaplin's estimated $16,000,000 fortune.

Chaplin was present for, and perhaps involved in yet another scandal during his marriage to Lillita. He was aboard the yacht *Oneida* for a birthday party hosted by William Randolph Hearst and Hearst's lover Marion Davies. At some point during this cruise, the guest of honor, Tom Ince, was shot in the head. Some people speculated that the extremely jealous Hearst had intended the bullet for Chaplin, since he was also a lover of Davies'. Whatever the case, the cover-up was so effective that the mystery has never been solved. Hearst's power was such that even his rivals in the newspaper business feared to investigate too closely.

The 1920s ended with the "shocking" details of actress Clara Bow's love life, as revealed by her private secretary, Daisy DeVoe. For the previous four years, Daisy kept an account of all the men with whom Clara engaged in sex. The list read like a Who's Who of Hollywood actors and caused many red faces when it hit the press— not in the gossip columns, but on page one. In addition to all the actors, she is rumored to have slept with Marion Morrison (the future John Wayne) and several other members of the University of Southern California football team.

Not surprisingly, this sort of behavior led to renewed calls for tighter regulation of the film industry. In 1930, the studio heads again exhorted Will Hays to reach into his bag of political tricks in order to placate the public. The result was Hays' most devastating contribution to the film industry, the introduction of The Motion Picture Production Code. The Code, as it came to be known, was a written set of morality regulations that all the studios were required to follow. This served as the means by which the movie industry could regulate itself and keep local censorship boards off its back. The Code was written by Father Daniel Lord, a Jesuit priest from St. Louis, and refined by Martin Quigley, the Catholic publisher of *Motion Picture Herald*. With the approval of Cardinal George Mundelein of Chicago, they set out to write an industry code that would eliminate "things inimical to the Catholic Church" from film.

With his background in politics and religion, Hays certainly knew the ropes when it came to dealing with city councils, church morality lobbyists, right-wing politicos, and the like. He was not always the most skillful person at covering his tracks, however. In 1930, he was caught bribing ministers and community leaders who were supposed to review films impartially for a variety of civic and religious organizations. Despite this scandal, Hays managed to keep his job because of his reputation for being tough on sex in films.

As a result of the code's strict enforcement, filmmakers toned down the sexual aspects of their projects. In particular, they became much more covert regarding anything related to homosexuality. Gone were the days when a director could freely explore gender roles and subvert them to his/her own purposes. Once The Code was instituted, it was no longer possible to make films like *A Florida Enchantment* or *The Wild Party*.

Any sort of censorship becomes a challenge for those daring enough to confront it. In Marlene Dietrich's first American film, *Morocco* (1930), she performs in top hat and tails, pauses at one point to give a female spectator the eye, then plants a kiss squarely on the woman's lips. She is otherwise heterosexually inclined throughout the film. Not to be outdone, Greta Garbo dresses in male drag throughout much of *Queen Christina* (1933). She also gives Countess Ebba a rather passionate kiss and assurances of time alone together in the country.

Comic teams such as Laurel and Hardy could get away with much more in the way of homosexual innuendo because of their childlike innocence. *Their First Mistake* (1932) can easily be read as the love of the bisexual Oliver Hardy for his gay neighbor Stan Laurel. It is simply the finest gender-bending comedy in a fifty-year period. Stereotypical male/female scenarios are twisted to fit their male/male relationship, with humorous results. Further instances of Laurel and Hardy playing with gender and sexuality can be found in: *The Soilers* (1923), which includes a gay cowboy in the final scene; *Get 'em Young* (1926), with Stan in drag; *Twice Two* (1933), where Stan and Oliver each plays his own wife; and *Jitterbugs* (1943), with Stan cross-dressing again as Auntie. And, of course, Stan and Oliver were *always* winding up in bed together in their films.

Cecil B. DeMille took a different approach to subverting the new regulations. He turned to making films with religious themes. The "godless heathens" in his pictures could always be counted on for an orgy scene or to capture and tie up naked Christian women, as in *The Sign of the Cross* (1932).

One of the first films to run afoul of The Code was the German import, *Mädchen in Uniform*, which showed the love between a teenage girl, Manuela, and her teacher. When *Mädchen* was brought to the United States, it was cut to ribbons by the Hays office. All hints of lesbianism were expunged from the film. Instructions such as, "Eliminate all views of Manuela's face as she looks at Miss von Bernbourg in the classroom," indicated the extremes to which the censorship was carried. Gone, too, was the teacher's defense of lesbianism to the headmistress, "What you call sins, I call the great spirit of love which has a thousand forms." By the time the movie was released to the theaters in 1932, film critics were perplexed at all the fuss about lesbianism. There was none to be found. Manuela and her teacher were now simply asexual.

Under great pressure from the Catholic Church, The Code was strengthened in 1934 to further crack down on characters with same-sex attractions. Catholic journalist Joseph Breen was hired by the Hays office to tighten enforcement of The Code. Only negative stereotypes and comic portrayals of gay, lesbian, and bisexual characters were allowed in film after that, and then only by implication. It was never permissible for a movie to acknowledge that any of the

characters were in fact homosexual or bisexual, or even to acknowledge that such people existed. According to the rules laid down by Father Lord, The Code boiled down to three basic principles:

1. No picture should be produced which would lower the moral standards of those who see it. Hence the sympathy of the audience should never be thrown to the side of crime, wrongdoing, evil or sin.
2. Correct standards of life, subject only to the requirements of drama and entertainment, shall be presented.
3. Law, natural or human, shall not be ridiculed, nor shall sympathy be created for its violation.

— from The Motion Picture Production Code—1934

It was the belief of the Hays Office that the portrayal of homosexuality on film would violate all of these principles and must therefore be absolutely forbidden. According to Gerald Gardner in his book, *The Censorship Papers*, three-quarters of The Code was devoted to detailing what sexual behavior could not be shown on screen. The forbidden classifications included adultery, seduction, rape, and sexual perversion (including male/male and female/female sex). The Code also included specific prohibitions of profanity, vulgarity, obscenity, blasphemy, and outrageous costume design. Forbidden words included *fairy, chippie, goose, madam, pansy, tart, nuts, hell,* and *damn.* Criminals, adulterers, and other sinful types could not go unpunished within the context of the film.

Once The Code was implemented, even use of the word *gay* to describe a homosexual character was disallowed. According to Vito Russo's book, *The Celluloid Closet*, gay only appeared once in that context during the entire reign of The Code—during the 1938 film *Bringing Up Baby*, in which Cary Grant responds to a comment on the nightgown he is wearing by ad-libbing, "I've just gone gay—all of a sudden!" The line does not appear in the script, but censors let it pass, presumably because it demonstrated how ridiculous and perverse it would be for any handsome leading man such as Grant to be considered gay.

During the glory days of The Motion Picture Production Code, no film could hope to be passed without Joe Breen's approval.

Most movie cinemas were owned by the studios and all studios had pledged to uphold The Code, no matter how much they hated it. Their rationale was that self-censorship was terrible, but government censorship was worse. The censor that they most feared was the U.S. Congress, which had repeatedly threatened to legislate against immorality in the film industry. The problem was that the studios now had a tiger by the tail. That tiger censored Walt Disney's *Fantasia* and the Ronald Reagan favorite, *Bedtime for Bonzo*.

One seemingly insignificant skirmish between Hollywood and Washington in 1939 was to have far-reaching effects. That was the year Frank Capra filmed *Mr. Smith Goes to Washington* for Columbia Pictures. The Hays Office had previously managed to talk both Paramount and MGM out of making a film from the novel *The Gentleman from Montana*. President Harry Cohn at Columbia was not so easily dissuaded. Joe Breen had foreseen trouble if a film about Congressional corruption was filmed and sent a letter to Cohn to that effect. When this did not deter him, Geoffrey Shurlock visited Columbia executive, Rouben Mamoulian, who assured him that the screenplay could be written in a way that the Washington politicians would not find objectionable.

Breen appealed to his boss, Will Hays, for help but Hays found nothing particularly wrong with the film concept. Apparently his days in the Harding Administration—the most corrupt in the twentieth century, until a former actor entered the White House six decades later—had led him to believe that political corruption was a way of life and everyone knew it. Whether everyone knew it or not, Congress was extremely displeased with the portrayal of Senators sleeping during important debates, swapping votes for World Series tickets, and being influenced by industry lobbyists. The Columbia Pictures publicity department managed to rub salt in the wound by inviting every Senator and Representative to a screening in Constitution Hall along with 4,000 other VIPs.

Retribution was swift and sure. Congress passed Senate Bill number 280, known as the Neely Anti-Blockbooking Bill, which struck the movie moguls where it hurt the most—in the bottom line. The bill made it illegal for distributors to require theaters to book a block of inferior "B" movies with each block of first-rate films that

they reserved. This legislation, and court cases that followed, eventually led to the loss of Hollywood's film theater monopoly. Now any theater could book individual films from any studio it chose. Later, we will see how this helped make the first successful challenges to The Code possible.

Meanwhile, back in Hollywood, not only was Humphrey Bogart banned from using the word *hell* in the film *Casablanca*, he was prohibited from even implying use of it through a pause. The line "What the–are you playing?" was struck by the Hays Office. In *The African Queen* (1951), Breen went even further, disallowing the use of the word *hell-fish*, and eliminating stomach growling. The censors forbade the use of a Bronx cheer in *Guys and Dolls* (1955). Columbia Pictures president Harry Cohn was told in 1942 by the Hays office that, "There must be no suggestion . . . that the woman is on the way to the toilet" in the film *Pal Joey*. She had to hold it a long time, because this film did not make it into the theaters for fifteen years.

One film that seems to have slipped by is *The Bride of Franken-stein* (1935), the work of gay director James Whale. The original *Frankenstein*, also directed by Whale, was such a hit that Whale's producer implored him to direct a sequel. Whale refused, saying "I squeezed the idea dry on the original picture, and I never want to work on it again." Eventually, however, he relented. Whale agreed to shoot the sequel, but stated that he had "no intention of making a straight sequel to *Frankenstein*."

Straight is the last word one would use to describe this film. Reading the subtexts and innuendoes, one discovers that, although his bride Elizabeth is heterosexual, Henry Frankenstein is probably bisexual and his partner, Dr. Pretorius is almost certainly gay. In fact, the title of the film can be interpreted in several different ways. Many people are under the mistaken impression that Frankenstein is the name of the monster and that the film's title refers to the mate that the two scientists have created for him. However, Frankenstein is actually the name of Mary Shelley's scientist and Elizabeth is his bride. But wait . . . Henry Frankenstein spends what was to be his wedding night with his partner, Dr. Pretorius. So who *is* the bride of Frankenstein?

Some critics have read this film and its predecessor as allegory for the way that society treats homosexuals as monsters. As Vito Russo notes, "The monster is hunted by the townspeople in the same way that groups of men in silent comedies had once run effeminate men off piers and out of town." In much the same way that director Whale was later run out of Hollywood for refusing to stay in the closet.

What diverted the highly religious censors in the Hays Office away from the homosexual implications in Whale's film was the existence of an even greater evil–that of blasphemy. Joe Breen reviewed the original script and wrote in a letter to Universal Pictures, "Throughout the script there are a number of references to Frankenstein . . . which compare him to God and which compare his creation of the monster to God's creation of Man. All such references should be deleted." Later he added, "You should omit the line 'If you are fond of your fairy tales' as a derogatory reference to the Bible." Breen implored Whale to replace a statue of Christ with "some other type of monument."

Beyond the blasphemy, Breen also felt that any implication of a sexual relationship between Frankenstein's monsters was objectionable. He insisted that the new monster be called a "companion" rather than a "mate." Finally, he insisted on eliminating a number of scenes because of their gruesomeness, saying, "Indeed it is our considered unanimous judgment that these eliminations will very materially help your picture from the general standpoint of entertainment." Just how the Hays office expected to improve a horror picture by eliminating the horror is still a matter of speculation.

Now that the clamps were being tightened, virtually nothing gay or bisexual made it past the Hays Office for the remainder of the 1930s and early 1940s. One exception was Katharine Hepburn's male drag in the 1936 film *Sylvia Scarlett*. Besides attracting the affections of actress Dennie Moore's character, who thinks her a boy, Ms. Hepburn gives Brian Aherne "a queer feeling." Beyond that, however, the only thing vaguely gay that the censors allowed was a string of asexual characters coded by Hollywood to represent contemptible homosexuals without portraying any actual "sexual perversion." These roles were played by a small cadre of actors–

most notably Franklin Pangborn, Harold Lloyd, Edward Everett Horton, George K. Arthur, and Grady Sutton.

In 1936, Samuel Goldwyn attempted to make a film of Lillian Hellman's play, *The Children's Hour.* The story is about a woman who loves a woman who loves a man. By the time the censors were done with this story, both women were in love with the man and the whole plot was irretrievably twisted. The scandalous behavior in the resulting film was simply an extramarital affair.

The ban against homosexuality was so utter and complete that even a film condemning it was banned. Filmed in 1939, *Children of Loneliness* tells two stories of "sick" homosexuals who must die because of their perversion. Vito Russo compares the film to *Reefer Madness* because of its hysterical style. This misguided "educational" film consists of two separate stories. In the first, a young woman named Eleanor Gordon begins to fall in love with a female coworker, Bobby Allen. Eleanor's doctor tells her that unlike Bobby, whose lesbianism is congenital, Eleanor is only attracted to women because she was "frightened by a man in her infancy." Heeding the doctor's advice, Eleanor rejects Bobby. The spurned Bobby throws acid at Eleanor. Eleanor retaliates by throwing acid in Bobby's face, causing her to run off wildly into the street where she is run over by a truck. The doctor then introduces Eleanor to a nice football player whom she marries, thereby solving her sexuality problems.

In the second story, artist Paul Van Tyne realizes that he can no longer hide his "abnormality" and seeks medical help. The doctor tells him that he "can never love as a husband because mentally he is a woman." Paul takes the only way out–he kills himself. The film was rejected by the censorship board because, "As its title implies, the film is about sex perversion."

Bisexual characters did not appear again in American film until the Second World War. Once they did return, they were particularly circumspect. Audiences viewing films of the 1940s and 1950s from today's perspective will tend not to see any homosexuality in the characters at all. We are now accustomed to gay, lesbian, and bisexual characters being very obvious. Audiences who grew up on *Desert Hearts* and *Claire of the Moon* often do not realize that there

was a time when film characters had to be at least as closeted as many of their real-life counterparts.

Searching for bisexual characters during the days of The Code meant looking for subtleties that modern audiences tend to ignore. Such inferences are often hidden in visual clues or double entendre. Otherwise they would not have made it past those guardians of public morals, the Hays Office. Only by understanding the director, actors, source material, and the film itself is it possible to make a reasonable call about the sexual orientation of many of these characters.

Things changed during World War II. Suddenly large portions of the population spent all their time with members of the same sex. People who always had thought of themselves as heterosexual increasingly depended upon those of their own sex for emotional support. Often, that developed into sexual comfort as well between designated "buddies" in the military or female workers in the defense plants back home. There was a great shift in acceptable gender roles for women. Rosie the Riveter became a heroic figure, someone to be emulated rather than avoided.

The lasting changes that the war made on the homosexual movement are presented in an excellent documentary by Greta Schiller and Andrea Weiss, *Before Stonewall* (1985). By the end of the war, a much larger segment of the American population had encountered homosexuality. Many were not going back. Those who resumed their heterosexual relationships were changed in their outlook and tolerance toward homosexuality and bisexuality. After all, *they* had done it and *they* were still just regular people.

In 1943, Howard Hughes took time out from building wooden airplanes to direct a film called *The Outlaw*. The story is about quarrels between Doc Holliday and Billy the Kid over a stolen horse and a woman named Rio. Reviewer Geoff Andrew described the relationship between the two men on screen as having "some surprising undertones suggesting homosexuality." Parker Tyler also saw "broad insinuations" of homosexuality in the film and compares it with Andy Warhol's *Lonesome Cowboys*. The film went through six years of censorship hassles before being released.

Eventually, after a large number of cleavage shots had found their way to the cutting room floor, The *Outlaw* was awarded The Code's

seal of approval. Despite the seal, state censors had a field day making further cuts after the film was released. Less than a week after it hit the theaters, the seal was revoked due to what was termed the lurid and misleading advertising used to promote the film. The next day, Hughes sued in Federal District Court for a temporary restraining order blocking implementation of the decision. His case, claiming $5 million in damages based on violation of First Amendment rights, was dismissed. Sweden and Denmark banned the film entirely. Canada went as far as censoring the film's trailer.

Although Joe Breen attempted to hold the conservative line as long as possible, the war had changed people's attitudes toward sex. People were no longer willing to accept that every celluloid relationship be pure and chaste. Without amending The Code, Breen simply altered his enforcement to bring it more in line with current tastes. Adultery and sex between unmarried people was no longer automatically outlawed. With films such as *The Miracle of Morgan Creek*, *For Whom the Bell Tolls*, and *Double Indemnity*, Breen awarded Code seals despite scenes that only a few years earlier would have been banned outright. Two weeks after the end of the war, in September of 1945, Will Hays retired as President of the Motion Picture Producers and Distributors of America. Hays, always a slick operator, managed to get a half million dollar "advisor" contract as part of his severance package.

Charles Vidor's 1946 film, *Gilda*, gave us a love triangle film with bisexuality as the subtext. In it, Glenn Ford's ex-lover, played by Rita Hayworth, is now married to the man he adores, George Macready, who is his new boss. Ford's feelings about his employer are broadly hinted in such lines as, "I was born the night you met me." These words are later repeated to Macready by Hayworth just before Macready proposes marriage. The fact that Ford congratulates Hayworth on their marriage rather than Macready indicates the intensity of his jealousy.

Reviewer Geoff Samuel said of this film, "The script is laced with innuendoes and euphemisms; and Ford finds himself as a character whose sexual attributes are not only ambiguous, but bordering on the perverse as his misogyny gradually gains the upper hand." Glenn Ford later confirmed the speculation that lines like "You must lead a gay life" were not merely coincidental. He remarked in

a *Film Comment* interview that he and George Macready "knew we were supposed to be playing homosexuals."

In Alfred Hitchcock's 1948 experimental film, *Rope*, two friends from prep school who are easily recognizable as gay somehow managed to elude the censors. Interestingly, it was not their relationship that the Hays Office wanted to change, but incidental British dialogue which sounded "fruity."

In 1948, the Motion Picture Production Code suffered a crushing blow when the Supreme Court ruled in *United States vs. Paramount Pictures* that the studios were in violation of antitrust laws. As a result, large theater chains owned by Warners, RKO, Fox, Loew's, and Paramount had to be sold. This decision was to have a profound effect on the ability of the Breen Office to enforce The Code. As long as the studios owned the vast majority of theaters, it was relatively easy to force all films to be submitted for Code approval. Once these theaters became autonomous, however, there was a much larger potential market for independent filmmakers who wanted to bypass The Code. Breen feared that this would make enforcement of The Code nearly impossible, since filmmakers could simply threaten to market their film without the seal if approval was not granted.

The next year, Breen's fears were realized. An Italian film, *The Bicycle Thief*, was submitted to Breen's office and rejected. Joe Breen wanted cuts in two places before a seal would be approved. The American distributor, Joseph Burstyn appealed and lost. He decided to show the film anyway without edits and without the seal. Although this decision restricted its access to theaters, the film not only became a box office success on the art circuit, but won the Academy Award for Best Foreign Picture.

If The Code was losing its power, the Catholic Church was not. Church members were asked annually to repeat a pledge that included the statement, "I promise to do all I can to strengthen public opinion against indecent and immoral films and to unite with all those who protest against them." The Church demonstrated its awesome power in 1950 when the Legion of Decency, which rated films for Catholic viewers, banned a picture called *The Miracle*. Calling the film "a blasphemous and sacrilegious mockery of a most sacred event," the Legion organized a boycott, posted a thou-

sand picketers outside a theater in New York, and stationed priests in front of theater lobbies to turn parishioners away. Theater licenses were revoked by city officials, bomb threats were called in, and fire departments suddenly found theaters in violation of safety codes.

In 1950, Joseph Mankiewicz directed *All About Eve*, the story of a young theater actress, Eve Harrington (Anne Baxter) who makes it to the top by backstabbing the star who has befriended her (Bette Davis). At the end of the film, we see Eve herself about to become a victim to an ambitious young woman. Everyone who sees the film knows what will happen to Eve. Knowing what we do about Eve's personality, it is not her generosity that will be her downfall, as it was with Davis' character. The only logical conclusion, therefore, is that Eve has invited this ambitious young woman to spend the night because she is sexually attracted to her. Indeed this is confirmed by Mankiewicz's biographer, Ken Geist, who says that the Eve Harrington character was conceived as a lesbian. One can only speculate whether Eve slept with critic Addison Dewitt and, if so, what her motivation may have been.

That same year, Michael Curtiz directed the film *Young Man with a Horn*. Lauren Bacall plays Amy North, a woman who, in Dorothy Baker's original novel, is described as having lesbian tendencies. In this film, she becomes the trumpeter's lover, but when that relationship fails, she runs off to Paris with a young woman artist. When she departs, the wholesome Doris Day tells her, "You're a sick girl, Amy. You'd better see a doctor."

Hitchcock was at it again in 1951 with *Strangers on a Train*. Although The Code forbade nearly every sexual and social aberration, it said nothing about insanity. Therefore, by making the main character a madman, Hitchcock was able to develop motivation for acts that any sane character would not have been able to get away with. The film is similar in many ways to *Rope*. This time, however, Guy and Bruno are strangers and plot their murder on a train rather than in an automobile. Robert Walker played Bruno as a homosexual.

The censors unsuccessfully attempted to delete the extramarital pregnancy. They eliminated, as in several other films, a reference to arsenic, substituting the generic word "poison." Breen also delivered a warning against Bruno explicitly demonstrating how to strangle Guy's wife. The state of Maryland went one step further by deleting

Bruno's speech suggesting he could knock Guy on the head with a hammer, pour gasoline over him, and set fire to his car. Apparently, if film viewers discovered how to kill people, there would be murders all over America. The Breen office also cut a speech by Anne that began, "Even if you had done it, I'd have stuck by you," because it condoned wrongdoing.

The first film in many years to openly deal with women who were sexually attracted to each other was the 1951 French film *Olivia*, directed by Jacqueline Audry. When the film was brought to the United States in 1954, it was renamed *Pit of Loneliness* in order to capitalize on the title of Radclyffe Hall's notorious lesbian novel *The Well of Loneliness*, which had never been filmed. Their advertising called it "the daring drama of an unnatural love." By the time the censors got through with *Olivia*, it was eleven minutes shorter. What was left of the film was allowed to be released because of its conclusion that lesbian love is not a valid emotional option. Critics had a field day discussing "the subject talked about in whispers," and "an unhappy and unnatural relationship."

In 1952, Joe Burstyn, distributor of *The Miracle*, was to have the last laugh on the Catholic Church. He and his lawyer, Ephriam London argued successfully that the Supreme Court should overturn the *Mutual Film Corporation vs. Industrial Commission of Ohio* decision. The court declared that films had the same protection under the First and Fourteenth Amendments as did other media. While the court did not go so far as to ban state censorship boards, it did leave them in a particularly vulnerable position.

Encouraged by this decision and by changes that had taken place in the Breen Office since the war, the distributors again submitted the antihomosexual film *Children of Loneliness* for review. Again it was rejected. When it was submitted for a third time in 1953, it was passed, but with mandatory deletions. The film was not to portray women embracing, men holding or caressing hands or about to kiss, suggestions of transvestism, references to characters as their opposite sex, or same-sex couples dancing together. The film was finally released in 1954, at the height of the McCarthy witch-hunts, which now included sexual minorities as well as Communists.

Most Hollywood producers and directors could not afford to take chances during the 1950s and early 1960s, so they dared not inno-

vate. Directors rarely went against convention for fear that one failure would ruin them and their reputation. Because of this, the job of challenging the restrictive Code was left to underground, independent, and foreign filmmakers. The one exception was director Otto Preminger, whose reputation and audacity were so great that he felt he could get away with making films that violated The Code. He had discovered that by releasing a film without The Code's seal of approval, he could make up for the lost revenue of those theaters who would not carry it by packing other movie houses with people who wanted to see something just a little bit naughty.

Preminger first challenged The Code in his 1953 film *The Moon Is Blue*, in which he used the word *virgin* and permitted an off-screen adultery to occur without any negative effect on those involved. Preminger released the film despite being denied The Code's seal of approval, becoming the first major filmmaker to do so. The film became a box office success. But this was not typical. More often, pictures such as *Tea and Sympathy*, which dealt with adultery, were hounded by the Catholic Church's Legion of Decency. Directors were forced to modify film endings such that adulterous lovers would be punished and state that what they had done was immoral.

Three years later, Preminger released *The Man with the Golden Arm*, which dealt explicitly with narcotics use and addiction, again in direct violation of The Code. When the Motion Picture Association of America, the parent body of the Breen Office, refused to award its seal of approval, United Artists decided to distribute it anyway and withdrew from the Association. The film was not only highly profitable, but also garnered Academy Award nominations for Frank Sinatra and Almer Bernstein. Following these two successes, The Code was revised in 1956 to eliminate prohibitions against drugs, prostitution, and interracial relationships.

Meanwhile, more lesbian and bisexual implications were popping up in films, apparently faster than The Code could stamp them out. The implication is strong in *Screaming Mimi* (1958) that Gypsy Rose Lee had an affair with a stripper who worked at her club. This film also somehow got away with a strip scene with sadomasochistic implications. In the same year, *The Goddess* exploited the Marilyn Monroe cult with a thinly disguised story about a small town girl

who rises to the top in Hollywood by sleeping with anyone who can help her career. In the story, Elizabeth Wilson is a woman who takes care of the Marilyn-like character, Kim Stanley, and clearly has passionate intentions. Elizabeth, in a fight with Kim's ex-husband tells him, "You take care of your little girl, and I'll take care of mine," adding "I'll take good care of her . . . I kind of love her."

Billy Wilder's *Some Like It Hot* is one 1950s U.S. film that seems to have gotten away with a hint of bisexuality. Jack Lemmon and Tony Curtis hide out in drag in an all-female band. A millionaire, played by Joe E. Brown, falls in love with Lemmon's female persona, Daphne. In the meantime, Marilyn Monroe's character has fallen for Tony Curtis' Josephine and kisses "her" on the lips in public. When Brown discovers that Daphne is really Jerry, he responds with a wry smile and says, "Well, nobody's perfect." However, he does not withdraw his marriage proposal.

Two English films, *Room at the Top* (1958) and *Saturday Night and Sunday Morning* (1960), were released in the United States without The Code's seal of approval. They enjoyed successful runs, further weakening the grip of The Code over filmmakers. Both films were denied the seal due to their frank treatment of the subject of sex. *Room at the Top* (1959) received two Oscars and four other Academy Award nominations including Best Picture. During this time, federal and state court decisions struck down censorship laws in New York, Pennsylvania, and the city of Atlanta.

Also in 1960, the largely unknown film director Stanley Kubrick was forced to delete a scene from the film *Spartacus* indicating the bisexuality of the Roman general Crassus. In this scene, Crassus (Laurence Olivier) is being bathed by his young slave Antoninus (Tony Curtis) as the two are discussing how to treat a woman. Crassus attempts to seduce Antoninus by asking whether he prefers *snails* or *oysters*, indicating that for himself, he likes both. Geoffrey Shurlock, the new administrator of The Code, wrote, "The dialogue on this page clearly suggests that Crassus is sexually attracted to women and men. This flavor should be completely removed. Any suggestion that Crassus finds a sexual attraction in Antoninus will have to be avoided." He further wrote, "The subject of sex perversion seems to be touched on in this scene. Specifically note Crassus putting his hand on the boy and his reaction to that gesture." The

film was released without this scene, which was restored only in the 1991 director's cut. Also deleted were battle scenes in which people were dismembered. Americans were not to be reminded that gruesome things happen to people who fight in wars.

By 1961, the only absolute proscription left in The Code was on "sex perversion," which, of course, included homosexuality. Otto Preminger took it upon himself once again to challenge the ban. He announced in September that he would begin shooting a film of Allen Drury's novel *Advise and Consent* and that he would not cut the homosexuality from the story. No one doubted that Preminger would release his film with or without a seal of approval. Therefore, on October 3, 1961, the Motion Picture Association of America (MPAA) announced that it was revising The Code to allow "prudent treatment" of "sexual aberration" on film. The intent was to give the illusion that they were still in control. Preminger's film would not cause further embarrassment by violating The Code. Another film contributing to this decision by the MPAA was *The Children's Hour*. William Wyler's second attempt to film Lillian Hellman's play had again been rejected by the MPAA censors. This time Arthur Krim, the President of United Artists, said that he would go ahead with the film, with or without the MPAA seal of approval.

The MPAA announced that, "In keeping with the culture, the mores and the values of our time, homosexuality and other sexual aberrations may now be treated with care, discretion, and restraint." Effectively, this cast aside the last prohibition against specific topics in film. The Code continued to exist, however, maintaining that homosexuality was a perversion. Films could now use terms such as *pansy, fag, fruit, lezzie,* and so on, but use of the nonpejorative words homosexual or homosexuality were still forbidden. This was explicitly confirmed in an October 1962 clarification of The Code which stated that "sexual aberration" could be suggested but not spelled out. In other words, homosexuality could appear in the film, but could not be explicitly mentioned. Now, by regulation it was truly "the love that dare not speak its name."

What prompted this statement by the MPAA was the British import *Victim* (1961). This was the first commercial film in more than forty years to explicitly call for humane treatment of homosexuals. The film advocated the repeal of the laws against homo-

sexuality that accomplish little more than making it easy for extortionists to ply their trade. When the film was denied the MPAA seal of approval, it took the now familiar route of release without the seal, playing primarily in art houses.

One 1962 film that strongly suggested, but did not spell out same-sex love was Edward Dmytryk's *Walk on the Wild Side*. This sappy love story cast Barbara Stanwyck as Jo Courtney, the evil bisexual madam of a New Orleans house of prostitution known as The Doll's House. It also features Capucine as Halley Gerard, Jo's beautiful young employee and lover, who would rather be with Dove Linkhorn, a man who has hitchhiked all the way from Texas to find her. This film may well have been the first instance of a same sex relationship appearing on screen that was not in the source material. The sexual relationship between Jo and Hallie is found nowhere in Nelson Algren's novel. Rather, it was the invention of screenwriter Edmund North.

Bit by bit, restrictions in The Code were chipped away until it was abandoned entirely in the late 1960s. Gore Vidal's screenplay for *The Best Man* helped this process by successfully retaining the word "homosexual" in 1964. In this film, a married politician is accused of having had sex with one of his army buddies when they were serving together in Alaska. We never learn for certain whether the accusation is valid, but it is certainly treated as something that would destroy a man's career.

From 1961, with the easing of the prohibition on "sex perversion," until the mid-1960s, bisexuality was treated as a dirty secret and nothing more. Bisexuality was never mentioned by name during this period, although it appeared in such films as *Advise and Consent*, *The Best Man*, *Victim*, and *Walk on the Wild Side*. However, in the 1965 English film, *Darling*, bisexuality was not only explicitly introduced, but we were shown a happy, well-adjusted gay character as well. The bisexual character in this film is a virile, young Italian waiter who sleeps with both Julie Christie and a gay photographer played by Roland Curram. This film went on to win three Academy Awards and receive two other Oscar nominations including Best Picture.

In 1966, most Hollywood stars were afraid of homosexual and bisexual roles, as are some today. The United States had many more hang-ups about the subject than did England or especially continen-

tal Europe. Robert Redford had been cast for the role of Wade Lewis, the husband of a popular starlet in the film *Inside Daisy Clover*. In Gavin Lambert's original screenplay, Lewis was a homosexual man who married Daisy Clover for sake of appearance at the request of the studio. Both Redford and director Robert Mulligan began to get nervous about this and requested changes.

Redford said that he asked for Lewis to become a character who sleeps with anything, including women. As time went on, however, people associated with the film became increasingly distressed. By the end of the editing cycle there were almost no references to Lewis' homosexual side at all. As released, the film contains only a telephone conversation in which the secret of his bisexuality is revealed.

The forces of censorship were in retreat, but more battles were looming. In 1967, members of President Johnson's Commission on Obscenity wrote, "The obvious morals to be protected are chastity, modesty, temperance, and self-sacrificing love. The obvious evils to be inhibited are lust, excess, adultery, incest, homosexuality, bestiality, masturbation, and fornication." However, this echo of the Hays policies was a minority opinion. The official findings of the Commission recommended the repeal of all state and local obscenity laws. Unfortunately, Richard Nixon had been inaugurated by the time the report appeared. He condemned the report and prevailed upon the Senate to bury it.

When Jacqueline Susann's best-seller *Valley of the Dolls* was brought to the screen that year, Alex Davion appeared as a bisexual fashion designer named Ted Casablanca. He is called "queer" and "fag" throughout the film. One critic asked, "What kind of pills do you take to sit through a film like this?" As will be demonstrated in later chapters, many more negative portrayals of bisexuals were to come.

INDEPENDENT FILMMAKERS
CHALLENGE THE CODE

Though few mainstream directors in Hollywood had the courage to directly challenge The Code's restrictions on the portrayal of homosexuality in film, a number of independent and underground filmmakers pushed the limits wherever possible. The first gay

underground film to have a major impact on the public was Kenneth Anger's *Fireworks*, made in 1947. The narrative of this film consists of a simple fantasy sequence. A young man goes out cruising, picks up a sailor, and later gets beaten up by a group of sailors. The first sailor returns and masturbates over him and the men wind up in bed together.

According to Richard Dyer's book, *Now You See It*, Anger's films were strongly influenced by the pagan belief and ritual system called Magick, espoused by Aleister Crowley. Sexuality is stressed in Magick as one form of access to the spirits. The further from the "norm," the more powerful the spiritual force will be. Crowley, himself, was described as "ambisexual" or open to all sexual objects and practices, by Rictor Norton in *A History of Homoerotica*.

Fireworks made a successful European debut at the Festival du Film Maudit, in Biarritz in 1949. There the film attracted the attention and admiration of the festival's organizer, Jean Cocteau, a French writer and director of gay underground films. Cocteau managed to persuade Anger to come to France to work with him in 1950. The film's most significant contribution to challenging The Code, however, came in 1957 when exhibitor Raymond Rohauer was fined $250 and sentenced to three year's probation for showing *Fireworks*. Two years later, the case went to the California Supreme Court, where the conviction was overturned because "homosexuality is older than Sodom and Gomorrah" and is therefore a legitimate film topic if properly handled. This ruling shook the very foundations of The Code and made subsequent challenges by Preminger and other Hollywood directors much more likely to succeed.

Anger again pushed the limits in 1963 with what was to become his best known gay film, *Scorpio Rising*. This film was a complex mixture of images in thirteen discrete sequences. It contained scenes of bikers, S/M, Nazis, popular bisexual actors, Jesus, drugs, Dracula, and more. The following year, screenings were subject to police raids in Los Angeles, New York, and San Francisco. In the latter two towns, it was confiscated along with *Un Chant D'Amour*, by Jean Genet, also a disciple of Cocteau.

Jack Smith was another underground gay filmmaker whose screenings were raided in New York. His *Flaming Creatures* premiered in April of 1963. This film pushed the limits of androgyny,

with copious use of transvestism, bisexuality, pre-op transsexuals (transsexuals who have not yet been surgically altered), and even a hermaphrodite. It was difficult for audiences to sort out exactly who was what–which, of course, made the authorities very uncomfortable. Less than a year later, two detectives showed up for a screening at the New Bowery Theater in New York and impounded the film, the projector, and even the screen. They also arrested the cinema's programmer (Jonas Mekas), the projectionist (Ken Jacobs), and the ticket taker (Florence Karpf). Mekas and Jacobs were sentenced to sixty days in the New York City workhouse.

The sentences were later suspended, but the conviction was never overturned, as the New York Supreme Court refused to hear the case. In the meantime, arrests and confiscations were made in Michigan, New Mexico, Indiana, and Texas. A special viewing was arranged for members of the Senate Judiciary Committee and the press by Senator Strom Thurmond. His aim was to demonstrate the type of filth Americans would be watching were the Supreme Court's newest nominee, Abe Fortas confirmed. After the viewing, *Newsweek* quoted one anonymous senator as saying, "The movie was so sick, I couldn't even get aroused."

Other directors from the gay underground, such as James Broughton and Gregory Markopoulos, were actively pushing the limits during this period, as well. But the one independent filmmaker who probably had the most profound effect in making gay characters (and sex in general) more acceptable in films was Andy Warhol. Warhol's influence was great, not so much because of his daring or innovation, but because his popularity led thousands of people who would not otherwise have seen movies with gay, lesbian, and bisexual characters to view his films.

One of Andy Warhol's greatest contributions to breaking down The Code was in turning the "obscene" into the mundane. In his film *Blow Job* (1963), we spend the entire film watching the face of a man who is on the receiving end of oral sex. What starts out as an exciting or titillating scene, ends up nearly as boring as watching the Empire State Building for hours on end. Audiences knew that there was a real hustler earning his pay just below the screen image, they knew that this was something simply not allowed under The Code, and they came in droves to see it.

The same may be said for *Taylor Mead's Ass* (1965). The film spends just over an hour focusing on–you guessed it–the buttocks of the sleeping Warhol star, Taylor Mead. Any titillation engendered by the viewing of a famous person's naked ass on the screen soon lapses, as one begins to think of it almost in terms of a backdrop. Instead, the viewer's attention becomes focused on minute things that *do* happen; the sleeper breathing, the night deepening, the changes in the texture of the film. Just as Lenny Bruce convinced us that any dirty word will become meaningless if repeated often enough, so too did Warhol demonstrate that any erotic scene, when viewed long enough, becomes prosaic. The taboo against nudity on film had first been broken in much the same way. A lengthy 1957 court case had determined that there was nothing erotic about the nudity in the particularly dull *Garden of Eden.*

Even today, long after the end of The Code, Hollywood is loathe to portray bisexual, lesbian, and gay characters in a positive light, as people who might be leading happy, productive lives. A sexual act between two people of the same sex can still garner films a stricter rating than a comparable scene with two of the opposite sex. The first film to receive the NC17 rating in the United States was *Henry and June* (1990), which included scenes between two bisexual women. This film was no more explicit than any number of hetero-sexual films that have received only R ratings.

Chapter 4

Lost in the Translation

The original is unfaithful to the translation.

— Jorge Louis Borges

"SANITIZING" BISEXUAL CHARACTERS

Over the past eighty years, Hollywood's influence on filmmakers in all parts of the globe has been enormous. Hollywood has produced tens of thousands of films over that period. At one time, the United States made more movies than all other countries in the world combined. Where does Hollywood get its ideas for all these projects? Not surprisingly, very few of the good stories are original. Instead they come from novels, plays, biographies, legends, sequels, and remakes.

Several of these stories have lost their bisexual characters in translation from source material to the screen. In many cases, this has changed the entire premise of the plot. In other instances, it has drastically altered the relationship between characters or changed the motivation for key incidents in the story. This has occurred for a variety of reasons, mainly homophobia, biphobia, sexism, general censorship, and the industry's primary concern—money. Despite the elimination of the Motion Picture Production Code, the pattern continues today.

Censorship tends to suppress sex in general and homosexuality in particular. Homophobia is most usually defined as the fear of, and prejudice against, those who are attracted to people of their own sex. Often, however, it is actually a fear of *having* same-sex attractions

or of *becoming* homosexual. Not surprisingly, homophobia is usually exhibited by heterosexuals who have little meaningful contact with homosexual or bisexual people. Like other forms of bigotry, it is an irrational fear of anyone who is different in any way. And like racism, sexism, classism, and ethnic hatred, it becomes a tool for keeping a certain group of people in power at the expense of others. In addition, the prejudice against gay men "who act like women" and lesbians "who don't know their place" are both reflections of this society's endemic discrimination against women. The homophobe generally lumps bisexuals in with "the rest of the queers."

The homophobic attitudes of those who wrote and enforced The Code contributed to two generations of bisexual, lesbian, and gay people growing up with the impression that they were alone in the world. There were no positive images of people like themselves to be found anywhere on the screen. Homophobia forced lesbian, bisexual, and gay actors and directors into hiding for fear of losing their careers. Many who did not stay in the closet suffered that fate, including director James Whale (*Frankenstein, Bride of Frankenstein,* and *The Invisible Man*) and actor William Haines (*West Point* and *Slide, Kelly, Slide*). George Cukor is believed to have been removed as director of *Gone With the Wind* because of his homosexuality.

Bisexuals are also victims of homophobia. They are queer-bashed, denied employment and housing, and lose the right to raise their own children just as gays and lesbians. Bigots who hate people for loving members of their own sex do not much care whether those people are also attracted to the opposite sex. Bisexuals, however, also suffer the effects of another form of prejudice, called biphobia. Biphobia comes from both heterosexuals and homosexuals, but often for different reasons. While some members of both groups tend to distrust bisexual people for not choosing their particular end of the sexual orientation scale, gays and lesbians sometimes feel that bisexuals are not reliable political partners because of their relationships with the opposite sex.

Biphobia among heterosexual people, in recent years, has been an AIDS-related sickness. Articles in *Newsweek, Cosmopolitan,* and various tabloids have stirred up hysteria against bisexuals by claiming that bisexual men spread AIDS to the heterosexual community.

In their fervor to fix the blame on bisexuals, these articles completely ignore the main paths of HIV transmission to and among heterosexuals. More dangerously, they promote the myth that as long as straight people have sex with other heterosexuals, there is no need to practice safer sex. Some lesbians also express the fear that bisexual women will be a vector for the transmission of AIDS into their community. Again, statistics show that IV drug use and unsafe sex practices are the overwhelming factors. More in-depth discussions on homophobia, biphobia, and other prejudices relating to bisexuality can be found in the books *Bi Any Other Name*, *Bisexual Politics*, and *Closer To Home*.

Just as the victims of totalitarian oppression who, for reasons of self-preservation or self-hatred, have aided in the genocide of their own people, the oppression of gay, bisexual, and lesbian people by their own kind has taken its toll on the community. This internalized homophobia is a form of self-loathing in people who have been raised by a prejudiced society to take on the attitudes of their oppressors. People with this form of self-hatred feel immense guilt over the way they are. They would tend to avoid a film project that positively portrays gay, bisexual, or lesbian people because it simply adds to their own list of "sins."

The extreme of this type of behavior is exhibited by those who persecute people like themselves in order to direct attention elsewhere. Avoidance of this sort can be seen among some closeted film directors who produce gratuitously negative portrayals of gay characters. It is also found among closeted right-wing government officials who persecute other gay people (especially those in the arts) in order to put themselves above suspicion.

One example of just that kind of hypocrite was Roy Cohn, Joseph McCarthy's right-hand man during the Red Scare of the 1950s. It is reported that for one speaking engagement before a "pro-family" group, Cohn pulled up in front of the banquet hall, left his male lover in the limousine, and went inside to give a speech about the sickness and perversion of homosexuality. J. Edgar Hoover was another perpetrator. On Hoover's orders, the Federal Bureau of Investigation summarily fired anyone suspected of homosexual activity. From the beginning of the Red Scare until the end of the Vietnam War, the FBI collected information on 25 million American

citizens and 13,500 progressive organizations, many of these because of "alternative" sexual orientations. Hoover often used the threat of exposure to coerce secretly gay, lesbian, and bisexual individuals to into supporting various right-wing causes.

Right-wing politicians seized upon the Red Scare as an opportunity to harass gays as well. Senator Kenneth Wherry, the Republican floor leader, told the *New York Post*, "You can hardly separate homosexuals from subversives." Hollywood right-wingers made movies portraying Communist Party members as sinister figures intent on destroying the United States of America and anyone who got in their way. One such film was *Big Jim McLain* (1952) starring John Wayne, whose character spouts pseudo-Freudian pop-psychology in an effort to conflate communism with homosexuality—"This one's a Commie because mamma wouldn't tuck him in at night. That one because women wouldn't welcome him with open arms."

Among those purged as a result of the McCarthy/Cohn/Nixon witch-hunt were hundreds of bisexual, gay, and lesbian government employees whose careers and lives were ruined. The result was the same in the film industry, where such men as Ronald Reagan and Walt Disney informed against their co-workers for the FBI. Griffin Fariello, author of *Red Scare*, describes Reagan as "the only President of the United States to have had a former career as a police stooge." Many talented people in Hollywood lost careers due to their political affiliations or their sexuality. One director chased out of Hollywood was Joseph Losey, who later directed *The Servant* and *The Trout* from Europe. Both films had implicitly or explicitly bisexual characters.

Dalton Trumbo, a screen writer and novelist whose screenplay for *Spartacus* contains a bisexual character, was one of the best-known names on McCarthy's list of enemies. Trumbo's most famous novel was *Johnny Got His Gun*, a powerful antiwar story written on the eve of World War II. McCarthy and his cronies reasoned that any American opposed to war must be a Commie. Trumbo was hauled before the House Un-American Activities Committee (HUAC) in the fall of 1947. There he became one of a handful of Hollywood figures who refused to implicate others in the film industry. The Hollywood Ten, as this group came to be known, were fined and imprisoned the following year.

For more than a decade, Trumbo was unable to sell his own work in Hollywood due to his denunciation by the Committee. He kept writing, however, and managed to use a number of "front men" to market his screenplays. Two of these stories won Academy Awards under other names. One was *The Brave One* (1956), for which credit was given to the fictional name, Robert Rich. Trumbo received his award nineteen years later, just before his death. The second was *Roman Holiday*, released in 1953 and credited to a friend named Ian McLellan Hunter. A few months later, Hunter was banned himself and was unable to work in Hollywood for sixteen years. Trumbo was posthumously awarded the Oscar for *Roman Holiday* nearly forty years after its release. In 1960, Universal agonized over whether to put Trumbo's name on the film credits for *Spartacus*, fearing boycotts or worse, but eventually sanity prevailed. This struggle was most ironic considering the film's subject–a man's fight for freedom.

One additional factor working against the representation of bisexual characters in film is the continued belief in some quarters that bisexuals don't really exist. This stereotype is given voice in *The Detective* (1968) as the psychiatrist tells a client that there is no such thing as a bisexual, "only a homosexual without conviction." Various gay films, such as *Torch Song Trilogy* (1988) have repeated the charge.

REWRITING BIOGRAPHIES

How does all this fear and self-loathing affect what bisexual characters we see on the screen? It usually means that bisexual characters are eliminated or turned into heterosexual characters. This sort of transformation occurs, not only with fictional characters, but with historical figures as well. In some cases, the subject was alive at the time the film was made and consented to being portrayed as straight. One celebrity who willingly had his screen persona "straightened out" was Cole Porter, played by Cary Grant in a pseudo-biographical film called *Night and Day* (1946). Porter's wife, Linda, was played by Alexis Smith, but none of his male lovers put in an appearance. Gay friend Monty Wooley not only shows up in the film, but plays a heterosexual version of himself.

Rudolph Valentino has been "straightened out" in two separate film biographies. The first was made in 1951 by Lewis Allen, with Anthony Dexter in the title role. *Punch* magazine film critic Richard Mallett described the story as "entirely imaginary." Ken Russell directed a reasonably accurate second attempt in 1977. This version starred Rudolf Nureyev as the famous celluloid lover and Michelle Phillips as Natasha Rambova, his bisexual wife. Her female lover, Alla Nazimova, is played by Leslie Caron. During the Reagan years, Valentino once again "became" straight in *The Legend of Valentino* (1983). This time Rudolph's attraction for men is passed off as a false accusation by an actress attempting to entrap him into marriage. However, Natasha was portrayed as a lesbian who divorced him because he insisted on having sex against her will on their wedding night.

Midnight Express, the screen version of Billy Hayes' autobiographical novel about his Turkish prison experiences, eliminated the homosexual scenes present in the novel. Director Alan Parker instead had Hayes (Brad Davis) gently turn down the advances of another male prisoner. Parker later described himself in an interview as "a boring heterosexual director." Who are we to disagree?

In the 1985 film, *The Secret Life of Sergei Eisenstein*, certain of his well-known "secrets" are only hinted at, or denied outright. For instance, when the Eisenstein character talks about his visit to Berlin he recalls it as a "frightening spectacle of refined perversion and every kind of sexual deviation." He mentions that he "explored this underworld of sexuality" and was "fascinated by the Bohemian facade," but he does not talk about what it was that turned him on. All he says is that, "Berlin forced me to reconsider my inhibitions toward women . . . and my supposed latent homosexuality. I've never felt that impulse, although I could not deny a somewhat latent abnormal sexuality, at least at the mental level."

Other bisexual historical figures whose film biographies neglect to mention their same-sex relationships include: *Marie Antoinette* (1938) and her lover Court Fersen; composer Stephen Foster in *Swanee River* (1941); George Sand, the bisexual female writer, who was played simply as a transvestite in *A Song to Remember* (1945), *Song Without End* (1960), and *Impromptu* (1991); Paul Bowles, whose relationships with men were glossed over in *Paul Bowles in*

Morocco (1970); Alexander the Great, whose life was committed to film in 1956; *Hans Christian Andersen* (1952), played as heterosexual by Danny Kaye, who was decidedly not; Julius Caesar in *Cleopatra* (1963); Michelangelo in *The Agony and the Ecstasy* (1965), starring right-winger Charlton Heston; Janis Joplin in *Janis* (1974); the legendary lover, *Casanova* (1976); Lord Byron in *The Bad Lord Byron* (1948); and explorer and writer Sir Richard Burton in *Mountains of the Moon* (1990).

Another historical figure whose bisexuality was retired to the movieland closet was Pu Yi, the main character of the film *The Last Emperor* (1987). What is curious about this film is that it does have another bisexual character, Pu Yi's traitorous cousin, Eastern Jewel.

After taking her first female lover in 1923, artist Dora Carrington wrote to a friend, "I feel now regrets at being such a blasted fool in the past, to stifle so many lusts I had in my youth, for various females." Nevertheless, the movie *Carrington* (1995) fails to note Carrington's bisexuality, while making no secret of her husband's.

James Dean is a legend whose film career lasted only sixteen months. During that time he starred in three feature films, only the first of which was released by the time of his death in 1955. No actor since Rudolph Valentino had generated so much sexual charisma in such a short time. Therefore, it should be no surprise that so many movies and documentaries have been made about his life. What is disappointing is that most simply ignore Dean's attraction to men, although the young star did little to keep this aspect of his life a secret.

None of the film biographies available directly address Dean's bisexuality. They talk about his girlfriends and interview his "roommates" and "close friends," but no mention is made of James Dean's male lovers. The first such biography was Robert Altman's first film. *The James Dean Story* was made in 1957, only two years after his death. It relies heavily on film clips and now-familiar photographs, but does not delve very deeply into his personal life beyond the age of sixteen.

The year 1976 was a big one for Dean fans, with two new films: *James Dean: A Legend in His Own Time* and *James Dean: The First American Teenager*. The first of these is a docudrama made for television. It is an account of Dean's life through the eyes of his

roommate, William Bast, whose girlfriend Dean wooed and then lost. In one scene, Dean tells Bast that he (Dean) owes it to his art to experience everything, including sex with men. However, it never says that Dean actually followed through. Instead, he sends Bast out to a gay bar to pick up a man for himself. In the latter film, the issue of bisexuality is raised, but not resolved. One Dean acquaintance says, "I don't know if he was bisexual." A second, and relatively enlightened voice later adds, "He was normal, which may mean bisexual . . . may not."

The most recent of the Dean films, as of this writing, is *Forever James Dean* (1988). In this one, the narrator explains that many war veterans in Indiana were upset that Dean had avoided the draft by filing as a homosexual. One veteran from Dean's hometown, however, said that Dean could not have been homosexual and he knew that for a fact, although he refused to elaborate. This is the old either/or myth again: if Dean was with a woman, he could have no possible interest in men.

A celebrated bisexual artist who has been the subject of multiple films is Mexican artist Frida Kahlo. Previously overshadowed by the fame of her husband, muralist Diego Rivera, she has been recognized in the last two decades as a major talent. The first of these films was *Frida*, directed by Paul Leduc in 1984. While not a documentary in the narrative sense, it does depict many of the significant events in her life, including relationships with unnamed women. The more recent *A Ribbon Around a Bomb* (1991), however, has no explicit references to female lovers. The film shows her attracted to an imaginary female friend and says she had affairs with other men besides Diego.

In a third film, Kahlo appears as a character in Canadian director John Greyson's peculiar fictional film, *Urinal* (1988). This nominally gay film is populated with a host of bisexual historical figures, including Frida Kahlo, Sergei Eisenstein, Langston Hughes, and Yukio Mishima, but no mention is made of any relationships between any of these people and the opposite sex.

Jean-Michel Basquiat is another artist whose bisexuality was suppressed on screen. The film *Basquiat* (1966) portrays him as both attractive and attracted to women, but completely neglects the sexual side of his relationships with men.

THE CASE OF NO SEXUALITY

What else could you possibly do to a bisexual identity besides turn it heterosexual or homosexual? In the case of T. E. Lawrence, *Lawrence of Arabia* managed to make him neurotic and utterly asexual. He does appear somewhat epicene at times and there are tender scenes with young Bedouin boys, but nothing explicit. There are virtually no women in the film, so there is also little opportunity to explore that aspect of his sexuality.

The bisexuality of one more historical figure was excised in 1993 in order to make the tale more dramatic. David Cronenberg's *M. Butterfly* is the story of a heterosexual man named Rene Gallimard who allegedly did not know that the female spy with whom he had been lovers for many years was actually a man. The story is based on the life of French diplomatic attaché Bernard Boursicot, described by biographers as bisexual.

Besides eliminating a number of bisexual, gay, and lesbian characters from films over the years, The Hays Office's decidedly restrictive language intimidated writers and directors from submitting bisexual characters for review in the first place. Lillian Hellman's play *The Children's Hour* had a long history of trouble with the censors because of its lesbian theme. Opening night on Broadway in 1934 brought threats of an injunction and trouble with the New York City police. In 1936, Samuel Goldwyn decided it would make a good movie. The Hays Office thought otherwise. They objected to the love triangle that featured a female school teacher and a male doctor who are both in love with another female teacher. By the time Joe Breen and his band of censors were done snipping, the two women, rather than lovers, were rivals for the same man. The script was so altered that Goldwyn changed the title to *These Three*, and director William Wyler said, "Miss Hellman's play has not yet been filmed."

Attacks on the bisexual Hellman's freedom of expression continued as the play was revived in 1952 while she was being harassed by the McCarthy committee. Her lover, writer Dashiell Hammett, had already been sent to prison for refusing to cooperate with Joe McCarthy's communist witch-hunt. When United Artists gave director Wyler another shot at making *The Children's Hour* in 1961,

The Code reared its ugly head once again. This time the studio would not back down, and threatened to release the film without the MPAA seal of approval.

Hammett had his turn to lose a gay character to the censors in 1941 with *The Maltese Falcon*. Peter Lorre's character was originally written as homosexual. The Code's Joe Breen wrote, "We cannot approve the characterization of Cairo as a pansy. . . ."

Daphne du Maurier's novel *Rebecca* was a best-seller in 1938. The following year, producer David O. Selznick took out an option on the screen rights. He hired Robert Sherwood to write a script and Alfred Hitchcock to direct this thriller about a woman who believes that her husband has murdered his first wife. The script was then sent to Joe Breen at the Hays office, who demanded a number of fundamental changes in the story. Hitchcock would not be allowed to film until he eliminated scenes in which there is "quite definite suggestion that the first Mrs. de Winter [Rebecca] was a sex pervert." References to Rebecca such as, "You'd have been more frightened if you had known the whole truth," "She was incapable of love," "She wasn't even normal," and "She told me things I could never repeat to a living soul," were eliminated from the script at the behest of the censors.

Another film character "straightened out" by the Hays Office appeared in Howard Hughes' sexually exploitive movie *The French Line*. This film and his previous effort, *The Outlaw*, were mainly designed to exploit the body of Hughes' young star, Jane Russell. Hughes did whatever he could to provoke the censors and thereby reap publicity for his films from a sex-hungry public. The files on these two films are among the largest in the history of the Hays Office. In March of 1953, Joe Breen wrote to Hughes, "The utmost care will be required regarding the characterization of Farrell Firelle in order to avoid any indication that he is a pansy." The character was completely straight by the time the film reached the screen. Breen also pointed out to Hughes that, "We cannot approve gags based on the Kinsey Report."

In 1956, Robert Anderson adapted his own play for the screen. *Tea and Sympathy* is the story of a young student whose classmates accuse him of being homosexual. He begins to fear that perhaps they are right, so he goes to his housemaster's wife for help. She

sleeps with him and "proves" to him that he is straight. Most of the accusatory comments of his classmates were toned down for the film at the request of the Johnston Office (enforcers of The Code at that time). In addition, the suspected homosexuality of one of the teachers and the bisexuality of the housemaster were dropped from the film version.

The works of Tennessee Williams were a favorite target of censors, as script writers well knew. When *A Streetcar Named Desire* was brought to the screen in 1951, Allan, Blanche DuBois' bisexual ex-husband, became completely heterosexual. Seven years later, in the film version of *Cat on a Hot Tin Roof*, Paul Newman's character was not interested in men after all. All implications of a relationship between Brick and the deceased Skipper had been eliminated. Later, as The Code was relaxed, Williams had more success getting his characters properly translated from the stage to the screen. Bisexual, lesbian, and gay characters from *Suddenly Last Summer* (1959), *The Night of the Iguana* (1964), and *Reflections in a Golden Eye* (1967) all survived to some extent.

Much of the motivation for murder was lost when *Les Diaboliques* (1955) excised the relationship between the headmaster's wife and mistress. In the film version, the headmaster's murder is justified as revenge for his sadistic treatment of the two women. Adapted from *La Femme qui Etait*, a novel by Pierre Boileau and Thomas Narcejac, the film is nonetheless one of the all-time classic suspense films.

"Call me Ishmael," is one of the best-known opening lines in American literature. But don't call him Queequeg's wife in the 1956 movie classic, *Moby Dick*. Passages from Melville's novel, such as, "I found Queequeg's arm thrown over me in the most loving and affectionate manner Thus, in our heart's honeymoon, lay I and Queequeg a cozy, loving pair He pressed his forehead against mine, clasped me around the waist and said that henceforth we were married" are nowhere to be found in the movie. Director John Huston and script writer Ray Bradbury were no match for the power of The Code.

When John Lee Mahin adapted William March's novel *The Bad Seed* for film in 1956, he quickly changed the character Emory Breedlove from bisexual to heterosexual. Worse was done to Clyde Barrow in the film *Bonnie and Clyde* (1967). The real-life bisexual,

who enjoyed threesomes with Bonnie and other men, became sexually impotent on film when played by Warren Beatty. Warren later reassured concerned fans in *Shampoo* (1975) by having sex with virtually every woman in the film.

Ugo Pirro's novel *Five Branded Women* tells the story of five Yugoslav women who slept with Nazi occupation soldiers and were subsequently driven out of town. In the book, two of the women were also lovers with each other, but this relationship is missing in Martin Ritt's 1960 film version.

As mentioned in the previous chapter, *Spartacus* was one of the last films to lose a bisexual character due to The Code. Dalton Trumbo's screenplay had Crassus attempting to seduce his slave, Antoninus. In the original script, this is the incident that caused the young slave to run away and join the rebel army. When the dialogue was cut before the film's release, the whole motivation for Antoninus' escape was lost.

The demise of The Code did not stop the disappearances of bisexual characters. When Jean Genet's play, *Deathwatch*, was translated to the screen in 1967, all the characters became either gay or straight. This film was probably most notable for having an actor (Vic Morrow) as director, a director (Paul Mazursky) playing a gay convict, and a Vulcan (Leonard Nimoy) as star and co-producer.

John Schlessinger, who made cinematic history in 1971 by putting a well-adjusted bisexual character in *Sunday, Bloody Sunday*, very nearly filmed a bisexual character two years earlier in *Midnight Cowboy*. Although it can be argued that Joe Buck (Jon Voight) was bisexual because he hustled both men and women, we are definitely left with the impression that he only enjoyed sleeping with the opposite sex. However, serious discussions were held before and during the filming of this movie over whether to show an actual sexual encounter between Buck and Dustin Hoffman's character, Ratso Rizzo. In the end, determining the true nature of the relationship was left as an exercise for the viewer.

Albert Innaurato's play, *Gemini*, contains a subplot about a son whose main interest is men, but who also has a girlfriend. When the play was adapted for the screen in *Happy Birthday, Gemini* (1980), the son became gay and the girlfriend is strictly a friend. That year, the original screenplay for *Victor/Victoria* was rewritten to eliminate

the bisexuality of the baron (who was turned into a gangster) and his wife, although the gay bodyguard was retained.

Richard Pryor's character in *Some Kind of Hero* (1982) does not become involved with another POW as he did in James Kirkwood's novel. Apparently, Americans were not ready to confer hero status on a soldier who slept with other men.

The Color Purple (1985) was Steven Spielberg's first serious run at an Oscar. Excellent performances by Whoopi Goldberg, Danny Glover, Margaret Avery, and Oprah Winfrey as well as a fine score by Quincy Jones could not overcome some rather conservative decisions about the script. In Alice Walker's Pulitzer Prize-winning novel, Celie's husband finally attains some degree of enlightenment, her sister displays a great deal of insight into the political situation in Africa, and Celie and Shug Avery are lovers. Vestiges of these plot elements remain, but the viewer would never notice without having read the book.

One of the most curious cases of a bisexual character being lost and then found was in Bram Stoker's book *Dracula*. Stoker's original handwritten notes for the book are available at the Philadelphia Library. In the book, there is a scene where Dracula drives his female companions away from Jonathan Harker, angrily saying, "This man belongs to me!" In Stoker's outline, the Count adds, "I want him." It is significant that this is the only actual piece of dialogue written in the notes, and it is repeated several times. Stoker must have realized that this would get him into trouble in Victorian England, so he toned it down to the more ambiguous statement in the novel. However, a number of films derived from this and other vampire novels have reintroduced the vampire's attraction for both males and females.

Despite its gay producer, *Interview with the Vampire* (1994) is one film that stubbornly resists this trend. Anne Rice's novel contains copious explicit sex between the vampires Lestat and Louis, but in the film they never even kiss. The homoerotic tension exists between them and between Louis and Armand in the movie, but there is no actual sex or intimacy. Further, the fact that Louis and the interviewer meet while cruising each other in San Francisco is completely desexualized.

Recently, a film about a character who *is* both male and female seems nonetheless to have lost the character's bisexuality in adapting the story for the screen. The film *Orlando* (1993), based on Virginia Woolf's novel, depicts the title character as always heterosexual, both in his early years as a man and her later years as a woman. The book, however, states that as a woman Orlando, "enjoyed the love of both sexes equally." Pictures of Orlando in the book were photographs of the bisexual Woolf's lover, Vita Sackville-West, also bisexual. Vita's son described the book as "the longest and most charming love letter in literature."

Chapter 5

Killers and Psychos and Queers!
Oh My!

Each man kills the thing he loves.

— Oscar Wilde

LUNATIC KILLERS
AND THE MENTALLY ILL

The real world of bisexuality, not surprisingly, has far fewer psychopathic killers per capita than its corresponding celluloid community. The fact that Hollywood in particular and other film producers in general are so willing to represent bisexuals as emotionally sick individuals is an indication of the depth of the prejudice against bisexuality (and homosexuality) among those people who control the money in film circles. While it is virtually impossible to find the resources to make a film of stories like James Kirkwood's *Good Times/Bad Times* or Laura Hobson's *Consenting Adult*, movies such as *Cruising* (1980), *Blue Velvet* (1986), and *Last Exit to Brooklyn* (1990) have relatively little trouble attracting multimillion dollar budgets. Joe Eszterhas sold the screenplay for *Basic Instinct*, a story about bisexual murderers, for $3 million. Meanwhile Paul Newman, an established actor and director, was unable to find backing for a film portraying a love story about a male runner and his coach. Faye Dunaway's proposed biographical film of Victoria Woodhull fell through, in part, because the first female presidential candidate was bisexual.

Examples of bisexual psychos, murderers, and misfits abound in film. In many countries, government or film industry policy dictates that bisexual characters may not be represented in a positive light. Under The Motion Picture Production Code, openly bisexual characters were not allowed for nearly three decades. Then, when screen bisexuality was finally permitted under The Code, it was with the caveat that the portrayal be negative in order to discourage "sex perversion" among viewers. Similar restrictions have existed in other countries in the past and continue in some even now. In the United States today, right wing politicians try to prohibit government funding to artistic projects which "promote homosexuality." Railing against the "filth" in Hollywood pictures is a standard fund-raising technique when pandering to religious ideologues.

Other films have been made which cash in on the existing prejudices of the film audience. The fact that they reinforce hatred against homosexuals and bisexuals seems to be of no more concern to the producers of these films than promotion of racism and racial violence was to D. W. Griffith when he produced *Birth of a Nation* (1915).

Throughout his career, director Alfred Hitchcock delighted in using "deviant sexuality" to heighten dramatic tension. Film critic Raymond Durgnat suspected that Hitchcock's transvestite trapeze artist in *Murder* (1930) was bisexual or homosexual, although nothing was overtly indicated. While never explicit, the gay and bisexual overtones among the murderers in other Hitchcock films are quite noticeable. In *Rope* (1948), John Dall and Farley Granger play two young men who murder a former classmate just to prove they can get away with it. The story is loosely based on the 1924 murder of a Chicago student by Nathan Leopold and Richard Loeb, who confessed during the trial to being lovers. Arthur Laurents, who wrote the screenplay for *Rope*, said that although he never discussed with Hitchcock whether or not the two characters were homosexuals, "It was apparent." Granger appears again in *Strangers on a Train* (1951), as a married man, obviously (but not explicitly) attracted to an apparently gay stranger who suggests he would be willing to kill Granger's wife. The twist, however, is that Granger wants to marry his mistress, not get involved with the stranger. A covert attraction occurs between Martin Landau and James Mason in *North by Northwest*

(1959), which features repressed sexuality throughout. Landau and Mason are conspiring to kill advertising executive Cary Grant.

The story from *Rope* was reworked and released again in 1959 as *Compulsion*. This version takes fewer liberties with the actual events in the case. An even more realistic film was made by Tom Kalin in 1992. *Swoon* tells the real story of Nathan Leopold and Richard Loeb, their love for each other, Loeb's interest in women, and the murder they committed. It also deals with their time in prison and the prejudice they faced because of their homosexual relationship and their Jewish ancestry.

Mental instability is just one of the many traits endemic to bisexuals in film. Lilith is a schizophrenic bisexual character in a 1964 movie by the same name. She has been in a private mental institution since age eighteen. In Ingmar Bergman's *Persona*, a nurse who is engaged to be married, loses her mind and her identity as she begins to fall in love with the actress who is her patient. Bisexuality and the loss of his male lover are indicated as the main causes of the great dancer's insanity in *Nijinsky* (1980). Both father and son lose their grip on reality after having sex with a male angel in Pasolini's *Teorema* (1986). In *Anita: Dances of Vice* (1987), a crazy old woman believes that she is a famous bisexual exotic dancer from a bygone era.

Abuse of women by bisexual men is a common theme for many filmmakers. The implication is that such men are gay, but are unable to handle it, so they marry to avoid suspicion and then take out their frustrations on their wives. In some cases this is probably realistic. However, to imply that all married men who enjoy sex with other men must hate their wives simply perpetuates a biphobic stereotype and misogyny.

Married bisexual men are portrayed as wife beaters in *The Leather Boys* (1964), *Petulia* (1968), *American Gigolo* (1980), *Blue Velvet* (1986), and *Total Eclipse* (1995). Michael Caine kills his wife in *Deathtrap* (1982), as does Peter Weller in *Naked Lunch* (1992). The bisexual husband in *Michael's Death* (1984) bites his wife's genitals so hard that she must be hospitalized. In the Italian film *Investigation of a Citizen Above Suspicion* (1970), a bisexual police homicide inspector goes so far as to murder his mistress so that he will be a hero for "solving" the case.

Male lovers of bisexual men in film fare nearly as badly. Marlon Brando's Major Penderton in *Reflections in a Golden Eye* (1967), kills the young private who is the object of his affections when he discovers that the boy is only interested in the major's wife, Elizabeth Taylor. In *Last Exit to Brooklyn* (1989), it is difficult to tell whether union men Harry and Vinnie, both bisexual, get more pleasure out of having sex with or beating their transvestite lovers. Bi psychopath Tim strangles his lover in *Hot Child in the City* (1987). Poets and lovers Paul Verlaine and Arthur Rimbaud spend most of their screen time together beating, stabbing, and shooting each other in *Total Eclipse.*

Films by gay directors are not immune to this sort of stereotyping. Pablo's bisexual boyfriend murders Pablo's gay boyfriend in Pedro Almodóvar's *Law of Desire* (1987). In Constantine Giannaris' 1991 film *North of Vortex,* the bisexual sailor beats up his lover, the poet, as they travel across the country.

The bisexual vampire, nearly always female, is another common character in films. One would imagine from the number of these films that the bisexual community must be a particularly bloodthirsty one. One of the first such films was Roger Vadim's *Blood and Roses* (1960), in which a once-dead female vampire has no qualms about seducing another woman to be with the man she loves. Two similar movies were *The Vampire Lovers* and its sequel, *Lust for a Vampire.* Both were produced in England in 1970 and feature female vampires with an insatiable appetite for women and the occasional man. Each draws its inspiration from Sheridan Le Fanu's classic book *Carmilla,* one of the main sources of the female vampire tradition.

Daughters of Darkness was filmed the following year in various European locations. It is derived from the female vampire's other traditional source, the legend of Elisabeth Bathory, who claimed that her beauty secret was to bathe in the blood of 800 virgins. Elisabeth, in this film, liked to keep her young female lovers alive, while leaving the male ones feeling rather drained. Also in 1971, an American film called *The Velvet Vampire* featured a vampire who invites a young couple to stay at her ranch in the desert. She then seduces both, killing the husband and chasing the wife all the way back to Los Angeles, where she is cornered by a crowd of cross-wielding religious fanatics.

Another English film, *Vampyres, Daughters of Dracula* (1975), is about two female vampires who are lovers, but also enjoy bringing

men home for a bite after sex. *Mary, Mary, Bloody Mary* (1976) is a Mexican film about a bisexual female vampire who gets competition from dear old dad (John Carradine). After a number of deadly sexual encounters, she winds up drinking the old man dry, too.

The Hunger (1983) features two big name bisexual vampires. These are Catherine Deneuve, the original vampire, and her younger initiate, Susan Sarandon. Ken Russell's *Lair of the White Worm* (1988) is another well-filmed horror flick. This one features Amanda Donohoe as a snakewoman vampire who sexually toys with virgins of either sex before putting the bite on them and sacrificing them to the snake god. In *Def by Temptation* (1990) an otherwise gay man, played by Michael Rivera, has his last sexual encounter with a female vampire.

The vampire imagery is quite strong in the 1989 Hungarian film, *Mielött Befejezi Röptet a Denever (Before the Flight of the Bat is at an End)*. The secret police agent who victimizes a boy and his mother is represented as a vampire in the land where the tradition got its start. He is certainly the most terrifying vampire character to appear without the aid of special effects or costuming.

Perhaps the best-known creature of the night, Dr. Frank N Furter, kills his former lover Eddie in *The Rocky Horror Picture Show* (1975), and feeds him to the guests.

Other bisexual killers abound in the cinema. Billie is the bisexual third of a trio of lethal women in Russ Meyer's film, *Faster Pussycat! Kill! Kill!* (1965). The deadliest, however, is the lesbian character, Varla, a brutal karate expert. In Claude Chabrol's 1966 French film, *Les Biches* a young bi woman named Why murders her lover/patron. The Belgian film, *Monsieur Hawarden* (1968), tells the story of a bi woman who spent most of her life as a man in order to escape being prosecuted for shooting the man who was once her lover.

For bisexual murderers on film, 1970 was a vintage year. Conrad, in *Something for Everyone*, will not let sexual orientation or a few dead bodies stand in the way of achieving his goal of living in a real castle. The title character in *Entertaining Mr. Sloane* kills the father of his male and female lovers because the father knows that young Sloane is a murderer. Robert F. Lyons plays a charming bisexual serial killer in *The Todd Killings*. In *Beyond the Valley of the Dolls*, the bisexual party host goes berserk and chalks up an impressive body count before he is killed himself.

The Brazilian film, *Amor Bandito* (1979) features a baby-faced bisexual killer named Tony who enters into a violent love relationship with his dead lover's roommate. Bisexual director Rainer Werner Fassbinder has two bisexual killers in his 1982 film, *Querelle*. The first is the title character, who murders his drug-smuggling partner and later sets up his brother and his lover to be arrested. The other killer is Gil, who commits two homicides. In Robert Altman's *Streamers* (1983), a high-strung bisexual soldier kills two members of another company over a relatively minor incident. Frank Booth, from *Blue Velvet* (1986), is a sadistic psychotic who has no preference for which sex he sexually terrorizes and kills. Members of the fencing team in the Dutch film *Touché* (1991) believe that Martijn killed his male lover, Michiel, because Martijn could not deal with his same-sex attractions.

Asia the Invincible castrates himself in *Swordsman II* (1991) in order to achieve the magical martial arts power necessary to destroy his opponents. This androgynous bisexual superhero kills dozens of enemies in a single battle. The 1993 sequel, *The East Is Red* features more of the same.

Sharon Stone plays a highly-sexed killer named Catherine–bisexual and quite handy with the ice pick–in *Basic Instinct* (1992). In the same film, her former girlfriend Beth is another bisexual who may be responsible for some portion of the body count. Yet a third bisexual killer in that film is an older woman named Hazel, who wiped out her entire family. Although all the women in the film are lesbian or bisexual, all the sex is heterosexual, thus adding to the prurient male fantasy.

Jack Carney is the bisexual killer in *Apartment Zero* (1989). He is not your everyday Hollywood psycho, though. He is a member of an Argentinean death squad and just loves his work. Another bisexual from the ranks of professional killers is the deadly sex goddess, Pussy Galore, in the James Bond classic, *Goldfinger* (1964).

Confessions of a Serial Killer (1992) is a low-budget exploitation film about a bisexual Texan who terrorizes, rapes, and murders women. The killer lives with his gay lover, who sometimes assists him in the murders.

Paramount's *Looking for Mr. Goodbar* was one of the biggest hits of 1977. A mild-mannered female teacher by day goes cruising the

night spots of New York City, looking to pick up men for quick sex. The last one she meets is a bisexual who has just had a fight with his male lover. He rapes her and stabs her to death. The killer's character is further exploited in a made-for-TV sequel called *Trackdown: Finding the Goodbar Killer* (1983).

OTHER BISEXUAL CRIMINALS

The world of the bisexual film criminal is not without its petty thieves. The film *Dog Day Afternoon* (1975) is about a down-and-out man named Sonny (Al Pacino) who robs a bank to get money for his boyfriend's sex change operation. His attempts to talk with his wife while he is holding hostages at the bank are touching and sad. The script is based on a real story, but it is unlikely that the story would have made it to film if it were not for the main character's "peculiar" sexual predilections. Patrick Dempsey plays another bisexual bank robber in the film *Bank Robber* (1993).

In Bertrand Blier's French comedy, *Going Places* (1974), Gérard Depardieu plays the more despicable of the two thieves, the bisexual one. In 1986, the actor and director teamed up once again on the film *Ménage*, in which Depardieu plays another bisexual thief. This one persuades his straight male partner in crime to try men. Eventually they become lovers. Actress Miou-Miou was the female lead in both films. In another French film, *L'Homme Blessé* (1983), Bosmans is a bi vice squad detective who employs the younger bisexual, Jean, to pick up men at the train station and then rob them after sex. In *We Think the World of You* (1988), Gary Oldman's bi character, Johnny, burglarizes a house for money to buy himself a dog.

One bisexual thief who is considerably more deadly than these small-time criminals is the title character in *The Black Lizard* (1968). She likes to steal beautiful things (including people) to keep in a museum on her island hideout. A number of other Japanese bisexual characters, all of them female, are portrayed as murderers and psychos. In the Italian film, *The Berlin Affair* (1985), the bisexual daughter of the Japanese Ambassador seduces and destroys a German couple on the eve of the Second World War.

The Japanese psychological thriller, *The Enchantment* (1989), contains a female bisexual character named Harumi who kills her

former male lover. He is the psychiatrist attempting to treat her current girlfriend for a multiple personality disorder. In another Japanese film, *With Beauty and Sorrow* (1965), the girlfriend of a woman who had long ago been abandoned by a man seduces him and then kills his son.

The Roman epic film is another favorite source of bisexual villains. It is easy to dislike the egotistical, power-hungry Roman rulers. Directors are quick to emphasize their bisexuality as a way of enhancing the feeling of depravity attached to the character. In the film *Spartacus* (1960), Crassus is a Roman ruler who crushes the slave rebellion and crucifies the hero. He is also the only character who is obviously bisexual. In *Caligula* (1979), the despotic ruler is the bisexual Caligula Caesar.

A more modern portrait of Italian bisexuality run amok is found in Pasolini's *Salo, or the 120 Days of Sodom* (1975). In this film, wealthy fascists kidnap boys and girls to participate in games of boundless depravity. Another bisexual sadist, though this time with consenting participants, is Wanda in *Seduction: The Cruel Woman* (1985).

One of the most unusual bisexual killers in film has to be Margaret in the cult film, *Liquid Sky* (1983). She discovers that space aliens are killing anyone who has an orgasm in her apartment. During the course of the movie, she dispatches both of her lovers, a gay friend, and two rapists.

In *Savage Nights* (1993), the bisexual protagonist is HIV-positive and has unprotected sex with various partners, including his heterosexual girlfriend. *Together Alone* (1991) is one of several films in which a married bisexual man has unsafe sex with gay men. With the news media working overtime to convince people that bisexual men are responsible for the spread of AIDS in the heterosexual community, we will surely see more films with this as a theme.

Although the production of films with bisexual killers and miscreants has abated somewhat since the mid-1980s, movies such as *Basic Instinct* and *Confessions of a Serial Killer* remind us that Hollywood is still not above using bisexuality to underscore the unsavory nature of its murderous characters. This policy of guilt-by-orientation helps to perpetuate hatred toward bisexuals and other sexual minorities, just as *Birth of a Nation* and the voodoo movies of the 1940s and 1950s fed into the prevailing racial hatred.

Chapter 6

Bisexual As Victim

I never did nothin' to a man that I wouldn't do to a woman.

— Peter Falk as Sam Diamond,
in Neil Simon's *Murder by Death*

NO REST FOR THE WICKED!

Films that do not portray bisexuals as psychotic killers often show them as victims instead. If Hollywood is any guide, it is not safe to be bisexual or to be in the company of people who are. Portrayal of bisexuals as perpetrators and victims parallels the institutional prejudice that white Hollywood blatantly promoted against women, people of color, and third world people in its first seventy years, and which still exists in subtle and insidious forms today.

One thing we all know is that it is decidedly dangerous to be a bisexual politician. None of the bisexual members of Congress has had the courage to "come out." Doing so would seriously jeopardize their careers. A number of films deal with this issue. In every case, the bisexual politician is the victim of his sexuality.

Otto Preminger's film *Advise and Consent* (1962) contains a subplot about a young Senator named Brig Anderson who, when it is revealed by extortionists that he has slept with a man, locks himself in his Senate office and slits his throat with a razor. Every politician in the film is hiding something, but only the secret of bisexuality is terrible enough to die for. In a similar story, *The Best Man* (1964) casts Cliff Robertson as a right-wing presidential candidate whose possible involvement with an army buddy years earlier nearly leads to his loss of the nomination. This time, however, the

opposition candidate refuses to use the smear against him, but only
because he believes it to be untrue. In the Spanish film, *El Diputado*
(1978), known in English as *Confessions of a Congressman*, the
Fascist party learns everything they need to destroy the career of
Congressman Roberto Orbea by setting him up with a young male
lover who acts as an informant. *Romance* (1988) is a Brazilian film
in which the bisexual politician is killed at the outset. The premise of
the film is to discover which of his many enemies was responsible.

Even omnipotent rulers in film find their lives in jeopardy when
they favor their same-sex lovers. In Greta Garbo's 1933 portrayal of
Queen Christina of Sweden, the monarch is constantly badgered to
marry. Finally, she is driven from the throne, in part because of her
bisexuality. Edward II, in Derek Jarman's 1992 film of the same
name, was put to death because he paid more attention to his male
lover than to his wife.

It is not only in politics that a person's career can be ruined due to
their bisexuality. An aptly named British film, *Victim* (1961), stars
Dirk Bogarde as a married barrister who is being extorted by some-
one who has found out about his relationship with a young man.
Farr is summoned to the police station when his name turns up in the
scrapbook of a young man who has just committed suicide in jail.
When a junior officer protests, "But Mr. Farr is married," his wise
old commanding officer simply replies, "Those are famous last
words." While arguing against the statute that enables extortionists
to victimize bisexual and homosexual men, the film also underscores
how easily these men fall prey. The promising young attorney must
risk his marriage and his career to stop the extortionists.

In the Italian film *A Special Day* (1977), Marcello Mastroianni
loses his job as a radio announcer when Mussolini's fascists find out
that he sleeps with men. Even a hot afternoon of sex with Sophia
Loren cannot save him once the discovery is made. Bisexuality is an
impediment to the priesthood in *Mass Appeal* (1984). The Monsi-
gnor feels that bisexuals (and homosexuals) will be unable to keep
their vow of chastity as heterosexual priests do. Therefore, he has
young Dolson drummed out of the training.

If being a bisexual is bad for your career, being a bisexual in a
relationship can be absolutely fatal. *Les Biches* (1966) is a film by
French director Claude Chabrol in which a wealthy bisexual woman

named Frederique is murdered by a young lover she has taken into her home. In the prison sexploitation film *The Big Doll House* (1971), a woman who murdered her bisexual boyfriend is among the prisoners. A lesbian, played by June Allyson, murders and mutilates her pregnant, bisexual lover in *They Only Kill Their Masters* (1972). James Coburn's bisexual character is murdered while attempting to discover who killed his wife in *The Last of Sheila* (1973). *Another Way* (1982) is a Hungarian film about a woman named Livia, who is married to a brutish army officer. When he discovers that she has a female lover, he attempts to rape Livia. He then shoots her as she is taking a bath. In *Deathtrap* (1982), Michael Caine's character dies a violent death at the hands of his male lover after they kill Caine's wife. The intensely depressing French film *L'Homme Blessé* (1983) seems to portray everyone as a victim, but it is the bisexual Jean who is murdered by the young man who loves him. In *Burglar* (1987), Whoopi Goldberg discovers that the murdered bisexual, Christopher, was killed by his own lover, the lawyer. That same year, bisexual rock singer Karon is strangled in the men's room of a chic LA dance club by his lover in *Hot Child in the City.*

More recently, Gregg Araki's film *The Living End* (1991) shows a masochistic, young bisexual man who is stabbed to death after picking up one of the film's leading men for sex. This was another movie where, in one way or another, every character in the film is a victim.

Bisexual fencer Michiel is killed in a match with his lover in *Touché* (1991). In *Basic Instinct* (1992), Beth, lover of the ice pick murderer, Catherine, is shot and killed by their mutual boyfriend, Nick. Two bisexual lovers, Sasha and Grace, are blown up by Sasha's wife in *Inside Monkey Zetterland* (1993).

In addition to *Advise and Consent*, there have been a number of films in which the bisexual character was a suicide victim. The earliest was 1928's *Geschlecht in Fesseln* (Sex in Bondage), in which a young man and his wife kill themselves when extorted by the man's former lover. Robert Aldrich's *The Legend of Lylah Clare* (1968) has Lylah jumping, falling, or being pushed to her death, depending on which version of the story you choose to believe. Marcia, in *That Tender Touch* (1969), is a widowed woman who falls in love with her adopted daughter. Marcia drowns herself when the young woman decides to end their affair in order to be monoga-

mous with her husband. In the movie version of *Ode to Billy Joe* (1976), we discover that the big secret leading to Billy Joe's jump from the Talahachee bridge was that he slept with a man. While it can be argued whether or not the overdose was a suicide, *The Rose* (1978) ends with the bisexual protagonist taking more drugs than her body can possibly handle.

In the Greek film *Thanos and Despina* (1968), Thanos and Yankos once were lovers when they fought together in the war. Now Yankos wants to renew that relationship, but is engaged to Despina. She falls in love with Thanos and they run away together. Yankos calls out the police and the villagers, ostensibly to track down his fiancé. Cornered, and neither wanting to return to Yankos, Thanos and Despina leap to their deaths from a cliff.

In a great many foreign films, the bisexual characters are victims of a violent death. In addition to the several listed earlier in this chapter, the following are noteworthy. Victorine, the beautiful young servant and lover of a female transvestite, is accidentally struck and killed with an ax wielded by a male suitor in the Belgian film *Monsieur Hawarden* (1968). In the Italian film, *The Conformist* (1969), the professor's bisexual wife is executed by a squad of fascist assassins because of her husband's political activities. In Norway's 1980 release, *Liv og Død (Life and Death)*, a young married doctor falls in love with a gay medical student. The two men and the accepting wife become involved in a triad, which comes to a tragic end as a result of society's homophobia.

Brazil is the source of *Pixote* (1981), in which the young bi hustler named Dito is accidentally shot by a ten-year-old-boy during a robbery. From Holland we have *The Fourth Man* (1983), the story of a man who is about to become a young widow's fourth husband dies a particularly gruesome death less than an hour after he discovers his bisexuality. In the French movie, *The Trout* (1983), nearly everyone is bi, but the one character who is completely casual and accepting of her own bisexuality is murdered. Most recently, in *The Crying Game* (1992), the young British soldier, Jody (Forrest Whittaker), is first kidnapped by the Irish Republican Army and then killed by his own troops.

There are a number of bisexual masochists in recent films. The hidden message here is that bisexuals are not only victims, but enjoy

it. One such pain seeker is the above-mentioned man in *The Living End*, who apparently enjoyed bringing home strange men who would beat him during sex. In an incident depicted in this film, he asks our gay hero Luke to hit him with a tennis racket.

The plot of Pedro Almodóvar's first film, *Pepi, Luci, Bom and Other Girls* (1980), hinges on the masochism of the bisexual woman, Luci. She has married a policeman, hoping that he will abuse her. He treats her nicely, however, and she leaves him for the sadistic lesbian, Bom. In a display of her extreme masochism, however, she falls in love with the cop again after he kidnaps her and beats her so badly that she lands in the hospital with several broken bones. The short film *North of Vortex* (1991) contains a scene where Sailor beats up Poet during their cross-country travels. One would expect Poet to break company with him at that point, but he only seems to fall more deeply in love.

It is not only masochistic bisexual characters who are beaten up. Union leader Harry Black is a bisexual who has an attraction to transvestites and boys in the film *Last Exit to Brooklyn* (1989). He gets beaten to a pulp and "crucified" when he is caught trying to pick up a young boy in a vacant lot in his neighborhood.

Bisexual women in film have been cast in the role of victims for decades. One of the earliest was the character Lulu in G. W. Pabst's 1929 classic, *Pandora's Box*. Down and out in London, she turns to prostitution in order to survive and picks up the wrong man—Jack the Ripper. The record for the earliest bisexual death though, is probably held by Ellen Barkin's character, Claire, in the movie *Siesta* (1987). She starts out a bloodied victim in the very first frame and spends the entire movie figuring out how she got that way.

Some bisexual victims in film happen to be based on true stories. Many of the great "shooting stars" in the twentieth century have been people in the arts who exhibited bisexual behavior. James Dean, Montgomery Clift, Yukio Mishima, Oscar Wilde, Rudolph Valentino, Judy Garland, Vaslav Nijinsky, Janis Joplin, and Frida Kahlo are all legendary figures whose lives were tragically cut short and about whom various films, documentaries, and videos are readily available.

With the constant stream of new AIDS movies, we will surely see more films portraying bisexuals suffering from the disease. The first

was a British entry called *Peter's Friends* (1992), directed by Kenneth Branagh, in which Peter calls all his old school friends together for a New Year's party to announce his HIV status. Another is *Savage Nights* (1993), where Jean is struggling with AIDS and a number of difficult relationships.

Of the films discussed in this section, only *Victim*, *El Diputado*, and *Mass Appeal* challenge the concept of bisexual as victim. In each case, the male protagonist struggles against the forces arrayed against him and, in some measure, overcomes them. Each, however, wins only a limited victory, and at great expense. His career opportunities are diminished in such a way as to reinscribe his victim status. It is significant that no bisexual women are portrayed as overcoming victimization. The "additional handicap" of being female is apparently too much to overcome in the eyes of the world's screenwriters.

Chapter 7

Wedded Bliss

Marriage is a fine institution, but I'm not ready for an institution yet.

— Mae West

STEREOTYPES OF BISEXUAL HUSBANDS

Rod Steiger's police officer in *The Naked Face* (1984) summed up Hollywood's image of the bisexual male quite succinctly with the line, "A bisexual is a fag with a family." Indeed, the bisexual married man in films from Hollywood and elsewhere is usually portrayed as a closeted homosexual and/or a man who has sex with other men behind his wife's back.

Typical of this treatment is the character Cecil in *Parting Glances* (1987). At a dinner he hosts for Robert and Michael, a young employee and his lover, we learn that Cecil has not told his wife that he is leaving the next day on a six-month trip to Asia. After dinner, Cecil discloses to Robert that he takes long "business" trips to foreign countries in order to have sex with young men without his wife's knowledge. He later flirts with Michael when Robert is out of the room.

Another closeted husband expresses his bisexuality in *The Lost Language of Cranes* (1991). When Owen's son declares his homosexuality (beneath a picture of the Queen of England), Owen begins to question his own long-hidden behavior. He eventually comes out to his wife and begins to bond with his son in a way that they have never been able to before.

Robert Redford plays Wade Lewis, a bisexual film star in the lamentable *Inside Daisy Clover* (1965). He marries young actress Daisy (Natalie Wood), but never tells her about his history of male lovers. Before long, he is back to his old tricks. Ruth Gordon carries the first half of the movie as Daisy's mother. Once she is locked away, the film is nothing but dull.

Three films featuring secretly bisexual husbands are about men in politics. The two best-known: *Advise and Consent* and *El Diputado* have the common thread of a politician being extorted by his political enemies. These films are discussed in the chapter on bisexual victims.

By far, the strangest of the three is a film about an Australian senator. The film's title, *The Everlasting Secret Society* (1988), refers to an underground political group of very powerful men who have organized to cover up and perpetuate their homosexual society within the government. The senator marries because voters expect a senator to be married. However, the wife (a former campaign worker) is unaware of the secret society. Nor does she know that their baby-sitter is the senator's lover, who will eventually become their son's lover and sponsor in the society.

Like *El Diputado*, the English film *Victim* centers on a highly respected married man being extorted over a same-sex affair with someone several years his junior.

Two mystery movies have a husband's bisexuality as central to the plot. In *Deathtrap* (1982), Michael Caine plays a famous play-wright who has recently written a string of unsuccessful plays. He invites a young student writer for a visit, telling his wife that he plans to kill him and steal his script. The wife does not know that the "student," played by Christopher Reeve, is actually his lover, and that she is the intended victim.

On the other hand, *The Last of Sheila* (1973) begins with the wife's murder. Her husband, played by James Coburn, assembles all the suspects aboard his yacht to play an extended game designed to determine who killed her. The game involves major secrets which each suspect is hiding. The secret of one of the participants is that he was the husband's lover. The script for this thriller was concocted by gay puzzle aficionados Anthony Perkins and Stephen Sondheim.

Very few of these films portray events as viewed from a woman's perspective. One exception is the final episode of Krzysztof Kies-

lowski's *Blue*, *White*, and *Red* trilogy. A young model is challenged by a judge she is visiting to inform the woman next door that the judge has been listening in on their telephone conversations and discovered that the woman's husband has a male lover. The model leaves with the intention of doing so, only to find that the daughter has also discovered the fact through her own eavesdropping. The husband is never seen in the film. We only hear his voice and that of his lover. Interestingly, it is not the wife's perspective that we have on this discovery, but merely that of an otherwise uninvolved stranger.

Wild Blade (1991) is a rare film in which the wife's feelings are central to the plot and not merely to the man's reaction. In this film, the wife discovers at her husband's funeral that he had been seeing a young hustler and owed the hustler's pimp a large amount of money. Her initial shock and anger give way to something more akin to lust as she begins to fall in love with the hustler and seeks to separate him from his master. The film otherwise suffers from an implausible plot, bad dialog, muddy sound, grainy film, and terrible editing.

Specifically gay-themed films often have a married man in one of the roles. An early example of this is *The Boys in the Band* (1970), written by gay playwright Mart Crowley. Several gay men are gathered at an apartment in New York to celebrate the birthday of one of their number. All gay stereotypes are represented, including the married man whose wife is unaware. Hank says he loves his wife very much, but can neither tell her nor leave her.

The character Ed, in *Torch Song Trilogy* (1988) is terrified that his fiancée will discover that he and Arnold are lovers. Once he is married, he tries to "go straight," but is easily derailed by Arnold's new lover. In the end, he returns to the city to resume his quest for sex with men. The script was written by gay playwright Harvey Fierstein, who also created the role of Arnold.

In gay writer/director Gregg Araki's *The Living End* (1991), one of the scenes involves Luke and a masochistic bisexual man he picks up. The man wants to be fucked and beaten, but when his wife returns unexpectedly, she kills him. Araki also heavily stereotypes straight people and lesbians in this film.

The Hours and Times (1991) is another film with a married bisexual man as a minor character. The film is a fictionalized account of a vacation encounter between John Lennon and his gay manager,

Brian Epstein. The bisexual character in this film is not Lennon, however. Rather, he is a commodities broker whom John picks up at a gay bar to bring back to the room for Brian. The man tells them that he is happily married, but likes men because they can give him what his wife cannot.

For his film *Together Alone* (1991), P. J. Castellaneta wrote, directed, produced, and even catered the film himself. Despite its extremely low budget, the movie is well-filmed. It tells the story of two men named Brian and Bryan who meet in a bar and go home to have sex. The story begins after sex when the two begin talking about their lives and interests.

During the course of the conversation, we learn that Castellaneta has a number of unresolved issues with bisexual men which we see him trying (unsuccessfully) to work out on the screen. Over the next hour, he manages to reinforce every existing negative stereotype about bisexual men. Bryan claims that Brian lied about his name in the bar. Then Brian refuses to tell whether or not he is HIV positive (they have already had unprotected sex by this time). Eventually, Brian admits that he has never been tested, saying he is not worried about AIDS because he never takes it in the ass. He also says he will never wear a condom if he can get away with it. Only reluctantly does he reveal that he is bisexual. Finally, at the end of the film he acknowledges that he is married, has a child, and that his wife is pregnant. He says, "I really like the surface respectability that married life gives me."

In the film *Closing Numbers* (1993), Anna is a happily married middle-class woman who discovers that her husband has a gay male lover. She befriends the lover and his circle of friends, one of whom is hospitalized with AIDS. The harsh truth hits home when her husband, who has refused to be tested, begins showing symptoms of the disease.

Mensonge (*The Lie*) is a 1993 French film with a similar plot. Emma is happily married to a reporter. While he is away on assignment, Emma discovers that she is pregnant with her second child. A routine blood test discloses that she is also HIV-positive. After a fruitless search to find out who her husband's girlfriend might be, Emma discovers his secret "promiscuous gay lifestyle."

The campy gay film, *Grief* (1993) is a behind-the-scenes satire on trashy television shows. One of the main characters is Bill (Alexis

Arquette), who is having an affair with fellow writer Jeremy while he is having relationship problems with his fiancée.

One has to wonder why Reggie in *The Leather Boys* (1964), ever got married. He seems to abhor married life and is not even civil to his wife, although he was plenty hot for her before the wedding. Now he finds enjoyment only in the company of his motorcycle buddies. It is a long time, however, before he discovers that these pals are gay. He is shocked when he finally comes to that realization.

Adios, Roberto (1985) is a comedy from Argentina in which Roberto has already separated from his wife. He is temporarily living with Marcelo, a friend's relative who turns out to be gay. One night while drunk, Roberto has sex with Marcelo. When he sobers up, Roberto has to deal with his own conflicting emotions, as well as ridicule from his wife, family, and even the confessional priest. In spite of all this, however, his relationship with Marcelo deepens, and the two become lovers. This film won the Audience Prize for Best Film at the 1987 New York Gay Film Festival.

In the delightful short film, *Time Expired* (1991), the action begins with Bob heading home to his wife, Ginnie, after two years behind bars. Just outside the prison, he is stopped by a transvestite named Ruby, who wants to talk to him. Bob brushes her off and goes to meet Ginnie and his mother. Ruby begins calling almost as soon as Bob gets home, so he reluctantly agrees to meet her in the park. There we learn that Ruby had been Bob's cell mate and lover, but that Bob wants to forget her and resume his former life. He tries to stall Ruby, but is unable to get her out of his mind. Ruby, tired of fighting for Bob's affections, goes to his house to lay it on the line. Ginnie demands to know what is going on. Finally they tell her, "One thing led to another and we . . . uh . . . consummated."

WHY WIVES TURN TO OTHER WOMEN

The stereotypical married bisexual woman in film is quite a different character. She turns to other women for love and affection because of the abusive nature of her husband. The classic example of this type of film is Steven Spielberg's *The Color Purple* (1985). Celie (Whoopi Goldberg) is abused by her husband "Mister" from

day one, and winds up in the loving arms of Shug Avery, a popular singer who is Mister's mistress. Though the book is explicit about the relationship between Celie and Shug, only vestiges remain in the film.

Fried Green Tomatoes (1991) follows a similar track, again with the film leaving much more to speculation than did Fannie Flagg's book. Tomboyish Idgie becomes best friends with her dead brother's girlfriend, Ruth. Much to Idgie's dismay, Ruth gets married and moves away. When Idgie comes to visit, she finds the pregnant Ruth being severely beaten by her husband. Ruth escapes with Idgie, they create a life together, open a restaurant, and raise the baby.

Far more explicit than either of these was *Lianna*, directed by John Sayles in 1982. Lianna (Linda Griffiths) is married to a pedantic, self-absorbed film professor who thinks about other people only in terms of how they will affect his career. He expects his wife to worship him and has coerced her into dropping out of school because it would look bad for him to be married to a student. When she sleeps with her lesbian night school teacher, he throws her out of the house and does his best to make her life miserable. She receives joint custody of the children only when he realizes that they get in the way of his dating. This is one of the few films where the lesbian leaves the bisexual woman, rather than the other way around.

The Incredibly True Adventure of Two Girls in Love (1995) includes three women who are at least experientially bisexual. Wendy is the only one who is currently married. Her husband, of course, is a crude and abusive man. When the film opens, Wendy is seeing Randy, a female high school student ten years her junior. The husband nearly kills Randy when he finds out about their relationship. Randy soon dumps Wendy for Evie, another girl in her class. Nonetheless, Wendy comes to Randy's aid when she and Evie get themselves in a jam.

Bound and Gagged: A Love Story (1993) is a little-known cross between a *Thelma and Louise* road movie and a *Three of Hearts* "gotta get my girlfriend back" film. Former porn queen Ginger Lynn Allen plays Leslie, a woman trapped in a marriage to a guy from the wrong side of Neanderthalia. Her bisexual girlfriend kidnaps her and they hit the road.

A short melodrama called *Minor Disturbances* (1992) features a disenchanted housewife, her jealous husband, and her lesbian lover.

The film begins with the wife's birthday. The husband's cheap gift is upstaged by the girlfriend's present, which is a beautiful necklace. His jealousy makes the wife afraid to kiss her lover goodnight when she goes home. The husband is totally uncommunicative, hangs up the phone on the girlfriend, and generally acts like a jerk. In the end he loses his wife to the girlfriend.

Chris Noonan directed an Australian film called *Cass* (1977) about a woman and her life choices. Cass is a documentarist who has just returned from the island of Mulala with incredible footage of a secret tribal ritual. Her husband, a doctor, has no time for her and is not interested in hearing about her desire to live a simpler life. When she tells him that she loves her friend Margo and would like to live in Margo's communal solar house, he throws her out. Margo is not interested in a committed relationship, however, so Cass gets in her car and drives off into the sunset.

Another Way (1982) is a Hungarian film set in 1958 following the unsuccessful uprising against the Communist government. Livia is married to an abusive army officer. She falls in love with Eva, an outspoken news journalist with whom she shares an office. Eva does not last long in an environment where every story is reviewed by army censors and repeated violations mean loss of both job and future employment opportunities. When Livia's husband learns of their relationship, he attempts to rape her, then shoots her as she is bathing. Jadwiga Jankowska-Cieslak won a Best Actress award at the Cannes Film Festival for the role of Eva.

One of the classic women's films of the 1980s was the French *Entre Nous* (1983). Interestingly, this is the English title. It was called *Coupe de Foudre* in France. Helene (Isabel Huppert) and Madeleine (Miou-Miou) meet accidentally and become best friends. Each has a husband who is despicable in his own way. Madeleine's forbids her to see Helene, so she moves away to Paris. He lures her back by setting her up with a dress boutique, but then destroys the shop when he finds Helene there. The two women then flee to the country together with their daughters. It is only in the final credits that director Diane Kurys reveals that the character Helene is her mother.

Another French movie, 1995's *Gazon Maudit* (*French Twist*) was written and directed by Josiane Balasko, who also plays its lesbian

main character. In the film, Loli is a young housewife whose husband, Laurent, is an arrogant real estate salesman who virtually ignores her while sleeping with various women behind her back. When Marijo (Balasko) stops by because her van breaks down, the two women fall in love. It is only when Laurent learns of Loli's attraction to another woman that he pays attention to her–pulling out all the stops to win her back.

Roman Polanski's *Bitter Moon* (1993) features a wheelchair-bound American expatriate named Oscar whose wife, Mimi, is intent on avenging the abuse he dished out before his accident. Part of her plan is to sleep with the uptight Nigel (Hugh Grant). The surprise comes when Nigel's wife seduces Mimi in plain view of the two men.

In 1985, Lina Wertmüller directed an Italian film titled *Sotto . . . Sotto*. In the film, Oscar is good-looking, egotistical, abusive, jealous with regard to his wife, and extremely homophobic. His wife, Ester, and neighbor, Adele, are best friends. After catching a glimpse of two women kissing in a park, Ester dreams that she is in a movie kissing Cary Grant, but his image dissolves into Adele. She realizes that she loves Adele and tells her so the next day. When Adele's lover stops by, she leaves the shades open so that Ester can watch. Ester is so turned on that she begs Oscar to make love to her out on the terrace, so that Adele can watch as well. The next morning, when Oscar asks what made her so passionate the previous evening, Ester confesses that she was thinking about making love to someone else, but refuses to reveal whom.

This sends Oscar into a jealous fit. He storms out of the house and tries to enlist Adele's help in tracking down the man who is making a cuckold of him. He accuses, threatens, and punches various men in a blind rage and ends up dead drunk. Ester finally confesses that the "other man" is a woman, but says she is one of the orphans at the convent. Oscar then talks with a group of actresses who work with a friend he just punched. One tells him, "According to the Institute for Sociology, within twenty years there will be 80 percent bisexuals." Another lists her lovers to show that she, too, is bisexual and that it is completely normal. Oscar calls them all a bunch of queers and wanders off to ponder the big question, "If the other lover is a woman, am I a cuckold or not?"

The film is listed as a comedy, but there is nothing funny about beating up one's wife for thinking about someone else during sex. The ending is particularly disappointing, as Ester nurses Oscar's wounds after he has beaten her for the third time, threatened to kill her, and tried to rape Adele.

We are still waiting for a film with the kind of well-adjusted, openly bisexual couple that one often meets at bisexual conferences and social gatherings. Perhaps that would be too dull for screenwriters, though it never stopped them from populating films with happy heterosexual couples.

Chapter 8

Anything That Moves

I could love anything on earth that appeared to wish it.

— Lord Byron

One of the most persistently clichéd film characters is the over-sexed bisexual who will have sex with anyone and anything. Film-makers around the world have helped to perpetuate this stereotype. The result of such stereotyping is the widespread, but incorrect belief that bisexuals are not capable of monogamy or long-term relationships. This misconception reaches the ridiculous extreme where many newspapers will not accept personal ads from bisexuals seeking long-term relationships.

PROMISCUITY AMONG SCREEN BISEXUALS

Paul Morrissey plays up the "anything that moves" cliché in his 1971 film, *Women in Revolt*. Here, Holly Woodlawn plays a bi-sexual nymphomaniac who works as a fashion model. By the end of the film, she is a vagrant wino, staggering her way through the Bowery. Woodlawn and two other drag queens play members of a feminist group called Politically Involved Girls (PIGs). The name is an apparent reference to the Society for Cutting Up Men (SCUM) whose member, Valerie Solanis had shot Andy Warhol two years earlier.

An extreme example of the stereotype is portrayed by Dennis Hopper in David Lynch's *Blue Velvet* (1986). His character, Frank, is a psychotic bisexual killer who actually says, "I fuck anything

that moves." The statement is gratuitous and does nothing to move the plot forward. It simply exists to emphasize the perverse nature of the killer and to help justify the presence of other gay stereotypes in the scene. Jay, the drug dealer in *Clerks* (1994), makes the same assertion to Silent Bob and anyone else willing to listen. Jay's contradictory statements and stated homophobia leaves his true sexuality in doubt.

In the 1987 comedy *Burglar*, the plot revolves around a murder which is blamed on Whoopi Goldberg's character. Goldberg has to prove her innocence while avoiding arrest for parole violation. Her investigation into the victim's background turns up the fact that the once-married superstud had male lovers as well. An acquaintance tells Goldberg that he basically screwed anything that moved.

Mirror Images II (1993) features Shannon Whirry as a pair of bisexual twins. Carrie is sexually scarred as the result of a childhood trauma. Nevertheless, she has no trouble attracting men and eventually marries. Terri, her evil twin, sleeps with Carrie's boyfriends and husband, causing great trauma because everyone thinks Terri died in a fire. The confusion drives Carrie to begin seeing a female psychiatrist. When she tells the psychiatrist that she is attracted to her, the doctor tells her that it is "just transference" and not to worry as she places her hand on Carrie's thigh. The two then undress and make passionate love in the office.

Color of Night (1995) is a psychological thriller in which Bruce Willis attempts to discover who killed his best friend. The suspects are members of the friend's therapy group, each of whom is psychotic and none are above suspicion. The breakthrough comes when Willis discovers that he, his friend, and four members of the group (including the one woman) have all slept with the same woman. This discovery, a couple other plot twists, and the requisite bloody "action scene" leads us to the identity of the real killer.

The remaining films in this chapter all share a similar plot device a bisexual stranger or family member comes to visit, and ends up sleeping with most of the household. The earliest such film is by gay Italian director Pier Paolo Pasolini in 1968. *Teorema* is a political allegory in which Pasolini attempts to fuse the teachings of Jesus with those of Karl Marx, arguing that Christianity has been co-opted by capitalism.

Pasolini's angel (Terrance Stamp) is a young man who is so gentle, so attractive, so . . . angelic that people cannot help falling in love with him. He seems totally unconscious of the erotic feelings that his presence evokes in people. He is the heavenly embodiment of the libido–innocent and irresistible. He is also an irresistibly chaotic force in the lives of the rich and, once touched, changes them forever.

The film begins with an unexpected telegram announcing the young man's imminent arrival. What follows is the story of his brief visit with the bourgeois family of a Milan industrialist and the consequences thereof. Shortly after his arrival, the angel is relaxing in the courtyard where the maid is working. His mere presence drives her to overcome her usual shyness and proposition him. He takes this completely in stride and accepts.

The angel is subsequently seduced by each member of the family. The husband, the wife, their son, and daughter all find him irresistible in ways that they would never normally feel for a relative stranger. Each goes mad with longing for him when he leaves. The daughter, already an introvert, becomes practically catatonic. She seems destined to spend the remainder of her days in a sanitarium. The son collapses into the most bizarre artistic expressions, one of which is urinating on his canvases. The mother suddenly cannot resist picking up random men on the street.

The father decides to turn his factory over to the workers. He goes to the railway station and sees a young man standing near the men's room door in a rather "professional" pose. Their eyes meet occasionally and the father stares at the man's crotch. When the man gets up and enters the restroom, he clearly expects the older man to follow. Instead, the father disrobes in the middle of the station. The maid also succumbs to the madness, becoming religious in the extreme. She performs acts of self-levitation over the church and has herself buried alive.

The allegorical meaning of all this is quite complex. One begins to wonder by the end of the film whether Pasolini has not also been seduced by his angel and ended up just a bit mad. He does seem to identify with each of the characters in some special way. Despite winning the Grand Prix award at the Venice Film Festival, *Teorema* was banned in Italy and Pasolini was arrested for obscenity.

The 1969 film *Angel, Angel, Down We Go* features an utterly obnoxious bisexual singer named Bogart Stuyvesant. He is the cult-like leader of a rock band whose members include Lou Rawls and Roddy McDowall. Holly Near plays a wealthy couple's shy daughter who is seduced by Bogart at her coming-out party. Later he seduces her mother and eventually the father, as well. Bogart has a hand in the death of both parents.

A bourgeois Italian family is again seduced in Radley Metzger's 1970 film, *The Lickerish Quartet.* This time the stranger is a woman–the motorcycle stunt rider in a traveling circus. The father, mother, and son find her attractive, in part because she resembles the bisexual actress they had seen together in a porno film. The trio invite her back to the castle, where she has sex with each in turn.

In *Something for Everyone*, Michael York's character, Conrad, has an obsession with the idea of living in a castle and is willing to do anything to fulfill it. Between these two films and a glut of bi vampire movies, bisexual relations in castles was a very popular theme in 1970. While traveling, Conrad discovers that Castle Ornstein is uninhabited. The owner is Countess Ornstein (Angela Lansbury), who no longer has the resources to keep the castle open.

Conrad, working as a chauffeur, later arranges the marriage of his two lovers, Annalisa and Helmut (the Countess' son). The wedding night is a disaster since Helmut has no interest in women. When Annalisa catches the two men kissing on the lips (which got the picture an R rating), she suddenly comprehends and prepares to expose the scheme. Conrad fixes that by driving Annalisa and her family off a cliff, jumping just in time to save himself.

Since Helmut is the heir to the wealthy family's money, he now has plenty of cash to reopen the castle. Conrad's plan is nearing a successful conclusion; he has only to seduce the Countess and marry her to become the Count. He meets his match, however, when the daughter reveals that she knows the entire plan. She has documented it thoroughly and sent the evidence to her lawyer to be opened upon her death. Her demand that Conrad marry her leaves him no alternative. Conrad's dream is now fulfilled. He lives with his three lovers, the Countess and her two children, in their beautiful castle on the hill.

In 1972's *Le Rempart des Béguines (The Béguines)*, Helene, the only daughter of a widowed politician, returns home from school to

find herself being seduced by her father's mistress, Tamara, who cuts quite a bohemian figure with her black kimono and Russian cigarettes. She is a very demanding lover. Eventually, in a twist on the standard *Lolita* plot, Tamara marries the father in order to be near his daughter.

Her Summer Vacation, released the same year, brought the bi-has-sex-with-the-whole-family film to South America. Following a very similar formula to *The Béguines*, young Giselle spends the summer at her father's ranch in Brazil learning about sex. She begins by having an affair with her stepmother. From there, she moves on to the ranch's handyman, her former baby-sitter, and her bisexual cousin. Little more than an excuse for soft-core porn, the movie was targeted squarely at the "art film" circuit.

The all-in-the-family plot seems to have taken about a twenty-year hiatus, only to reemerge with another cluster of films in the 1990s. The first is a French Canadian entry called *Cap Tourmente* (1993). Roy Dupuis plays Alex, a troubled young bisexual sailor returning home to Mother with his friend, Jean-Louis. During the course of the action, Alex sleeps with Jean-Louis, Mom, and his sister Alfa. His bisexuality seems to be taken rather matter-of-factly, with the biggest concern being who will pair up with whom.

The subgenre returned to its roots in 1994 with Sandra Bernhard playing the female counterpart to Terrance Stamp's angel of *Teorema* in the Australian film, *Dallas Doll*. Dallas (Bernhard) is a U.S. golf pro with semimystical powers who moves in with an Australian family after being bitten by their dog. With the exception of the young daughter, every member of the family falls under Dallas' spell. Soon she has convinced them to take over the family farm and turn it into a golf resort.

One of the more interesting scenes features a game of strip miniature golf between Dallas and Rosalind, the otherwise conservative mother. The background music is *Our Lips Shouldn't Touch*. The father, the son, and the mayor also come in for their share of comic sexual adventures. Things begin to unravel as family members discover more about Dallas, themselves, and each other. The bizarre ending involves space aliens and cattle.

This was followed in 1995 by a stunningly bad film called *A Friend of the Family*. Featuring soap opera dialogue and worse

acting, it is not difficult to see why this lame excuse for a movie bypassed the theaters and went straight to the markdown table at the video store.

In the film, Linda is having a difficult time with the dysfunctional family she married into. Her husband, Jeff, works all the time. His daughter, Montana, sleeps with every guy in town and goes out of her way to make Linda's existence a living hell. Meanwhile, son Josh lies about attending law school because his father will throw him out of the house if he discovers that Josh is secretly studying filmmaking.

Into this chaotic scene arrives Elke, the sister of Linda's school-mate. Elke says she has been robbed while traveling and needs a place to stay, so Linda lets her use the guest house. Slowly but surely, she seduces each member of the household. In the process, she molds them into a caring, loving family. The most significant transformation is in Montana, who not only becomes nice to every-one and stops sleeping around, but also loses her valley girl accent!

Of course, there are any number of soft-core porn films in which bisexual women have sex with virtually everyone they encounter. Better-known examples include *Honey* (1981) and the *Emmanuelle* series. The female bisexuality in these films is purely for the titilla-tion of the heterosexual male target audience. Corresponding male characters do not exist in the soft-core realm, although they began appearing in hard-core pornography in the late 1980s.

Chapter 9

Do the Hustle

Suppress prostitution and capricious lust will overthrow society.

– Saint Augustine

BISEXUAL MALE PROSTITUTION

A favorite image of bisexuals promoted by screenwriters around the world is the male prostitute or "hustler." Often depicted as a shadowy figure of the night, the hustler recalls the vampire tradition in film. Movie hustlers may be bisexual by inclination, or merely by economic necessity. In many of the films, it is difficult to determine which is the case. In others, the character begins his career as a heterosexual, only to broaden his interests as the film progresses.

One of the best-known hustlers in film history is Joe Buck in *Midnight Cowboy* (1969). Buck (Jon Voight) arrives in New York a naïve young stud from Texas, hoping to make his fortune as a male prostitute for women. After being hustled for twenty dollars by his first client and finding the competition much stiffer than he had imagined, reality begins to set in. Joe's mentor and only friend, Ratso Rizzo convinces him to start hustling men to keep from starving.

Joe's fear of sex with men stems from a gang rape in which both he and his girlfriend had been victims. This fear manifests itself when he panics during a sexual encounter Rizzo arranged with a gay businessman. Joe severely beats and robs the man in order to obtain money so that he and an ailing Rizzo can go to Miami for the winter. A clear, but unstated subtext in this movie is that Buck and Rizzo have fallen in love.

American Gigolo (1980) is another big-name U.S. film in which the protagonist sleeps with both men and women. Richard Gere plays a narcissistic male prostitute in Los Angeles. An accomplished linguist, he serves as a freelance guide and interpreter for affluent women of various nationalities visiting the city. He mistakes Lauren Hutton for one such woman and begins a relationship with her, but she has been around and has no illusions about him. It becomes clear that Gere's character also sleeps with men when his gay former pimp sets up an S/M threesome with a wealthy couple. This encounter leads to a murder charge and develops into the main plot line in the film.

Mark Keyloun plays the title character in *Mike's Murder* (1984), the only film by gay director James Bridges that includes gay characters. Mike is murdered and his girlfriend, played by Debra Winger, wants to know why. She investigates his life and discovers that Mike had stolen a large quantity of cocaine from the wrong man. In the process, she also learns that he had been a street hustler and the boy-toy of a famous record executive.

Less Than Zero (1987) is the story of three teens from L.A. with too much money and not enough intelligence. Julian's father gives him a record company as a high school graduation gift. Over a period of months, he loses the company, is disowned by his dad, and runs up a $50,000 tab from a drug dealer. The dealer begins selling Julian's body to gay clients in order to pay off his debt. The film title apparently refers to the amount of sympathy we have for the characters by the time the credits roll.

A number of hustler movies were produced by Andy Warhol's Film Factory. Most were directed by Paul Morrissey, a strangely out of place right-wing figure who nonetheless put a large number of bisexual characters on the screen. The first Warhol hustler film, *Blow Job* (1963), did not actually show the hustler on screen, but his presence is felt throughout. The film consists of a thirty-minute reaction shot of a man enjoying a blow job. The hustler (and his sexuality) are not identified.

My Hustler (1965) was the first Warhol film with anything resembling a plot. It may be less than a coincidence that this was also Morrissey's first Warhol picture as production assistant. The film is set on Fire Island in New York, where Ed Hood's friends and neigh-

bors lust after his blond hustler, Paul America. Hood tells the assembled group that he got the beautiful boy from Dial-a-Hustler and is quite pleased with his rental. The guests vie to see who will be the first to bed down the young stud.

Following Warhol's attempted assassination in 1968, Morrissey became the man who called the shots at the Film Factory. His first film from this era was *Flesh* (1968), in which Joe Dallesandro stars as a bisexual hustler. He has promised his wife that he will earn enough money for her lover's abortion. The young and beautiful Dallesandro has a considerable amount of sex during the course of the day. He also takes time out to counsel a young man just getting into the business about the tricks of the trade, telling him, "Nobody's straight. What's straight?" The film ends with Joe returning home with the money to be undressed again by his wife and her girlfriend.

Not surprisingly, Joe is all worn out by the time the sequel comes around. In *Trash* (1970), he is again a bisexual hustler, but his wife is played by transvestite Holly Woodlawn. Actually, the problem with Joe is not too much sex, but too much drugs. He is no longer able to achieve an erection, which is a major detriment to both his relationship and his career. Holly supports them by selling old furniture and other trash she has collected from the streets of New York. *Rolling Stone* magazine called *Trash* the film of the year. A planned sequel with Joe as a drugged-out cabby and their child as the school dope peddler never materialized.

Kevin Bacon starred in Morissey's final hustler movie, *Forty Deuce* (1982). In this bleak film about troubled and exploited teens, all the hustlers seem to be gay. Orson Bean plays the married man whose interest in underage males makes him an easy target for the hustlers, who attempt extortion by blaming him for a boy's fatal drug overdose.

My Addiction (1993) is a Canadian film that looks like a throwback to the Warhol era. Glenn is a married man who has fallen hopelessly in love with a bisexual hustler named Dick. The hustler's girlfriend explains that everyone loves to suck Dick's dick. The problem is that Dick is not interested in a relationship with Glenn, but Glenn refuses to leave until Dick physically throws him out. The

film ends with Glenn and his wife swearing off their addictions, but never addressing the underlying problems in their relationship.

In *Wild Blade* (1991), Donna is the wife of a bad comedian named Clark. Their marriage is going nowhere until they decide to take a vacation together. While Clark is poolside, running off at the mouth about something, she tells him to drop dead. He immediately obliges. It is only at the funeral that she discovers that Clark has been seeing a young hustler known as Colt. Her outrage is tempered by the fact that she finds herself attracted to the young Kevin Bacon look-alike. She arranges a meeting where she can pay off Clark's debts and have the boy, who seems quite amenable, for herself. Things go badly for everyone concerned, however, and the deal is never consummated. Far and away the best thing about this film is the music performed by Ella Fitzgerald, Johnny Hodges, and Duke Ellington.

Following in the footsteps of *Boys in the Band*, *Some of My Best Friends Are . . .* (1971) brings together another group of self-hating pre-liberation gays—this time at Christmas Eve in the Blue Jay bar. One of the minor characters is Jim, a hustler who beats up a transvestite (played by Warhol star Candy Darling) in the restroom. Jim claims that he has gay sex only for the money. Other celebrities appearing in the film include Lou Reed (composer of *Walk on the Wild Side*) and Fannie Flagg (author of *Fried Green Tomatoes*). British *Monthly Film Bulletin* said, "In comparison, even *Boys in the Band* looks like a masterpiece of subtlety and deep thought. And anyway, it was a lot more fun."

Gus Van Sant's first feature-length film, *Mala Noche* (1985) is the story of Walt, a young gay man with a fetish for even younger Mexican boys. Walt passionately yearns for Johnny, an unresponsive sixteen-year-old who merely taunts him. Frustrated, he settles for Johnny's friend Roberto, a hustler who is less adamant about the sex of his partner as long as he can be on top.

Returning to the mean streets of Portland, Oregon, Van Sant's best film to date is *My Own Private Idaho* (1991). It stars River Phoenix as Mike, a narcoleptic young blond obsessed with finding his mother, and Keanu Reeves as Scott, a dark-haired son of the mayor who is "slumming" to get back at his family. The two are best friends and work as street hustlers. Mike is primarily interested

in men, including his friend Scott, but sleeps with women for money. Scott, on the other hand, prefers women. He sleeps with men mainly to annoy his father and to make ends meet until his inheritance comes. River Phoenix was named best actor at the 1991 Venice Film Festival for his role in this film adaptation of Shakespeare's *Henry IV.*

RUNAWAYS

Every few years, Hollywood latches on to a new titillating theme and works it to death. In the 1950s, it was women in prison movies. The 1960s followed with films about hippies and free love. The theme for the 1970s was teenage runaways. Since runaway teens often turn to prostitution to survive, this was a perfect opportunity for exploitive sex on the screen. NBC took up the challenge with a pair of made-for-TV movies called *Dawn: Portrait of a Teenage Runaway* (1976) and *Alexander: The Other Side of Dawn* (1977).

In the first film, Eve Plumb plays Dawn, the fifteen-year-old child of a single mother who runs away from her Arizona home to make a life for herself in Hollywood. Eventually she becomes a streetwalker on Sunset Strip and falls into the clutches of a pimp named Swan. It is only when she meets the bisexual hustler, Alexander, that her life begins to turn around.

This movie achieved such a high audience rating that the producer immediately began putting together a sequel, focusing on Alexander's story. Alex is pushed off the family farm in Oklahoma and winds up in Hollywood. A street-smart friend hooks him up with female clients, but he eventually branches out into men as well. When Alex is arrested on a drug charge, the judge releases him on the condition that he and Dawn leave town. *TV Guide* called the film "lip-smacking moral prurience," while *The New York Times* said that it was "well worth watching."

The Worst Boy in Town (1989) is Mexico's top hustler film. The title character is Pepe. By day he is a common, homophobic criminal who hangs out with other boys like himself. Ostensibly all are straight, though the scene in the steam bath has strong homoerotic overtones. By night, Pepe becomes Emanuel, a transvestite hustler turning tricks at a local bar to keep his family afloat.

Brazil is the leading South American country for films with bisexual, gay, and lesbian characters and has produced its share of films with hustlers. In 1986's *Além da Paixao* (*Happily Ever After*) Fernanda is a happily married upper-middle-class mother of two in São Paolo, Brazil. One night she has a dream about dancing passionately with a blonde woman. The woman in the dream then becomes a black-haired man in drag. The next day, she literally runs into him on her way home from work. This man of her dreams is a female impersonator in a local club who supplements his income by working as a street hustler. Fernanda and Miguel begin a passionate affair, but she eventually tires of his dishonesty and returns to her family, sated and wiser.

Before the release of his smash hit, *Kiss of the Spider Woman*, Hector Babenco's best-known film was *Pixote* (1981). Pixote is the youngest of three boys who escape from a brutal youth detention center to return to their lives of petty crime in the streets. Two of the boys, Dito and Lilica, become lovers, but Lilica leaves when Dito falls for Sueli, an older female prostitute with whom they are working. Tragedy strikes as the bisexual Dito is shot while robbing one of Sueli's clients.

1992's *Die Blaue Stunde* (*The Blue Hour*) is a German film about a hustler named Theo who prefers sex with men, but falls in love with Marie, the older and somewhat outlandish Frenchwoman who lives next door.

Another German contribution to the international glut of bisexual hustler films is *Gossenkind* (*Street Kid*), made in 1991. Directed by well-known German actor, Peter Kern, it is the story of fourteen-year-old Axel, who sells himself at the train station in Dusseldorf. He is not quite old enough to be prosecuted by the authorities for his prostitution. The first thing one notices about Axel (Max Kellerman) is his fabulous hair, perhaps the finest ever to appear on a male in film. At the 1991 Amsterdam Gay and Lesbian Film Festival, Kern revealed that he interviewed more than 600 boys and their parents before finding just the right Axel, only three days before shooting was scheduled to begin.

Axel has a girlfriend, who is also a young prostitute, but the boy takes more than a professional interest in his male clients. One is a theater technician named Karl-Heinz who takes Axel away to the

country for a few days of sex and relaxation before the police begin to close in.

Smukke Dreng (*Pretty Boy*) is a 1993 Danish film set in Amsterdam. It tells the story of Nick, a thirteen-year-old runaway who turns to prostitution to survive in the big city. He has a short relationship with a bisexual man, but is soon out on the streets again. Nick's luck seems to be improving when he joins a gang of teenage prostitutes and becomes lovers with the girl who leads it. But the streets are hard and they claim another victim before the film mercifully comes to an end.

In one of the most unrelentingly morose French films ever made, innocent Henri falls in love with Jean, the hustler he has just witnessed beating and robbing a trick in the train station toilet. 1984's *L'Homme Blesse* (*The Wounded Man*) is not a film for the squeamish. Jean's pimp is a married cop who uses his position on the vice squad to give him the power and cover to pursue his illicit activities, which include burglary and child molestation. He tells Henri, "Some things you must do so you can regret them after." When Jean's girlfriend throws him out of the house, things begin to go downhill for both him and Henri. In the end, Henri escapes the situation by following the cop's advice.

A more recent French film in which the hustler is at center stage is *Je n'embrasse pas* (*I Don't Kiss*). Pierre leaves the safety of his small town to live in Paris. When his job as a dishwasher falls through, a friend introduces this ostensibly straight young man to the world of male prostitution. Pierre instead becomes the kept boy of a middle-aged woman, but the lure of easy money quickly changes his mind. Hardened by life on the streets, he tells clients, "I don't kiss, suck, or take it up the ass." He later becomes involved with a wealthy male television personality, however, before finally falling in love with a female prostitute.

Before Pedro Almodóvar burst on the scene, Spain's best-known gay director was Eloy De La Iglesia. In 1976, his *Los Placeros Ocultos* (*Hidden Pleasures*) was the first Spanish film with a gay theme. It is the story of a bank director who roams the streets of Madrid looking for male teenage prostitutes and falls in love with a straight seventeen-year-old boy from a poor family. The story deals

with their developing relationship and their age, class, and social differences.

Similar themes are explored in 1978's *El Diputado* (*The Deputy*). A married socialist politician in post-Franco Spain begins a relationship with a street hustler who is extortion bait set by the fascists who are trying to destroy the politician's career. The boy unexpectedly falls in love with the politician, whose wife suggests that they simply form a family together. The family then evolves into a love triad as the boy discovers his attraction to women. This film was a huge success in Spain and other Spanish-speaking countries, playing for a year in Peru and two years in Mexico.

The third entry by De La Iglesia is 1982's *Colegas* (*Pals*), which is the story of three male friends in Madrid. When Antonio learns that his sister is pregnant and the father is his friend José, the three friends decide to work as hustlers at a gay bathhouse to earn money for an abortion. Their careers are short-lived and they eventually turn to drug smuggling to raise the cash.

Like De La Iglesia, Lino Brocka was a gay filmmaker who frequently depicted the lives of hustlers. He began with his second film in 1970, *Tubog Sa Ginto* (*Goldplated*). which tells the story of a love affair between an older man and a street hustler. The film was condemned by the Catholic Church and was not well received in Brocka's native Philippines—the Marcos government banned Brocka from filming in the slums. Imelda Marcos insisted that he must make films that, "only reflect the good, the true, and the beautiful." He ignored the proscription and was frequently arrested as a result.

In 1975, Brocka filmed *Maynila: Sa Mga Kuko Ng Liwanag* (*Manila: In the Claws of Neon*). This story begins like so many in the Philippines, with a young boy moving from the country to the city of Manila to find his girlfriend who disappeared and was probably sold into prostitution. Deep in the city's slums, however, he finds that he must turn tricks as well, in order to support himself.

After the overthrow of Ferdinand Marcos, Brocka served with the Aquino government on the committee to draw up a new constitution. He worked hard to ensure that the new document would contain language protecting freedom of speech and expression. He then returned to the slums and began making films again. Brocka's best-known film, *Macho Dancer* (1988), returns to a familiar theme. Pol

is a young boy from a poor family living near an American military base. When his GI "boyfriend" is transferred back to the States, Pol's family no longer has enough money to live on. He goes to Manila and moves in with a boy named Noel who is there searching for his sister. Pol earns money as a "macho dancer," dancing with other boys in the sex clubs, and by having sex with businessmen. He and Noel become lovers, but when Pol is beaten up by the police and a prostitute named Bambi comes to his rescue, he falls in love with her.

1969's *Bara No Soretsu* (*Funeral Procession of the Roses*) is a Japanese film in which Eddie and Leda are two transvestites working in the Genet Bar. Leda is gay and dresses in the traditional kimono, while Eddie is bisexual and crossdresses in modern female clothing. In one of several references to the story of *Oedipus Rex*, one of the men that Eddie brings home from the bar turns out to be his father.

Bezness (1992), written and directed by Nouri Bouzid, is a Tunisian contribution to the list of bi hustler films. The story centers on Fred, a foreign photographer sent to the coastal resort of Sousse, Tunisia to document the "bezness"–young prostitutes who solicit foreign tourists. There he meets Roufa, a young man who sells his body to both male and female tourists from Europe. The film's main theme seems to be exploitation–of locals by Fred, Fred by thieves, women by men, tourists by the bezness, and vice versa. Bouzid's earlier *Man of Ashes* (1986) is Africa's best-known gay film.

The hustler is one of film's most universal gay images. The sample here includes films from more than ten countries. When films with strictly homosexual hustlers are included, the country count nearly doubles. The fact that many of these films are made by gay filmmakers would tend to discount the idea that this universality is based simply on a gay stereotype. Given that nearly all the hustlers are doing this work to avoid starvation, this may be simply an extension of the bisexual/gay victim syndrome.

Chapter 10

Bi Camp

The chief enemy of creativity is "good" taste.

— Pablo Picasso

The term "camp" refers to a special brand of humor, usually associated with a gay male sensibility. It is frequently characterized by a sort of reveling in excess or bad taste. Paul Roen, author of *High Camp*, says that camp "derives from a certain ironic discrepancy between results and intentions." Camp is one of those things that is simply difficult to define. It has to be experienced. As Supreme Court Justice Stewart Potter once said about pornography, "I know it when I see it."

Though some gay directors have deliberately set out to create camp films, many more from the straight world have done so inadvertently. This is often the result of poor acting, directing, sets, costumes, or writing. In other cases the story simply ages badly and becomes laughable despite its original intent.

This is not to say that all bad films are camp. Of the hundreds of terrible films produced each year, only a few will achieve that lofty status. Nor is it true that all camp films become cult favorites. Many camp classics have gathered a cult following, but the two are different concepts and one neither implies nor excludes the other.

The cult film that practically defines the genre is one that targeted a camp audience from the start. Released more than twenty years ago, *The Rocky Horror Picture Show* still plays to midnight audiences across the United States and around the world. Tim Curry stars as the Sweet Transvestite from the planet Transsexual in the galaxy of Transylvania. Dolled up in leather and fishnets, the bi-

sexual Frank N Furter is a mad scientist who is building himself "a man with blond hair and a tan." Every head toss, nostril flare, and arched eyebrow is a tribute to the legendary camp screen actresses who preceded him. The fun begins when an ordinary, straight couple, Brad and Janet, find themselves stranded at Dr. Furter's castle. Furter manages to seduce them both before the night is over. The memorable music was written by Richard O'Brien who plays the butler, Riff-Raff.

When one thinks of John Waters films, it is easier to ask which of them are *not* camp. *The Village Voice* once called Waters, "the visionary of camp and the den mother of the bizarre." William S. Burroughs dubbed him the "Pope of Trash." Who else but John Waters would cast Patty Hearst as a juror in a murder trial, feature a transsexual as a suburban housewife, or stage a song and dance number in a men's prison? Waters says that his lifelong quest is to satirize the "strange behavior of white people in Baltimore."

Waters' film *Pink Flamingos* (1972) is somewhat unique in that the bisexual sociopath is a sympathetic character. Glenn Milstead's Divine is "the filthiest person alive," a title that she strives to maintain at all cost. She is a self-described lesbian who nevertheless enjoys sex with her son. People go to see this movie as much for its grossness as for its social commentary. It features cannibalism, strange sex involving a chicken, and a man who sings through his anus. Just when you think the film cannot get any more perverse, Divine is seen following a small dog. When it defecates, she reaches down, picks up the turd, and eats it.

Desperate Living (1977) features another bisexual character, Muffy St. Jacques (Liz Renay), who is on the run after killing a baby-sitter who locked her child in the refrigerator. She escapes to Mortville with her lover, Mole McHenry (Susan Lowe), a professional wrestler who describes herself as a man trapped in a woman's body. The camp quality of this film derives mainly from the performance of Edith Massey as Queen Carlotta. With her bevy of leatherboy bodyguards and her legendarily bizarre delivery of lines, she plays the role of Mortville's resident despot with delightful depravity.

Waters once called *Faster Pussycat! Kill! Kill!* (1965) his favorite film. Its director, Russ Meyer was the reigning king of the sexploitation film in the 1960s. This is perhaps his masterpiece. *Pussy-*

cat is a black and white film featuring a trio of deadly go-go dancers–a straight woman, a lesbian, and a bisexual woman. They drive their sports cars out to the desert to unwind and end up killing a man who makes the mistake of racing them. They kidnap his girlfriend and proceed to a secluded farm occupied by an old man and his two gorgeous sons. A pushing match between the lesbian's Porsche and Vegetable, the muscle-bound son, is especially memorable.

Meyers' first big-budget film was the truly bizarre *Beyond the Valley of the Dolls* (1970). Twentieth-Century Fox hired film critic Roger Ebert to write the screenplay, which was meant to be a sequel to *Valley of the Dolls,* based on Jacqueline Susann's hit novel. The script turned out to be nothing of the sort. Besides sex, drugs, and rock-n-roll, it featured a psychotic bisexual hermaphrodite. The classic 1960s music is provided by the Strawberry Alarm Clock. Gene Siskel gave the film a thumbs down.

Certainly much of what we consider camp humor today traces its roots to the work of bisexual writer Oscar Wilde. One of the earliest camp films is based on Wilde's play, *Salomé.* Described in an earlier chapter, the film *Salome* indulged itself in art deco scenery and fantastic costumes. Forty-four-year-old Alla Nazimova starred in the title role, with fanciful head gear and an unusually exaggerated acting style.

Nazimova's was not the first *Salome* and it has been remade several times since, often with campy results. Only the most recent remake, *Salome's Last Dance* (1987) has bisexual content, however. Ken Russell's version takes place in a brothel, where the workers are performing Wilde's banned play as a surprise for their favorite customer.

In the film, Wilde is cheerfully entertained by his young lover, Bosie, but also professes to love his wife and family. Imogen Millais-Scott appears as the petulant Salome, performing the famous Dance of the Seven Veils. "Bring me the head of John the Baptist!" is her favorite and most memorable line. At the end of the play, the police burst in and Wilde is arrested for corrupting the morals of a minor. He protests, "We've had one melodramatic ending tonight. Two might be an indulgence."

Directing camp films is nothing new for Ken Russell. His stylized biography of Peter Ilyich Tchaikovsky is deliciously overacted. *The*

Music Lovers (1971) features Richard Chamberlain as Tchaikovsky, with Christopher Gable as his lover and Glenda Jackson as his wife. The marriage is a disaster and the implication is that the only woman Tchaikovsky ever loved was his mother. The film opens with the composer and his lover rolling about in a blood-red bed. Other favorite scenes include a humorously phallic dream sequence backed by the *1812 Overture*. Jackson is involved with bisexual characters in numerous other films, including three more directed by Russell.

In 1988, Russell moved away from campy period pieces to produce a campy horror film–*Lair of the White Worm*. Amanda Donohoe stars as a vampirish snakewoman. The story is a loose rendition of Bram Stoker's final novel, written as he was slowly losing his sanity due to Bright's disease. In the movie, a Scottish archaeology student discovers the skull of an unknown creature in the front yard of a bed-and-breakfast. Digging further, he unearths a Roman temple that was dedicated to some sort of snake god. Coincidentally, the parents of the bed and breakfast owners had disappeared mysteriously the previous year.

While the young people are searching for clues (and finding them with incredible ease), their neighbor, Lady Sylvia (Donohoe) is collecting male and female virgins as human sacrifices for the snake god. She is fond of alluring clothing (or none at all) and easily seduces her prey. She bites them, injecting a venom that paralyzes her victims instantly. Her favorite sex toy is a strap-on dildo with the head of a snake. The film has some good special effects, but the "worm" is green, not white.

The avante garde team of Andy Warhol and Paul Morrissey combined to produce several camp films with bisexual characters. Many of the early ones consisted simply of Warhol turning on the camera and having actors do whatever they wanted, including sexual acts.

Of their scripted films, *My Hustler* (1965) showed both men and women lusting after a hustler of unknown sexuality. However, *Lonesome Cowboys* (1967) was the first to explicitly include bisexuality. This gay spoof on the western film genre features a band of fey cowboys, with Viva as the Beauty of the West, Taylor Mead as her nurse, and Frances Francine as the transvestite sheriff. One cowboy does his ballet exercises at the hitching post because, "it builds up the buns"–the better to hold up his holster. Others taunt a

fellow cowpoke for applying his mascara incorrectly. The film was seized at a screening in Atlanta, where the court solicitor's assistant called it, "just the type of thing that, in my opinion, would make the ordinary person sick."

From 1968 through 1972, Morrissey directed Joe Dallesandro in three films which have come to be known as The Flesh Trilogy. *Flesh* and *Trash*–with their static camera work, marginal dialog, and transvestites in female roles–are described in the chapter called "Do the Hustle." Transvestite Holly Woodlawn is wonderfully convincing both in the scene when she masturbates with a Miller High Life bottle and when she refuses to give up a pair of fabulous silver platform shoes to her social worker in return for welfare money.

Morrissey claims that the third film, *Heat* was originally based on *The Blue Angel*, but eventually evolved into a reworking of *Sunset Boulevard*. Dallesandro plays a former child star who is attempting to make his big comeback. As with the rest of the trilogy, polymorphous perversity and ludicrous acting are rampant. Joe is sleeping with former actress Sally, her "lesbian" daughter Jessie, the landlady, and other men. When Jessie becomes pregnant and delivers a baby, it is played by Dallesandro's real-life child. She sedates the baby and carries it around in a shopping bag so she can go out with Sally and Joey.

Bisexual German director Rainer Werner Fassbinder directed films at a frantic pace during his short career. The first of four in 1972 was *The Bitter Tears of Petra von Kant,* a parody of Frank Capra's *The Bitter Tea of General Yen*. Petra is a fashion designer and veteran of two marriages. At the time of the film, she is involved in relationships with two women. The first is her slave-like secretary, Marlene, who worships Petra but whose love Petra abuses. The second woman in Petra's life is Karin, a working-class woman with whom she falls hopelessly in love. Karin, whose husband has left for Australia, moves in with Petra and becomes her lover. Petra's normal self-sufficient exterior begins to crumble as she becomes increasingly subservient to Karin, waiting on her and using her influence to advance Karin's career as a model. All the while, Karin is still having relationships with men she picks up, making Petra extremely jealous.

When Karin's husband returns, she does not hesitate to leave Petra to rejoin him. Petra becomes inconsolable, then turns to Mar-

lene, offering her a completely equal and free relationship. Marlene, who has not uttered a word throughout the film, now makes the film's strongest statement, packing her bag and leaving in total silence. Molly Haskell of *The Village Voice* called the film, "a tragic love story disguised as a lesbian slumber party in high camp drag."

Fassbinder's final film was *Querelle* (1983). With its blatantly artificial lighting, sets, and acting, this adaptation of Jean Genet's novel is bizarre, to say the least. Brad Davis plays the title character, not as a realistic sailor, but more as a gay fantasy from a 1950s physique film. From the scantily clad sailors to the phallic mooring posts on the dock to the brutally attractive Nono, the film oozes homoeroticism.

Toward the end of the film, Querelle falls in love with a murderer who resembles his brother (they are played by the same actor). He helps the man commit a robbery and pin the crime on his brother. Jeanne Moreau reprises the film's dual theme of narcissism and betrayal with the words of Oscar Wilde, "Each man kills the thing he loves." She has been lovers with both Querelle and his brother.

Unquestionably one of the most camp Hollywood films of its era, *Myra Breckenridge* (1970) was based on a best-selling novel by Gore Vidal. This is the story of a gay man named Myron (played by film critic, Rex Reed) who has his sex changed and becomes Myra (Raquel Welch). Scenes which elevate this film to everlasting camp status include Welch using a dildo to rape a muscular young stud, Reed masturbating as he fantasizes about hot dogs and whipped cream, Mae West singing "You've Gotta Taste All the Fruit," and West again, giving her an assessment of a young Tom Selleck. *Life* magazine proclaimed the film to be representative of all that is wrong with America.

Among the most wonderfully camp Japanese films is *Black Lizard* (1968). Much of its bizarre flavor can be attributed to bisexual writer Yukio Mishima, from whose play this film was adapted. The title role is played by transvestite actor Akihiro Maruyama, who originated the role on stage. In the tradition of the Japanese Noh plays, the actor's gender is never acknowledged, nor is it part of the character's persona.

The Black Lizard is a master thief and collector of fine things. She is easily recognized by the tattoo of a black lizard on her arm.

Her aim is to acquire a legendary diamond by kidnapping the daughter of its owner. This she manages to do twice, but both times she is tracked down by the man who is Japan's most famous detective. The weakness in her otherwise flawless scheme stems from her dual attractions. The Black Lizard is attracted to both the daughter and the detective. Among the artifacts in the Black Lizard's private museum of beautiful things are people whom she has kidnapped, murdered, and stuffed in order to preserve them in a youthful state. One of these is played by Mishima himself–a man with an obsessive fear of growing old. His preserved body is displayed in the arms of another man.

Originally advertised with the catch line, "It's not a musical," *Boys in the Band* (1970) is a classic of camp gay film. The story is set at a Manhattan birthday party attended by a group of heavily stereotyped pre-Stonewall gay men. As the evening wears on, the barbs become more pointed and the self-analysis more woeful. Many of the lines are hilarious, others simply memorable. Laurence Luckinbill plays the bisexual half of a bickering couple. The film is now very dated, but is still a must-see.

A great film presence from the 1950s through the early 1970s, Elizabeth Taylor nonetheless also starred in some real stinkers. One of the worst was a film called *X, Y, and Zee* (1971). The hilariously dated clothing and hairstyles only add to the marginal dialogue and absurd plot development. Taylor is married to Michael Caine, who is involved with Susannah York. The film attempts to be another *Who's Afraid of Virginia Woolf?*, with three participants rather than four. The anger, love, and mind games are all there, but the writing is not Edward Albee by a long shot.

Unable to terminate the Caine/York affair any other way, Taylor discovers York's bisexuality and sets out to seduce her. Taylor's look of utter triumph when Caine walks in on them at the end of the film is worth the price of admission.

Desperate Remedies (1993) is an old-fashioned "bodice-ripper" with a twist–it is the heroine who gets the girl. Filmed in Auckland, New Zealand, this film is a curious and campy mix of period sets, anachronisms, and quirky camera angles. The list of relationships grows quickly out of control, so the viewer must pay attention. Dorothea is Anne's lover. Nevertheless, she marries William, a

schemer who is about to lose his fortune. Dorothea hires a sailor named Lawrence to marry her pregnant sister and give the child a father. She pays Fraser (the biological father) to leave on a boat for San Francisco. Fraser and Dorothea apparently have a romantic liaison in their past as well. Ever the charmer, Fraser flirts shamelessly when Lawrence comes to make sure that he leaves town. Lawrence is desperately in love with Dorothea who, though she is clearly attracted to him, saves herself for Anne. In the end, the two women walk happily into the sunset. English publication *Time Out* declared that the film, "dares to be bad and succeeds quite splendidly."

Italian filmmaker Federico Fellini made a number of films which could be considered camp, but none more so than *Fellini Satyricon* (1969). If this film were to be made in Hollywood today, it would be called *Encolpio and Ascilto's Totally Bizarre Adventure*. Petronius' *Satyricon* is the jumping-off point for this film, which is stuffed with excesses of every kind. *Satyricon* is about a young man named Encolpio, his friend and rival Ascilto, and their travels in the Roman Empire during the time of Nero.

The fact that both of its heroes are bisexual was considered just one of the film's many depravities at the time of its release. The script seems like one disjointed scene after another, held together by only the most tenuous of plot threads and designed mainly to shock the audience by pushing the limits of decadence. In one scene, the two young men fight over an epicene slave boy whom they both desire. In another, they help to kidnap a hermaphrodite who is allegedly able to perform miraculous cures. In a third, Encolpio is wed to a pirate who has captured and enslaved them.

Falling squarely into the category of unintentionally camp is a 1967 film called *The Girl with the Hungry Eyes*. Made by obviously misogynistic men, this film features a stereotypical butch, man-hating lesbian called Tigercat and her femme bisexual girlfriend, Kitty. The two are first seen traveling the roads of California in a souped-up Corvette, looking like a reprise of Russ Meyer's *Faster Pussycat*. Kitty clearly wants out of the relationship, but whenever she casts her eye on a man, Tigercat kills him. She finally makes her escape when another butch puts the moves on her and Tigercat engages the intruder in a "cat fight."

Joe Sarno was another well-known sexploitation filmmaker in the 1960s. Many of his films featured bisexual characters in order to heighten the sense of depravity. Some of the films also appear to be quite campy because of their over-the-top plots, acting, and dialog.

A good example is his 1964 film, *Sin in the Suburbs*. Louis Muse is coded as a gay character, but sleeps with his "sister," Yvette. They recruit bored suburban housewives and their lovers to organize a sex club, featuring live shows and anonymous partner swapping. Kathy, the daughter of one of the women, breaks up with her boyfriend and runs to Yvette for comfort. They quickly become lovers. When Yvette brings her to the sex club, Kathy sees her mother on stage about to have sex with a man who is not Kathy's father. She vows to leave her family and Yvette to make her own way in the world.

Sometimes Aunt Martha Does Dreadful Things (1971) features a kinky relationship between a sadistic drag queen and his equally bizarre bisexual boyfriend. Hiding out in Miami after killing a wealthy older woman, Paul takes on the identity of Aunt Martha. When lover Stanley starts seeing "loose" women, Martha becomes extremely possessive. Stanley is quite passive during the seduction scenes, but becomes psychotic when the sex begins. The opening shots of Baltimore and the "birthing" scene are reminiscent of John Waters films from the same era.

Camp scenes appear in many of gay Spanish director Pedro Almodóvar's films. *Law of Desire* is Almodóvar's semiautobiographical melodrama about the loves and losses of a self-indulgent gay film director named Pablo. From the very beginning—a kinky sex scene that turns out to be the ending for a movie he is about to release—this film is full of surprises.

Antonio (Antonio Banderas) has become obsessed with Pablo and picks him up in a bar after stalking him for days. When Pablo suggests they go home together, Antonio says, "I don't normally sleep with guys." Whether or not this statement is true, he does sleep with Pablo. Later in the film he also sleeps with Pablo's sister.

The sister, Tina, is played by the marvelous Carmen Maura, star of *Women on the Verge of a Nervous Breakdown* (1988). Tina began life as Pablo's brother, but is now an attractive woman, thanks to the miracle of modern medicine. When she was a boy, she and her

father became lovers and ran away to Morocco. There she had the sex change operation, after which they continued to be lovers. As the film begins, she has sworn off men and prefers women. At least until she is seduced by Antonio.

The plot revolves around a murder and the mistaken attempt by the police to pin it on someone with amnesia who is unable to defend himself. *Law of Desire* is probably the only film on record where a murderer successfully bargains for one more hour of freedom and spends it having sex with another man.

Clearly targeted for camp status from the start, *The Adventures of Priscilla, Queen of the Desert* (1994) is a delightful musical drag comedy from Australia. It is about the adventure of three drag entertainers—a gay man, a bisexual man, and a male-to-female transsexual—who cross the desert in a bus on their way to a gig in a hotel managed by the bisexual's ex-wife. The trio lip-syncs their way through some of the best music of the previous two decades, both onstage and in the wilderness. The costumes are just . . . well . . . fabulous. Instances of gratuitous sexism mar an otherwise excellent film, but it is nonetheless well worth seeing.

Chapter 11

The Butt of the Joke

Men show their character in nothing more clearly than what they think laughable.

— Johann Wolfgang von Goethe

Humor relating to bisexuality appears in several films, not all of them strictly comedies. Some of it consists of jokes or situations that any bisexual or bi-supportive person might find amusing. In other cases, it is simply a reflection of the mean-spirited homophobia or biphobia of the moviemakers involved.

A fine example of bi situational humor is found in Paul Bartel's demo short, *Naughty Nurse* (1969). A man and a woman are having rather kinky sex in a cheap hotel room when they hear a knock at the door. A sadistic cop walks in and threatens to arrest them for being so sick and perverted. Instead, the pair undress him and pull him into their lovemaking. The joke is sprung in the next scene when we see the three standing at an operating table. One of the doctors is telling the nurse that she was very good. So good, in fact, that *she* can be the cop next time.

Bartel's *Scenes from the Class Struggle in Beverly Hills* (1989) is based on a French sex farce. One scene involves two servants making a wager over which will be the first to seduce the other's female employer. If Juan wins the bet, he will be forgiven a monetary debt. If he loses, he must have sex with Frank. Juan at first protests, saying that he could never make it with a man. Frank replies, "Psychologists say you can break old patterns by doing something new . . . twenty-one days in a row."

May Fools (1990) is an actual French farce directed by Louis Malle. After the death of the matriarch, an entire extended family is trapped at Mom's country estate during a general strike. This group of people with differing motives and values makes for some interesting, but subtle, humor. Young Françoise receives quite an education during the weekend, despite the refusal of adults to answer her questions: "What is sperm? . . . What is the pill? . . . What is a dyke?" and "Why does Claire tie up her friend at night?" (The friend in question is Claire's bisexual lover Marie-Laure.)

Another French comedy of note is by one of Europe's most underrated directors, Nelly Kaplan. *La Fiancée du Pirate* (*A Very Curious Girl*) is a 1969 film about a young Gypsy woman named Marie who is fed up with the way she has been treated by the people in her village. She decides to get her revenge by charging for sex. Since she is the most beautiful woman in town and the only one in the trade, her business thrives. Former employer Irene and most of the men become her clients. Soon she is bringing economic ruin on the villagers who once tormented her. They plot against her, but Marie is much too clever and easily turns aside their attacks. She strikes a final blow in the village church, then dances off down the country lane. Louis Malle plays a cameo role as a farmhand named Jesus. This film was the official French entry at the 1969 Venice Film Festival.

Jeff Goldblum plays the bisexual protagonist named Bruce in the comedy *Beyond Therapy* (1986). Every major character is either a psychiatrist or a client. The twist is that the psychiatrists are the ones most desperately in need of help. Goldblum meets a woman through a personal ad, but discovers that she has always been afraid of gay and bisexual men. She likes him, however, and decides that she would rather be with him than continue to have sex with her therapist. The therapist is outraged that she could believe a bisexual man to be a better lover than he is. His diagnosis of her "problem" is that she is a "fag hag." He dismisses his own premature ejaculation problem by stating that anyone who thinks sex should last a long time is just plain sick. Publicity photos for the film alternately describe Bruce as "confused" or "bi-sexual" [sic].

California Suite (1978) is a star-studded piece of comedy written by Neil Simon. Michael Caine plays the part of Sydney, whom the

actor has variously described as bisexual or homosexual. Indeed, Sydney's sexual identity will vary according to one's interpretation of bisexuality. Certainly he and wife Diana began with little more than a contractual marriage. They rarely, if ever, have sex. Over the years, however, they have grown to truly love and depend on each other. Sydney highlights this ambiguity with the statement, "I love you, Diana, more than any woman I've ever known." Their sharp-tongued dialogue contains some of the best humor in the film.

Christopher Isherwood's autobiographical character from *The Berlin Stories* has undergone many transformations on its way to becoming the Brian of *Cabaret*. Though most of the action takes place at the Kit Kat Klub, where Joel Grey stars as the androgynous Master of Ceremonies, a major subplot centers on Brian, his relationship with Sally, and their friendship with Baron Maximillian. When the Baron leaves the country without warning, Brian seems relieved to see him go. "Screw him," he says. "I do," reveals Sally. Brian stops her cold by responding, "So do I." Cabaret received eight Academy Awards in 1972.

German director Monika Treut often includes bisexual and trans-gendered characters in her films. *My Father Is Coming* (1990) contains several. The protagonist, Vicky, is in a panic because she has convinced her conservative Bavarian father that she is a successful actress and is married (neither of which is true) in order to avoid him demanding that she return to Germany. She asks her gay roommate, Ben, to pretend to be her husband, saying, "Look butch, OK?" Ben finds that this seriously cramps his lifestyle. He winds up sneaking out to the bars at night. The father observes Ben going out and assumes that there is trouble in the marriage. He also cannot imagine why a man would allow his wife to be such a terrible housekeeper.

When Vicky auditions with Annie Sprinkle for a film role, she fails miserably. However, she meets a female-to-male transsexual who becomes her lover. She then becomes lovers with one of her female coworkers at the restaurant. Meanwhile, her father has become involved with Annie. Having a bisexual lover himself profoundly alters his views on the subject.

As with most any film in which she appeared, Ruth Gordon is really the show in *Where's Poppa* (1970). In this case, she plays a senile old lady living with her unmarried son in Manhattan. Her

married son lives on the opposite side of Central Park and is frequently summoned to help with the cranky matriarch. He always cuts through the park to save time and is always mugged. The last time, he is attacked by a gang whose members force him to commit a rape. The would-be victim turns out to be a male cop in drag who is part of an undercover operation, and the son is arrested. Rather than being angry or disgusted, however, the cop sends him flowers and asks him out on a date. The son is truly touched and considers beginning a relationship with him.

Steve Martin's *L.A. Story* (1991) contains a cheap sight gag in which two ostensibly heterosexual couples in adjacent hotel rooms are about to engage in sex. In sequence, each of the four people form thought bubbles showing them thinking about one of the partners in the next room. The last bubble is the second male's, fantasizing about the same man his partner is. The sequence is played strictly for laughs and gets them in most theaters.

Another visual joke occurs in *To Wong Foo, Thanks for Everything, Julie Newmar* (1995). Early in the film, Sheriff Dollard is knocked unconscious by a drag queen he has mistaken for a woman and sexually assaulted. During his attempt to track down "the homos," we discover that the source of his homophobia is a deeply repressed attraction to men. This becomes clear in a bar scene in which the sheriff, seething with anger at gays, begins to excite himself with his own description of men touching each other, much to the confusion of the other patrons.

The essence of humor is found in springing the unexpected. In this society—raised on the heterosexual/homosexual dichotomy—it is bisexuality which is unexpected. As such, it becomes an easy subject for humor, regardless of whether the intent is injurious or benign.

Chapter 12

Oil and Water?

On ne peut ici-bas contenter qu'un seul maître!

– from *Femmes Damnées*,
Charles Baudelaire

Before the advent of Identity Politics, people we now identify as gay, lesbian, bisexual, transsexual, drag queen, transvestite, leather, S/M, etc., were all simply known to the outside world as "queer." Hatred and ignorance were, in a sense, the great equalizers. Women and anyone who acted in some way woman-like were second-class citizens and not deserving of respect or equal rights. Despite years of slow and unsteady progress, these attitudes are still held by a large and powerful minority of the population in the United States.

The rise of the gay liberation and feminist movements brought the ability to organize and fight oppression. But with it also came a fracturing into separate identity groups with overlapping objectives, but uneasy communication. Curiously, one of the biggest divisions, and one of the slowest to heal, is that between lesbian and bisexual women. The reasons for this are complex and far beyond the scope of this book. However, lesbian-identified researcher Paula Rust has written an excellent book, *Bisexuality and the Challenge to Lesbian Politics* detailing the results of her research into the subject.

LESBIANS AND BISEXUALS TOGETHER ON FILM

The uneasy relationship between lesbian and bisexual women is evident in a number of films produced in the last several years.

113

The Fox (1967) is about a bisexual woman named Ellen and her lesbian lover Jill who live on a farm in Canada. They live and work quite happily together until a drifter shows up and seduces Ellen–the "fox" who raids the hen house. What confused critics most about this film was that the more butch partner of the female couple (Anne Heywood) was the bisexual, while the lesbian (Sandy Dennis) wore dresses. Typical for its time, the movie treats lesbianism as a "problem" that can be cured by the right man. Ellen is the one who is cured, while Jill is killed by a misogynistically symbolic tree falling between her legs.

Personal Best (1982) is the classic example that people love to hate. The film begins with the 1976 Olympic trials in Eugene, Oregon. Runner Chris Cahill (Mariel Hemingway) does poorly, while Tory Skinner (Patrice Donnelly) performs brilliantly in the pentathlon. The two meet later that evening. Tory takes Chris home, they arm wrestle, belch, fart, smoke dope, tell stupid jokes and make love. Once they begin training under the same coach, they move in together.

Both the relationship and the film go quickly downhill from there. Having introduced the two women as lovers, director Robert Towne seems to be unable to explore the effect this high level of competition has on the physical and emotional relationship between them. In the end, Chris leaves her lesbian lover for a spectacularly dull male swimmer.

The Bostonians (1984) is another shining example of the "you can't trust bi women 'cause they'll leave you for a man" subgenre. Vanessa Redgrave plays the role of lesbian suffragist Olive Chancellor, for which she received an Academy Award. The story centers on young Verena (Madeleine Potter), a gifted young orator in Boston's budding Women's Movement. Olive falls in love with Verena and her talents. Verena moves in with her, promising never to marry. Olive arranges for her to speak on behalf of the movement at every opportunity because Verena has the gift for enchanting audiences, which Olive lacks.

Olive's distant cousin, Basil (Christopher Reeve) meets Verena and begins to steal her heart away. He is a perfect gentleman, chivalrous, sexist, and obstinate, and works as a lawyer in New York. Basil believes that the women's movement must be stopped, and

writes reactionary pieces for magazines saying so. Basil tells Verena things like, "You should give yourself to me." He says that she should be his private love rather than a public figure. The more Basil tells her what she should do, the more she loves him. It is enough to make you hurl your popcorn.

In the end, the bisexual Verena kisses off Olive and the movement. She runs away with Basil to get married rather than speak to her biggest audience ever. A dedicated suffragist, Olive overcomes her fear of public speaking and takes her place to carry on the fight. When author Henry James' story first appeared in *Century Magazine* in 1885, editor Richard Watson Gilder described *The Bostonians* as the most unpopular piece he had ever published.

Oranges Are Not the Only Fruit (1989) is an English made-for-TV movie based on a novel by Jeanette Winterson. Jess is a teenage girl whose mother is extremely religious and is constantly harping on her to lead a chaste and conventional life. Jess has other ideas, however, and falls in love with Melanie. When Melanie moves away, Jess falls for her neighbor, Katie. Jess' mother has her thrown out of their religious congregation, saying that due to her "unnatural passions" she cannot be saved. Melanie returns with a boyfriend and announces her engagement. Ian, the boyfriend, notices that Jess is upset and condescendingly tells her not to worry, and says, "Melanie has told me everything and I forgive you." Jess spits on them and never speaks to Melanie again.

Three of Hearts (1993) opens with Ellen moving out after telling Connie that she "needs a little space." The rest of the film is pretty unrealistic. Connie (the lesbian) decides that she can get Ellen (the bisexual) back by hiring Joe (a hustler) to seduce Ellen and then cruelly dump her. This will prove that all men are evil and of course Ellen will come running back to her. Or at least that is what Hollywood thinks. There is little evidence to make one think that the writer or director have had much contact with lesbian or bisexual women.

The one saving grace in this film is the bisexual character. She gives a spirited defense of her sexual orientation to her clueless suburban sister. Also, she does not fall for the dubious charms of Connie or Joe, each of whom claim that they can seduce "any woman, anywhere, any time." The script is a rip-off of the 1980 lesbophobic picture *Windows* (not a product of Microsoft), in which

a lesbian arranges to have the heterosexual woman she desires raped, so that she will come to her for comfort.

Rose Troche's *Go Fish* (1993) is a refreshing inside look at lesbian life in the 1990s. It blends a sharp wit and a clever mix of characters to challenge lesbian stereotypes both within and outside the community. The story revolves around Max (Guinevere Turner), who has not gotten laid in ten months, and Ely, who continually invokes the memory of her ex-lover, now hundreds of miles away, to avoid having to deal with new relationships. Over time, however, love grows.

The one woman who *is* getting plenty of sex is Ely's roommate, Daria (Anastasia Sharp). Each time she gets together with Kia and Max, she has a new girlfriend. It is when she sleeps with a man, however, that things get dicey. She imagines that a lesbian court is assembled and that she is being prosecuted for her "evil deed." Daria tells the jury that of course she is still a lesbian, saying, "I have more sex with women than all of you combined." Nonetheless, many of the women insist that she is no longer a lesbian sister and vow never to sleep with her. What is particularly challenging about this scene is its juxtaposition with one in which Kia's lover is thrown out of her heterosexual family for sleeping with a woman.

Lesbians Who Date Men, also released in 1993, is a short film that takes another humorous look at lesbian/bisexual relationships. One running joke throughout the film is the cancellation of a woman's lesbian card when she sleeps with a man and its restoration when she returns to relationships with women.

Can't You Take a Joke? (1989) is an short Australian spoof on film noir. The premise is that Amanda Drax, a cartoonist whose main character is a female detective, helps a young woman named Jenny find her lost sense of humor. Jenny had misplaced this important item the previous night when her boyfriend left her for a transvestite. Amanda reveals that her lover left her for a man. This lover was their cartoon strip writer, who had persuaded Amanda to change her detective from a butch lesbian to a bisexual. Amanda falls in love at first sight with Jenny. Meaningful looks pass between them, teasing the viewer throughout the film, before they finally get down to some serious kissing . . . but only after the sense of humor has been recovered.

Loretta is another lesbian cartoonist who falls for a bisexual woman in *Bar Girls* (1994). This film has been frequently compared by reviewers with *Go Fish* and found wanting. Most of the action takes place at the *Girl Bar* and in Loretta's apartment. Loretta is a writer for a cable TV cartoon series. She falls for Rachel (Lisa D'Agostino), who is in the process of divorcing her husband. What exists of the plot revolves around their monogamy issues. The relationship unravels when Loretta overreacts to a female police cadet flirting with Rachel at the bar. Look for a cameo by Chastity Bono, who is named after a bisexual film character created by Sonny and played by Cher in the late 1960s.

From New Zealand comes another short film called *Peach* (1993). In it, a Maori woman is married to a ratty, unredeemably sexist man with whom she has a baby. He invites several of his fellow tow truck operators over for drinks. One is a beautiful butch woman his wife had noticed in town earlier that day. At the party, the wife and the object of her desire get together in a sensuous scene involving a peach. They are about to kiss when the baby begins crying. When the wife returns, she catches her husband trying to corner the other woman in the kitchen. When the woman decides to leave the party, the wife holds out the peach to her. The woman tells her, "Watch it rot, or taste it while it's ripe," indicating that the wife must make up her mind to "taste the fruit" before they can go any further. The woman then walks out the door, fires up her truck, and hits the road.

In *Claire of the Moon* (1992), Claire Jabrowski and Dr. Noel Benedict are assigned to the same cabin at a women writers' retreat. From the instant they meet, they get on each other's nerves. Noel is a lesbian who is currently celibate and recovering from an infatuation with a patient who left her to marry. She begins writing each day at 5 AM, cannot work with any noise in the cabin, and is obsessive about things being clean and in their place. Claire, on the other hand, gets up late, likes to party late with guys she picks up in town, plays loud music, smokes compulsively, and leaves her cigarette butts in the sink. Claire has no faith in psychiatry and continually calls Noel "shrink." Noel annoys her by saying, "Men and women cannot achieve true intimacy."

Surrounded by "dangerously bizarre women," Noel and Claire gradually become closer, but continue sparring throughout. When

challenged on her "promiscuity," Claire says, "I'm into whatever feels good at the moment." Noel later tells her, "I never get involved with women who straddle both sides of the fence." Nearly one hundred minutes into the film she finally does, though, as Claire and Noel end up where you knew they would all along.

Patricia Rozema's *When Night is Falling* (1995) is similar in theme, but a much better movie. Camille is a professor of mythology at a Protestant college who has lost the struggle to keep her vow of chastity until marriage. Her lover, Martin, works at the same school. While doing laundry and mourning the death of her dog, Camille meets Petra, a free spirit who works in the circus. The attraction between the women is immediate and Petra's little subterfuge enables them to meet again to explore it. Despite a long struggle with Camille's heterocentric religious upbringing, Petra stays the course and the two eventually become lovers. The film is beautifully photographed and edited. Many of the scenes are laden with erotic and religious imagery. One of the refreshing things about this film is that the religious characters, though homophobic, are not caricatured. They simply are what they are. This film is highly recommended.

Quest for Love (1988) was South Africa's first feature film directed by a woman—Helena Nogueira. Set in a fictional country at the end of apartheid, this political thriller is based on Gertrude Stein's novel, *Q.E.D.* Alexandra is a bisexual writer and political activist who is seeing two men when Dorothy falls in love with her. The two women sail away on a yacht with Mabel, who is in love with Dorothy. Once the shifting sentiments are sorted out, it is Alexandra and Dorothy who end up together. The movie was a breakthrough, not only in bringing lesbian and bisexual women to the South African screen, but for its forthright depiction of the government's torture and murder campaigns against the black majority.

Michal Bat-Adam directs and stars in an Israeli film called *Each Other* (1979). In this erotic love story, she plays Yola, an Israeli writer who meets a vacationing French photographer named Anna on a train. The two become friends and eventually lovers, threatening Yola's marriage.

The 1993 film *Erotique* is composed of half-hour erotic fantasies directed by three women. The second segment, *Taboo Parlor*, is by

German director Monika Treut. It opens with a lesbian business-woman named Claire in bed with her bisexual lover, Julia. When Julia suggests that she is in the mood for something that she has not done in a while, Claire just rolls her eyes. Claire is an adventure-some woman, however, and will do almost anything to keep her young lover happy.

The two discuss what type of man to pick up and decide on a handsome, American criminal. They set off for a shipboard club called the Taboo Parlor and find just the man they are seeking (this *is* a fantasy, after all). The three ride the bus back to Claire's apart-ment, setting off a minor orgy enroute. When Claire discovers that the man is packing a knife during sex, she has an even bigger surprise for him. Look for a cameo by the delightful Marianne Sagebrecht as the club's dance mistress who must be obeyed.

In films involving lesbian and bisexual women, the animosity of the 1980s has softened in the 1990s. Films such as *Go Fish* and *Lesbians Who Date Men* even manage to have a sense of humor about the tensions and cultural differences. This trend reflects what is happening in the real world as well. The very real threat of the Religious Right has caused, to an extent, the transgender, bisexual, lesbian, and gay communities to put aside their differences in a fight for survival.

Chapter 13

In Their Own Image

Love doesn't have a sex.

−Agnes Moorehead

As mentioned earlier, it has traditionally been very difficult for lesbians, gays, and bisexuals in the film industry to be open about their sexuality. In the past, there have been particularly heavy penalties to pay for that admission. Even now, many are reluctant to jeopardize their incomes by telling the truth. Therefore, the "true" sexuality of many people we now think of as bisexual was only discovered posthumously.

In other cases, it is difficult to assign a sexuality with certainty because of marriages of convenience, publicity ploys, and other deceptions. Furthermore, some people's sexual orientation changes over time. Others may be behaviorally bisexual, but self-identify as heterosexual or homosexual due to stronger emotional, social, or political associations with one sex or orientation.

HISTORICAL DEFINITIONS OF BISEXUALITY

In examining historical figures, the terms bisexuality, homosexuality, and even heterosexuality may be anachronistic because the concepts were understood differently, if at all, during the person's lifetime. How people in ancient Greece, Victorian England, and twentieth century Hollywood comprehend their sexuality (and that of people around them) is decidedly different. The concept of sexual

identity has evolved rapidly over the past several years and, even now, is understood in vastly divergent terms in cultures around the world.

Before the days of psychologist Havelock Ellis, the term bisexual meant having the reproductive capability of both sexes. Only gradually was this displaced by the notion of sexuality we understand in this era of Identity Politics. Therefore, historical film personages who may have acted in a way we would think of as bisexual might not have considered or even heard the term. This is not to say that bisexual people did not exist before there was a word to describe them. However, they would not have thought of themselves as bi.

With all of this in mind, in this chapter and the following one, the work of film personalities who may be considered *behaviorally* bisexual is discussed, regardless of whether they have ever identified as bisexual or understood the meaning of the word in its current context.

BISEXUAL ENTERTAINERS: MAKING A DIFFERENCE

An increasing number of film entertainers are ending the speculation and uncertainty by openly declaring their bisexuality. Born Norma Kuzma, Traci Lords began her film career at the age of 14 in hard-core porn movies, styling her screen name after Katharine Hepburn's character from *The Philadelphia Story*. When it was discovered that she had lied about her age, all her early films became illegal and had to be withdrawn. It is now a felony in the United States to own one. Lords made the transition to "legitimate" films in 1988 through *Not of This Earth*. Her first real break, however, came two years later when John Waters asked her to appear as a teenage delinquent in *Cry-Baby*. Lords has since appeared in several other films including another Waters picture, *Serial Mom* (1994). She has also branched out into singing and television, appearing as a regular on the *Roseanne* show.

Performance artist and porn veteran, Annie Sprinkle is one of the more prolific of the openly bisexual actresses. Among her more recent film credits are *My Father Is Coming* (1991), *Linda/Les and*

Annie (1989), and *The Sluts and Goddess Video Workshop or How to Become a Sex Goddess in 101 Easy Steps* (1992).

Sandra Bernhard is another bisexual performance artist with a growing list of film credits. She can be seen in *The King of Comedy* (1983), *Without You I'm Nothing* (1990), *Inside Monkey Zetterland* (1993), *Dallas Doll* (1994), and the Sesame Street favorite, *Follow That Bird* (1985). Bernhard made *Late Night* host David Letterman squirm by calling Madonna "the best lover I ever had." More recently, she played a bisexual character on television's *Roseanne* show.

One of the reasons that Roseanne's TV show is so positive in its portrayal of sexual minorities is that Roseanne herself has had sex with other women. When asked about it by *Vanity Fair*, she said, "Yes, I have done that. The way I think about it is that anybody can have sex with anything." After a successful career as a stand-up comic, Roseanne made her Hollywood debut in 1989 with the comedy, *She-Devil*. She followed this up with an appearance in *Freddy's Dead* (1991), the sixth in the *Nightmare on Elm Street* series.

Susie Bright became a legend dispensing advice on lesbian sex under the name Susie Sexpert for *On Our Backs* magazine. In 1989, she played the role of John Lennon in *Grapefruit*, an all-female production of Yoko Ono's account of life with John and the Beatles. That year, she also appeared in Monika Treut's *The Virgin Machine*. In 1994, she and Lizzie Borden coauthored the screenplay for *Let's Talk About Sex*, which appears in the *Erotique* trilogy. She has also toured with a video lecture about the history of lesbian erotica, called *All Girl Action* and a male porn collection, titled *How to Read a Dirty Movie*.

A number of bisexual singers have been seen in films over the years. One of the first was Bessie Smith, the so-called "Queen of the Blues." Her only film appearance was a starring role in *St. Louis Blues* (1929), a short film in which she plays a wronged wife. The film was coproduced by blues legend W. C. Handy, who wrote the title song.

Jamaican-born Grace Jones once opined that, "It's ridiculous for a woman to say that she's not attracted to other women." She has appeared in a number of films including two that have bisexual characters, 1982's *La Truite* (*The Trout*) and *Siesta* (1987).

David Bowie openly declared his bisexuality during the 1970s, but with his constantly changing image decided to "come out" as straight a few years later. Bowie has appeared in more than a dozen films during his long career. One movie of interest to bisexual fans is *The Hunger*, in which his lover is a bisexual vampire. Bowie's ex-wife Angela Bowie published a book called *Backstage Passes: Life on the Wild Side with David Bowie.* In it, she details their sexual relationships with each other and with various friends and acquaintances, including David's encounters with Mick Jagger. She says, "David and I may in fact have been the best-known bisexual couple ever." Angela appeared in a film called *Demented.*

Speaking of the great Rolling Stone, Mick began his film career in 1970 starring as Australia's notorious outlaw Ned Kelley in a film of the same name. Later that year, he played a reclusive, bisexual rocker in *Performance.* In the 1980s he appeared in a few other minor films, such as *Burden of Dreams* (1982) and *Running Out of Luck* (1986)-which pretty well summed up his film career at that time. Jagger came back strong in 1992, however, with a fine performance as a bounty hunter in the time-travel thriller, *Freejack.*

Always evasive about her sexual orientation, Madonna has nonetheless hinted strongly at bisexuality and used it as a theme in videos such as *Justify My Love* and in her best-selling erotic picture book, *Sex.* In addition to a slew of rock videos, she has turned in quality performances in several feature films including *Desperately Seeking Susan, Dick Tracy,* and *A League of Their Own.* In perhaps her worst role, her character has a bisexual husband in *Body of Evidence* (1992).

Once the wife of bisexual singer Kurt Cobain, Courtney Love's own career has blossomed in the past few years. Her first film role was in *Sid and Nancy* (1986). This was followed by *Straight to Hell* (1987), a sort of punk, spaghetti western featuring Dennis Hopper, Elvis Costello, and Grace Jones. Love's film career took off in 1995 when she served as executive music coordinator for the hit movie *Tank Girl.* The following year saw her appear in several more films, including *Basquiat. Girlfriends* magazine has linked her romantically with Sandra Bernhard and Amanda de Cadenet.

Holly Near is another singer/songwriter who has exhibited bisexual behavior. Before Near and Don Johnson became stars, they

appeared together in an obscure film called *Stanley Sweetheart's Magic Garden* (1970). Holly appears as a single mom in *Dog Fight* (1991) and as the daughter in *Angel, Angel, Down We Go* (1969), also known as *Cult of the Damned,* a drug and murder movie so bizarre that it appears in both *The Psychotronic Encyclopedia of Film* and *Incredibly Strange Films.* In *The Todd Killings* (1970), she plays the accomplice of a bisexual serial killer.

British pop singer and political activist Tom Robinson can be seen in the Monty Python film *The Secret Policeman's Ball* (1979), singing "Glad To Be Gay." He also wrote the music for Rosa von Praunheim's 1979 film *Army of Lovers: or Revolt of the Sex Perverts.* Although he still prefers to identify as gay, Robinson says, "I find myself now at the age of forty-two a settled family man, a father and very happy."

One of the creative geniuses responsible for the success of *Monty Python's Flying Circus* was the late Graham Chapman. Buoyed by the popularity of their five-year run on the BBC in the UK and Public Television in the United States, the Monty Python troupe produced a number of successful movies including *Monty Python and the Holy Grail* (1972), *Monty Python's Life of Brian* (1979), in which Chapman stars as the reluctant savior, and *Monty Python's The Meaning of Life* (1983).

Like Tom Robinson, Chapman was a father who identified as gay and worked for gay rights in England. Chapman said that he had devised a test for himself in order to determine his sexuality. In a random sample of commuters, he found himself attracted to 70 percent men and 30 percent women. Fellow Python member Eric Idle described Chapman as "the quiet pipe-smoking alcoholic who could reduce any drinking party to a shambles by consuming half a distillery and then crawl round the floor kissing all the men and groping all the women."

British actor Rupert Everett came out as bisexual in 1992, telling *Out* magazine, "It's time for people to be honest about what they do." Everett's film career took off when he starred as homosexual spy Guy Burgess in *Another Country* (1984), reprising a very successful stage role. Since then, he has appeared in several dramatic roles including a bisexual character in *Inside Monkey Zetterland* (1993) and a gay character in *Remembrance of Things Fast* (1994).

Bisexuals in film is not a new phenomenon, however. Going way back, German exotic dancer Anita Berber was known to have had numerous female and male lovers throughout Europe. She appeared with Conrad Veidt in the 1919 film *Anders als die Anderen*, which argued for legalizing homosexuality in Germany.

American expatriate Josephine Baker was another dancer who made it to film in Europe. A recent biography written by her son discusses her bisexuality and her appearances in *Zou Zou* (1934), *Princess Tam Tam* (1935), and *The French Way* (1940).

Throughout the years, many of Hollywood's sexiest leading men were bisexual. In the 1920s, the man who stole the hearts of women (and more than a few men) was Rudolph Valentino, who starred in such films as *The Sheik* and *Blood and Sand*. His second wife was Natasha Rambova, a costume and set designer whose lover was a married actress and writer named Alla Nazimova (who was Nancy Reagan's godmother) Together Rambova and Nazimova wrote, directed, and produced a film version of Oscar Wilde's *Salomé* with what was reputedly an all-gay, lesbian, and bisexual cast. Nazimova had previously slipped a short lesbian scene past the censors in her 1921 film, *Camille*.

Rod LaRocque's film career spanned twenty-five years and included appearances in Cecil B. DeMille's original *The Ten Commandments* (1923), *Let Us Be Gay* (1930), and *The Hunchback of Notre Dame* (1939). His marriage to Vilma Banky in 1927 was staged as a Hollywood spectacular by producer Samuel Goldwyn. Banky appeared in films as well, including *Son of the Sheik* with Rudolph Valentino. LaRocque has also been linked with actor Gary Cooper.

Tyrone Power was one of Hollywood's top leading men, appearing in such films as *Jesse James* (1939), *The Razor's Edge* (1946), and *Witness for the Prosecution* (1958). Since his death, a number of biographers have written about the various men and women in his life. One of those men was Errol Flynn, another popular leading man whose bisexuality was posthumously revealed. Flynn was certainly known around Hollywood and the world as a lady's man, but biographer Charles Higham also discusses Flynn's same-sex attractions. These allegedly included Power and writer Truman Capote. Boze Hadleigh reveals that Flynn's wife, silent film star Lily Damita was bisexual as well.

Cary Grant was another durable leading man with a bisexual bent. Grant, who appeared with Marlene Dietrich in *Blonde Venus* (1932), was known to have been lovers with actor Randolph Scott while both were married. According to cult film director Ed Wood (who was somewhat of an authority on the subject), Grant was a transvestite as well. In 1938, he got an opportunity to wear women's clothing in the film *Bringing Up Baby*. Through this film, Grant became the first Hollywood actor to use the word "gay" in a homosexual context. While Grant played sophisticated men, lover Randolph Scott was known for his macho action characters in films like *Jesse James* (1939), *The Spoilers* (1942), and *Ride the High Country* (1962).

Actor Robert Taylor was believed to be gay when the studio engineered a marriage between him and Barbara Stanwyck. Later, however, he left her for another woman, Ursula Thiess. Capucine, who played Stanwyck's lover in *Walk On the Wild Side*, reported that Stanwyck was also believed to be bisexual. One of Taylor's early film appearances was with Greta Garbo in the 1936 version of *Camille*, directed by George Cukor. He appeared in several more films over the next three decades, including *Song of Russia* (1943). For this, he was called before the House Un-American Activities Committee where he testified against fellow actors.

Peter Lawford was identified as bisexual by Sal Mineo in a 1972 interview with Boze Hadleigh. Lawford made his screen debut at the age of eight and went on to appear in *The Picture of Dorian Gray* (1945), *Exodus* (1960), and *Advise and Consent* (1962). During the years of his greatest film success, he was also brother-in-law to President John Kennedy.

The repressive 1950s brought a bumper crop of bisexual actors to the silver screen. It now appears that most of the male sex symbols of that era had relationships with both men and women. One of the greatest, and shortest-lived talents was James Dean, whose entire film output consisted of the films *East of Eden*, *Rebel Without a Cause*, and *Giant*. Dean was romantically linked with a number of women, but it was well-known that he had male lovers as well. When asked by a reporter about his attraction to men, Dean replied, "I'm certainly not going through life with one hand tied behind my back." One of his costars in *East of Eden* was a young actor named

Sal Mineo, who was open about his bisexuality in the 1970s. In *Giant* (1956), Dean teamed up with Rock Hudson and Elizabeth Taylor in what was to be his final film. He did not live to see it released.

Dean's main rival in the mid-1950,s was another young rebel named Marlon Brando. Though he may not look like it today, Brando was as much a sex symbol as Dean, and made his fame in such films as *The Wild One* (1954) and Tennessee Williams' *A Streetcar Named Desire* (1951). Brando played a bisexual military man opposite Elizabeth Taylor in the 1967 film *Reflections in a Golden Eye*. He starred in one of the most talked-about films of the 1970s-*Last Tango in Paris*. In a 1976 interview in Paris, he told a reporter, "Like many men, I, too, have had homosexual experiences and I am not ashamed."

Another heartthrob of the 1950s who appears to have been bisexual was Montgomery Clift. Biographer Barney Hoskyns describes Clift's male relationships and his marriage in the book *Montgomery Clift: Beautiful Loser.* Clift starred in such classics as *A Place in the Sun* (1951) and *From Here to Eternity* (1953). Thanks to the generosity of Elizabeth Taylor, he was given a role in Tennessee Williams' *Suddenly Last Summer* (1959), despite severe drug, alcohol, and psychological problems that made shooting nearly impossible. He was subsequently barely able to make it through *The Misfits* (1961), which was the final film for both Clark Gable and Marilyn Monroe. Clift died at the age of 46 from a heart attack. For gay fans, one of Clift's most memorably camp scenes comes in *Red River* (1948), when he and costar John Ireland pull out their six-shooters and compare them.

Unlike Dean, Brando, and Clift, roles played by Anthony Perkins rarely inspired romantic thoughts. His most famous films were those in which his character was more than a little past the bend. *Fear Strikes Out* (1957) was Perkins' first starring role. He played Jimmy Piersall, a Red Sox outfielder who suffers a nervous breakdown. The part of Norman Bates in Alfred Hitchcock's *Psycho* (1960) became his most famous role, after which he was forever typecast. As the obsessive murderer, he ruined the reputation of loving sons the world over. In *Mahogany* (1975), he plays a bisexual photographer. Perkins told *People* magazine that he had numerous

gay affairs. He married relatively late in life and was the father of two children. Perkins died from AIDS in 1992 at the age of 60.

According to his manager, Elvis Presley was another star who shared his bed with men as well as women. This was particularly true early in his career. Presley shot to fame as the King of Rock and Roll, but he also made a surprising number of successful movies in the 1950s and 1960s. These include such classics as *Love Me Tender* (1956), *Jailhouse Rock* (1957), and *Blue Hawaii* (1961).

When asked about his homosexuality in a 1980 interview, Rock Hudson protested, "Come on, now. You've got the wrong guy." Events were to prove otherwise, however. By the end of the decade, we learned that Rock had been "the right guy" for a number of male and a few female lovers. Despite this fact, Hudson was particularly biphobic, making a number of derisive comments about bisexuals in a 1982 interview with Boze Hadleigh. Besides his appearance with Dean in *Giant*, he can be seen in *A Farewell to Arms* (1957), *Pillow Talk* (1959), and with Doris Day, Tony Randall, and Paul Lynde in *Send Me No Flowers* (1964).

According to Sal Mineo, actor Jeffrey Hunter was another member of the bisexual film brigade. Two of his best-known films were *The Last Hurrah* (1958) and *The Longest Day* (1962). Trekkies may also remember him from the *Star Trek* TV pilot, "The Cage."

Another bisexual actor with the unlikely name of Dack Rambo, appeared in several forgettable films in the 1970s and 1980s. He is best remembered today for his role in the TV series *Dallas*. Rambo contended that the role diminished precipitously once it became known that he slept with men.

In the UK, Laurence Olivier's brilliant and versatile career spanned six decades on both stage and screen. According to biographer Donald Spoto, he was married three times, including once to a another bisexual. In *Spartacus* (1960), Olivier played the bisexual character Crassus. Olivier had a ten-year relationship with bisexual actor Danny Kaye, star of *The Secret Life of Walter Mitty* (1947) and *Hans Christian Andersen* (1952). Kaye can also be seen camping it up with Bing Crosby in *White Christmas* (1954). In one scene they impersonate two women while lip-syncing a song called *Sisters*. Kaye was a member of the Committee for the First Amendment, which organized in opposition to the HUAC witch-hunt.

Dennis Price was another English actor with a penchant for men and women. He appeared in more than eighty films in a career spanning four decades. Price was outed in his lover's autobiography, *The Unsinkable Hermione Baddeley.*

Bi actor Laurence Harvey played the Christopher Isherwood role in *I Am a Camera* (1955) as a coded "confirmed bachelor" who ends up married to Sally Bowles. In *Walk on the Wild Side* (1962), he starred as Dove Linkhorn, whose girlfriend has a special relationship with the madam of a New Orleans house of prostitution. Harvey also played a bisexual film executive in *Darling* (1965).

Perhaps no family has provoked more controversy nor had more success acting on film, stage, television, and radio than the Redgraves. Sir Michael's 1983 autobiography, *In the Mind's I* reveals his bisexuality. Among his film accomplishments are *The Importance of Being Earnest* (1952), *The Dam Busters* (1955), and *Connecting Rooms* (1971), in which he plays a gay school teacher.

The marriage of British film couple Charles Laughton and Elsa Lanchester has been the object of much speculation. Her autobiography says that he was gay. Cary Grant lists Lanchester as bisexual or lesbian, while she insists she was neither. Between them, they made nearly one hundred movies over a period of five decades.

A more openly bisexual European actor is Helmut Berger, who starred in Luchino Visconte's *The Damned* (1969) and the 1971 version of *Dorian Gray.* He will also be familiar to fans of the *Dynasty* television show. French romantic idol Alain Delon is another bisexual actor who came out in Europe. He appeared in *The Leopard* (1963), *Is Paris Burning?* (1966), and *Diabolically Yours* (1967).

Male actors are not the only leading bisexual stars in the film industry. After being dismissed from her job at Paramount, American actress Louise Brooks got her big break in 1929 in one of the great German silent films: *Pandora's Box.* She plays the lead character, a woman who is having an affair with a countess, but marries a wealthy man. In the 1985 documentary, *Lulu in Berlin*, Brooks denied ever having had any lesbian relationships. On other occasions, however, she has admitted to a number of sexual encounters with other women including one with Greta Garbo.

Garbo achieved international stardom crossing the Atlantic in the other direction. She had been making movies in Sweden and was

persuaded to come to Hollywood by her director, Mauritz Stiller. One of her most famous roles after coming to America was that of Sweden's bisexual monarch, Queen Christina. Such was Garbo's allure that set designer Cecil Beaton, who usually preferred men, found himself attracted to her to the point of proposing marriage. She declined, but they had a long and intimate relationship, nonetheless.

Garbo's chief rival, both on the screen and between the sheets was Marlene Dietrich (*Blonde Venus* and *The Blue Angel*). Also native to Europe, Dietrich became lovers with Garbo's lover, Mercedes de Acosta. According to Beaton, both Garbo and Dietrich had affairs with John Gilbert as well. Donald Spoto lists Douglas Fairbanks Jr., Gary Cooper, Yul Brenner, and John Wayne among Dietrich's lovers. Another biographer, Michael Cimino adds Edith Piaf and Ernest Hemingway to the list. Dietrich once told Bianca Stroock, "In Europe it doesn't matter if you're a man or a woman. We make love with anyone we find attractive." When her film career was over, Dietrich made a successful second career as a cabaret and concert performer.

Before leaving her native Germany, Dietrich teamed up with openly bisexual French actress Margo Lion to perform a duet called *Sisters,* about two girlfriends buying underwear for each other. With Lion as soprano and Dietrich picking up the low register, the number caused quite a sensation.

Judy Garland was another star who combined singing with a successful film career. Besides her marriages to band director David Rose and director Vincente Minnelli, Garland enjoyed romantic liaisons with a number of other famous men and women, including Betty Asher and Tyrone Power. Garland's most famous film, *The Wizard of Oz* (1939), has become a beloved cult classic in gay circles. For bisexuals, the film is cherished for the line in which the scarecrow informs Dorothy that some people go both ways.

Comic actress Beatrice Lille's film career began in 1926 with *Exit Laughing* and ended with *Thoroughly Modern Millie* in 1967. At the age of twenty-four, Lille married Sir Robert Peel and remained Lady Peel until her death seventy years later. In the meantime, she is reported to have been lovers with Judith Anderson and Katharine Cornell, among others. Her autobiography is titled, *Every Other Inch a Lady.*

Ona Munson is best remembered for her role as the scandalous Belle Watling in *Gone With the Wind* (1939). Munson's love letters to Mercedes de Acosta include phrases such as, "I long to hold you in my arms and pour my love into you." Her first of three marriages was to film director Eddie Buzzell.

The quick-witted Tallulah Bankhead was a highly underrated actress from the same era. Born into a political family from Alabama, her grandfather was a senator and her father was Speaker of the House. Stories about Bankhead abound. Some, no doubt, contributed to the relatively small number of film roles she received during her forty-eight-year career. She can be seen in *Stage Door Canteen* (1943) and Alfred Hitchcock's *Lifeboat* (1944). Her best performances, however, were on stage in London and New York. When asked about her sexual orientation, her reply was, "I've rejoiced in considerable dalliance, and have no regrets . . . I found no surprises in the Kinsey Report." Tallulah, who referred to herself as "ambisextrous" is said to have told Joan Crawford, "Dahling, you're divine. I've had an affair with your husband. You'll be next."

Such statements were not merely idle threats, as Crawford was widely reported to have been bisexual as well. This was later confirmed in daughter Christina's book, *Mommie Dearest*. A favorite with gay male audiences for decades, she has more film credits in Paul Roen's *High Camp* than any other actress. Among them are *Flamingo Road* (1949), *Johnny Guitar* (1953), and *What Ever Happened to Baby Jane?* (1962).

Judy Holliday's first three starring roles were directed by gay director, George Cukor. She won the Best Actress Academy Award in 1951 for the second of these, *Born Yesterday*. According to one biography, her career suffered greatly because of her bisexuality. She was one of the many performers banned from working in Hollywood and television due to the McCarthy witch-hunts.

Shirley MacLaine became one of several well-known personalities in the late 1960s to proclaim that everyone is inherently bisexual. Among her best roles is Martha, the lesbian schoolteacher in *The Children's Hour* (1962).

Best known in recent years for her dentures, Martha Raye was once a minor star in Hollywood. She played opposite Charlie Chaplin in *Monsieur Verdoux* (1947) and appeared in a number of other

films over a forty-year career. In a *Washington Post* interview, Mark Harris, her seventh (and final) husband revealed that Raye had been bisexual. She told him, "I went both ways, like yourself."

From her first movie, *Citizen Kane* (1941), to her role as Endora in the hit TV series, *Bewitched*, Agnes Moorehead had a long and successful career. In a 1973 interview she said, "A woman may love a person who is this or that, male or female. Love doesn't have a sex." She is said to have told one husband, "If you can have a mistress, I can, too." Indeed, she is believed to have had a number of them over the years.

Federico Fellini once said, "Capucine had a face to launch a thousand ships . . . but she was born too late." Like many who sailed to reclaim Helen of Troy, she shared a taste for both women and men. Born Germaine Lefebvre, Capucine was a top Paris fashion model in the 1950s. She made the transition to film in 1960 and captured major roles in *Walk On the Wild Side* (1962), the *Pink Panther* series (1964-1983), and *Fellini Satyricon* (1969). In *Las Crueles* (1971), she plays a lesbian character. Like Dietrich, Capucine was somewhat frustrated by the dichotomous attitudes in the United States. In a 1985 interview with Boze Hadleigh, she said, "Most Americans think it's either 100 percent heterosexual or 100 percent homosexual. It's much more complex than that."

In the 1960s, bisexual English actress Coral Browne played supporting roles in two 1968 films featuring bisexual characters: *The Killing of Sister George* and *The Legend of Lylah Clare*. A few years later, Maria Schneider got her start with fellow bisexual Marlon Brando in *Last Tango in Paris* (1973). She came out soon after turning down the role of Drusilla in *Caligula*. In 1979, Schneider played a lesbian folk singer who falls in love with a married woman in *A Woman Like Eve*.

Anaïs Nin's relationship with Henry Miller and his wife June has been the subject of two films: *The Room of Words* and *Henry and June*, both released in 1990. Few people are aware, however, that Nin herself appeared in Kenneth Anger's *Inauguration of the Pleasure Dome* (1954). Nin's bisexuality is well-documented in her famous diaries.

Many of today's young actresses are much more open about their sexuality than their forebears. The actress with the longest stage and

screen pedigree is Drew Barrymore, who came out as bisexual in a *Movieline* interview. Barrymore began her film career in *Altered States* (1980) at the age of five, following this up two years later with *E.T. The Extra-Terrestrial*. Her best-known, and most controversial role to date is in *Poison Ivy* (1992) in which she shares a kiss with Sara Gilbert.

Amanda Donohoe has played bisexual characters in *Lair of the White Worm* (1988), *The Rainbow* (1989), and in TV's *L.A. Law*. In a *Diva* magazine interview, Donohoe said, "If a woman came into my life who was absolutely stunning and satisfied me emotionally, intellectually, and sexually, I'm not going to draw the line and say, 'I can't because you're a woman.' I find it hard enough to find someone to be with, why narrow the field?"

Several factors are leading to a rise in the number of bisexual stars we see on screen. There have always been bisexuals in the film industry, but more have been willing to come out in recent years. The more people come out, the easier it becomes for others to come out, and the more difficult it will be to discriminate. The process has far to go, of course, but significant progress is being made.

Bisexuality is no longer an automatic impediment to appearing in films. In addition to the changing social climate, this is a reflection of the changed economic reality in Hollywood. One difference is that studios no longer have actors under contract for years at a time. Therefore, they are far less concerned about their off-screen behavior as a reflection on the corporation.

Additionally, independent filmmakers have been more open to casting bisexual, lesbian, and gay actors. Since the Hollywood studios no longer have the stranglehold over exhibition rights that they once did, they must either keep up with new challenges and new talent or lose market share. Much of that market share, they have discovered, comes from bisexual, gay, and lesbian viewers.

Chapter 14

By the Bi

The only unnatural sex is that which you cannot perform.

– Colette

The bisexual community is about fifteen years younger than the gay and lesbian community in terms of organization and political action. In the early days of what was then known as the gay liberation movement, the community in the United States was galvanized by the Stonewall Riots, which became a rallying point for people of alternative sexualities. Gay organizations had existed in the United States as early as the 1930s and bisexuals were part of those organizations from the beginning. European organizations started even earlier in less repressive countries. In the aftermath of Stonewall, the gay community included homosexual and bisexual men and women, as well as drag queens, transsexuals, and others who were disenfranchised due to their sexual orientation. As the movement grew, it became increasingly obvious to the women in it that the balance of power was severely weighted toward men. Women who loved women increasingly began to call themselves lesbian, as separate from the overall gay community. As a result, the term gay began to generally be applied only to homosexual men.

With the rise of the right-wing political agenda in the 1970s and early 1980s, and the resultant growth in hate crimes, gays and lesbians increasingly saw heterosexuals as an enemy to be feared. By extension, anyone who had an attraction for the opposite sex was also suspect and often made to feel uncomfortable in gay and lesbian circles. It was out of this sense of exclusion and frustration with the existing community that bisexual people began to organize sepa-

rately. As a distinct movement, the bisexual community is only a little more than ten years old at this time.

THE BISEXUAL INFLUENCE OFFSCREEN

With its relatively late start on the political scene, the bisexual movement can be thought of as being roughly where the gay and lesbian community was in the late 1970s as far as the production of literature and film. Essays on the subject of bisexuality have only recently been published. Literature and erotica by openly bisexual people is a relatively new phenomenon. Films with bisexual themes by "out" bisexual directors have only recently begun to appear.

Among those directors is Boston area documentarist, Sharon Gonsalves. She began her career with *More Than Survivors* (1991), a documentary about incest survivors in recovery. This she followed with a video about the bisexual community, called *Bi the Way . . .* (1992). More recently, she appeared in another documentary called *Embracing Our Sexuality: Women Talk About Sex* (1993).

The London bisexual community participated in the filming of a series of HIV prevention videos known collectively as *No Secrets* (1991). A video called *Queers Among Queers* (1994), about bisexuals in the San Francisco area, was recently produced under the direction of documentarist Catherine Byers-White.

Lizzie Borden is an openly bisexual director whose films challenge conventional notions of race, class, and sexual politics. After studying painting and art history, she became a film editor and then started her own production company, called Alternate Current. Her first feature film was *Born in Flames* (1983), a futuristic feminist story set in post-revolutionary New York. This was followed by a nonmoralistic (and therefore controversial) film about prostitution, called *Working Girls* (1987). Most recently, she directed *Let's Talk about Sex*, which appears in the 1994 trilogy, *Erotique*.

Once self-identified as lesbian, Maria Maggenti now she says she has too much respect for her "omnisexual possibilities" to give herself a label. She describes her first feature film, *The Incredibly True Adventure of Two Girls in Love* (1995) as highly autobiographical. It is based on her first relationship with a girl after returning to the United States from Nigeria. Maggenti's earlier documentaries

and short films have won a number of awards at festivals around the world.

Much has been written about the influence of such gay and lesbian directors as James Whale, Dorothy Arzner, and George Cukor. However, a number of bisexual directors have also made their mark on the film industry. One of the earliest was William Taylor, whose career ended abruptly on the night of February 1, 1922, when he was murdered in his Westlake home. At the time of his death, Taylor was president of the Screen Directors' Guild and had directed a number of successful silent films at Paramount, beginning with *The Criminal Code* (1914).

Known as the man who discovered Greta Garbo, Mauritz Stiller was Sweden's most successful director during the silent era. He is best remembered for *The Atonement of Gosta Berling* (1924). Though Garbo had only a relatively small role, this was the first film for which she received critical acclaim. It eventually led to international recognition. Both Stiller and Garbo were bisexual and nearly inseparable in the early 1920s. Most experts agree, however, that their relationship was nonsexual.

Stiller was recruited by Metro Goldwyn and came to terms on the condition that he could bring his talented young star with him. Garbo quickly became the more important asset as far as Metro was concerned. Stiller was dismissed after bitter disputes with the studio bosses over production control issues. Leaving Hollywood, he vacationed in France for several months and died shortly after returning to his native Sweden. Stiller is known to have had a male lover named Elnar Hansson. Several women also claimed to have slept with him. Stiller's gayest film was 1916's *Vingarne* (*The Wings*) featuring a homoerotic relationship between a teacher and his student.

More recently, Swedish director Staffan Hildebrand came out in the *Aftonbladet* newspaper as being bisexual. Though his long-term relationships have always been with women, Hildebrand says that he has had a number of passionate affairs with men. Hildebrand is best known for *Stockholmsnatt* (1986), his film about youth violence in Sweden.

Venezuelan-born Fina Torres is another young director who openly identifies as bisexual. Working in Paris, she wrote, directed, and filmed *Mecaniques Celestes* (*Celestial Clockwork*) in 1993. It is

the story of Ana, a young woman from Venezuela who flees to Paris to escape an arranged marriage. There she becomes involved with a bisexual woman, marries a gay man to avoid deportation, and begins her career as an opera singer. Torres' previous movie, *Oriana*, was filmed in Venezuela in 1985.

Sergei Eisenstein was one of the most influential directors of all time. Same-sex attractions were particularly dangerous in the Soviet Union during the Stalin era, but biographers identify him as probably bisexual. Eisenstein directed such classics of the Soviet cinema as *Potemkin* (1925), *Ten Days That Shook the World* (1927), and *Alexander Nevsky* (1938). In addition, he produced some of the finest film theory books ever written. Many of these are sought out by film students and directors now, more than fifty years later.

After moving from the actor's role to that of director in 1925, Edmund Goulding made a number of big name movies. Among them were *Paris* (1926) with Joan Crawford; *Grand Hotel* (1932), starring Crawford and Greta Garbo; and *The Razor's Edge* (1946), based on Somerset Maugham's novel and starring Tyrone Power. A versatile filmmaker, he also wrote the scripts for several of his films and even composed the score for one. In his book, *The Sewing Circle*, Axel Madsen confirms that Goulding was also versatile in his affections for men and women. Despite his successful track record, Goulding had difficulty getting work following *The Razor's Edge*. It has been speculated that he was ostracized because of his "lifestyle."

Director Kenneth Macpherson, his wife Bryher, and the poet H. D. (Hilda Doolittle) composed a trio whose relationship was easily as complicated as that of the Valentino triad. Macpherson was bisexual, Bryher was apparently a lesbian and H. D. was lovers with Bryher and both of the men Bryher married. No less a personage than Sigmund Freud called H. D. "a perfect bisexual." In point of fact, none of them were movie people. They were all writers who thought it would be fun to produce a film that was out of the ordinary. Though the film *Borderline* was never a financial success, it was well-received in Europe and challenged a number of social barriers.

Released in 1930, *Borderline* went far beyond the normal Hollywood boundaries not only in sexual orientation, but in race as well.

During the silent era in Hollywood, most films were cast with whites only. If there were any black characters, they were played by white actors in blackface. There were also "race movies" produced, which were designed for black audiences (segregation was still the norm in U.S. film theaters). These films had only black actors. In *Borderline*, however, Macpherson crossed the line by including international star Paul Robeson and his wife Eslanda Goode, both black actors, in the cast. The company avoided potential racial problems by filming near Bryher's home in Switzerland. H. D.'s role in the film is the neurotic Astrid, while Bryher plays the cigar-smoking butch lesbian who runs the hotel. As the comic relief character, she tallies her accounts in the lobby, totally oblivious to all the people self-destructing around her.

Paul Robeson continued to work as a singer, publisher, actor, and civil rights leader, appearing in several more films before being targeted by the House Un-American Activities Committee in 1947. His passport was subsequently suspended and he was unable to leave the country for more than a decade, never appearing on film again.

Mitchell Leisen began his Hollywood career as a set decorator and costumer. Among his accomplishments were costumes for Cecil B. DeMille's *Sign of the Cross* (1932), which featured gay and lesbian characters. With DeMille's assistance, Leisen became a top film director, counting *Easy Living* (1937), *Lady in the Dark* (1944), and *The Mating Season* (1951) among his efforts. In 1954, he was fired by MGM for flirting with allegedly heterosexual men on the set of *Bedevilled*. Since "sexual deviants" were banned from Hollywood studios during the McCarthy era, Leisen changed careers, becoming a successful interior decorator. He was also a talented sculptor. Leisen was married for fifteen years to opera star Stella Yeager. He also had relationships with actor Eddie Anderson, choreographer Billy Daniels, and Natalie Visart.

Following the Second World War, a number of bisexual and gay underground filmmakers began to emerge in the United States. The first and most unabashedly bisexual of these was the poet James Broughton. Working from 1946 through 1988, he produced nineteen films including *The Pleasure Garden*, which won the *Prix de Fantaisie Poétique* at the 1954 Cannes Film Festival. *The Bed* (1968)

also garnered a number of festival awards and, in doing so, helped to break down the taboo against frontal nudity in American film. An autobiographical film called *The Adventures of Jimmy* (1950) features a bisexual protagonist. Broughton's recent autobiography, *Coming Unbuttoned*, celebrates his relationships with men and women over several decades, including a number of bisexual writers and artists.

Among the men who shared Broughton's bed was underground film director Stan Brakhage, whose wife and children became part of Broughton's extended family. Brakhage filmed all three of Broughton's wedding ceremonies, which Broughton later edited and released as *Nuptiae* (1969). One of Brakhage's most highly regarded films was *Lovemaking* (1968), a film about the naturalness of sexuality. Its four sequences feature heterosexual and homosexual lovemaking, dogs copulating, and naked children at play.

The name Andy Warhol was nearly synonymous with underground film in the 1960s, although many of the films attributed to him were actually directed by Paul Morrissey. Even on these, however, Warhol usually operated the camera and acted as producer. Variously described as bisexual, homosexual, and asexual, Warhol had a profound influence on underground film culture. In reference to his sexual orientation, the defiantly ambiguous Warhol said, "When I got my first TV set, I stopped caring so much about having a close relationship." The Warhol/Morrissey team included a number of bisexual characters in their films. Andy Warhol will long be remembered for underground classics like *Blowjob* (1963), *Chelsea Girls* (1966), and *Lonesome Cowboys* (1967).

Of course the most famous, or notorious, of all bisexual directors was the son of the official German translator for Truman Capote and Tennessee Williams. By the time he died in 1982 at the age of thirty-seven, Rainer Werner Fassbinder had directed forty-three films, twenty-five stage plays, and four radio plays. He had also been at the forefront of the New German Cinema movement, which revolutionized the West German film industry. He once claimed that if there were an atomic war, people should stick by him because he had more energy than a bomb.

Fassbinder was demanding and impatient as both a director and lover. Two of his male partners (El Hedi Ben Mohammed Salem and Armin Meier) committed suicide. His marriage to Ingrid Caven did

not last long either, but at least she survived. Many of his lovers, including these three, also appeared in his films. *Ein Mann wie Eva* (*A Man Like Eva*) is a semifictionalized film about Fassbinder released only a year after his death. Nonetheless, it reveals much about his character and methods of film making. The Fassbinder character is played by an actress named Eva Mattes, who appeared in three of his films.

Michael Redgrave's son-in-law, Tony Richardson, was also bisexual. He was married to actress Vanessa Redgrave and together they had two daughters. He also had a daughter with actress Grizelda Grimond. Though his autobiography neglects to mention his relations with men, writer Gavin Lambert said that Richardson "introduced me to several of his male lovers." Among the films that Richardson directed are *Look Back in Anger* (1958), *Tom Jones* (1963), *Hamlet* (1969), and *The Hotel New Hampshire* (1984), which features a love scene between Jodie Foster and Nastassia Kinski.

Perhaps the best-known costume designer of all time was Edith Head, whose Hollywood career lasted nearly sixty years. During that time she compiled more than a thousand film credits and received eight Academy Awards. She also appeared as herself in a film called *The Oscar* (1966). Married twice (the second time for thirty-nine years), Head had an active interest in women and the opportunity to dress thousands during her career.

No modern film is complete without a musical score. One of the most memorable was that written by Leonard Bernstein for *West Side Story* (1961), for which he won an Academy Award. Bernstein had earlier written scores for *On the Town* (1949) and *On the Waterfront* (1954). He also appeared, along with Louis Armstrong, in *Satchmo the Great* (1957). The composer was married for more than twenty-five years and was the father of three children. In addition, he had relationships with a number of men. According to producer Mark Goodson, Bernstein became the first major entertainer to break through McCarthy's "blacklist" when the Ford Motor Company sponsored a television broadcast of one of his concerts.

Cole Porter was another bisexual composer with multiple film credits. The first was *Broadway Melody of 1940*. Porter's score featured *I've Got My Eyes on You* and *Begin the Beguine*. Porter's

Broadway hit musical *Kiss Me Kate* was translated to the screen in 1953. The film version featured *Why Can't You Behave* and *Too Darned Hot*. Bob Fosse was one of the dancers in this film that was originally shown in 3-D. *High Society* (1956) was a musical remake of *The Philadelphia Story*, starring Grace Kelly, Bing Crosby, and Frank Sinatra. Other Porter film credits include *Silk Stockings* (1957) and *Can-Can* (1960).

As an independent producer and later owner of RKO studios, Howard Hughes was one of the more powerful figures in Hollywood. When Hughes produced *The French Line*, it was the first film to be released by a member studio without the Production Code seal of approval. Archbishop Ritter of St. Louis decreed that any Catholic who saw the film would fall "under the penalty of mortal sin." Needless to say, the 3-D extravaganza opened to overflow crowds.

Biographer Charles Higham says Hughes was bisexual and had affairs with many male stars including Cary Grant and Tyrone Power. Anyone seeking additional confirmation in his films need look no further than *The Outlaw*, directed by Hughes in 1943. The sexual tension between the male leads is quite obvious. The censors, however, were too distracted by Jane Russell's breasts to notice. It was Howard Hughes who first hired James Whale in 1930 as a dialogue director for his epic *Hell's Angels*. Whale went on to become a highly successful, openly gay film director.

BISEXUAL WRITERS

Another major influence that bisexuals have had on the film industry has been in the source material that is turned into movie scripts. A significant number of talented bisexual writers have supplied novels, plays, and scripts that formed the basis for films ranging in quality from the worst trash to award-winning cinema.

Colette was one of the earliest and most successful bi film writers. She made her mark as a writer of short stories and novels, beginning in 1900 with *Claudine á l'École,* the story of a bisexual girl at school. This was the first of four Claudine novels, each published under her husband's name because women were not *supposed* to write erotica. Colette's first break in the world of film was through her close friend, Musidora, an extremely talented actress,

screenwriter, and director in the early French cinema. She adapted and began filming Colette's *Minne* in 1916, but did not complete the project. The following year, however, Musidora brought *La Vagabonde* to the screen. In 1918, Colette wrote an original screenplay called *La Flamme Cachée*, which was also directed by Musidora. Colette wrote dialogue for *Filles en Uniforme,* the French version of the German *Mädchen in Uniform*, in 1920.

Claudine á l'École was filmed by Serge de Poligny in 1936. Her novels were also favorites for adaptation by director Simone Bussim in the 1930s. In 1948, Jacqueline Audrey directed *Gigi.* Two years later, Audrey finally brought *Minne* to the screen. Colette collaborated again with Audrey in 1951 when she wrote the script for the melodrama *Olivia*, a film about lesbian relationships at an upper-class French boarding school. In 1956, two years after the author's death, Audrey directed her last Colette film, *Mitsou.* Colette's most successful film however, was Vincente Minnelli's remake of *Gigi* in 1958. This version won nine Academy Awards including Best Screenplay Based Upon Another Medium. Most recently, Abby Freedman directed *La Fleur de l'Age* (1993), about the loves of an older woman.

In addition to her script writing, Colette was a respected film critic in her native country, beginning as early as 1917. She has been the subject of films as well. The first of these was a 1950 documentary by Yannick Bellon. More recently, a film called *Becoming Colette* (1991) tells of her metamorphosis from a young and innocent country girl into a celebrated Parisian writer.

Simone de Beauvoir was another well-known Parisian bisexual. A brilliant feminist and existentialist philosopher, she was also lovers with Jean Paul Sartre. She once expressed the opinion that "In itself, homosexuality is as limiting as heterosexuality: The ideal should be to be capable of loving a woman or a man; either, a human being, without fear, restraint, or obligation." In 1945, she published *Le Sang des Autres*, the story of Jean Blomart, a patriot leader in the French Resistance. Thirty-nine years later, *The Blood of Others* was brought to the screen by French director Claude Chabrol. The film's one saving grace is Jodie Foster in the role of Hélène. Simone was the subject of a 1982 documentary in her native France.

Across the Channel, Virginia Woolf was one of the bisexual writers in the famed Bloomsbury Group. Her novel *Orlando* has twice been

adapted for film. The first was by Ulrike Ottinger, a German film-maker whose work tends toward the experimental end of the New German Cinema. She released *Freak Orlando: Small Theater of the World in Five Episodes* in 1981. A more recent and coherent film by Ottinger is *Johanna D'Arc of Mongolia* (1988). The second adaptation is simply called *Orlando* (1993), and was directed by Sally Potter. It features Tilda Swinton in the title role and Quentin Crisp in his rightful place as Queen of England.

Daphne du Maurier was another British bisexual whose writing made it to the big screen. Her 1938 novel *Rebecca* was Alfred Hitchcock's first Hollywood movie and his only film to receive an Academy Award for Best Picture. The film was also nominated for Best Script. In 1963, Hitchcock revived the Du Maurier connection, adapting her short story for *The Birds*.

By the early 1930s, Christa Winsloe was one of Germany's best-known writers. *Mädchen in Uniform* (1931) is based on Winsloe's play, *Gestern und Heute* (*Yesterday and Today*). In 1933, she published the story in novel form as *The Child Manuela*. Her subsequent novel, *Girl Alone*, included another bisexual girl who became the last character of alternative sexuality to appear in German literature before the Nazi purge. Winsloe was married to Count Ludwig Hatvany at the time *Gestern und Heute* was written, but later became the lover of journalist Dorothy Thompson, wife of writer Sinclair Lewis. Christa Winsloe was murdered in the Nazi-occupied portion of France in 1944 after a long career of antifascist writing. Others associated with *Mädchen in Uniform* escaped to England and America when the fascists came to power. One of those was the film's director, Leontine Sagan. Though married, Sagan was also outspoken about her relationships with women.

Mercedes de Acosta was another screenwriter who had relationships with both men and women. As previously mentioned, she was lovers with both Greta Garbo and Marlene Dietrich. She was also married to Abram Poole and had relationships with Natalie Barney and Alla Nazimova.

Perhaps the dean of male bisexual writers, though he did not live to see any of his works on film, was Oscar Wilde. *The Picture of Dorian Gray* was one of his most popular works, both in print and on the screen. This was first filmed by Richard Oswald as a 1917

German silent feature called *Das Bildnis des Dorian Gray.* Subsequently it was directed under its original title by Albert Lewin (1945) and Glenn Jordan (1974). In addition, it was filmed in 1971 by Italian director Massimo Dallamano as, simply, *Dorian Gray.*

Equally popular with audiences, though not with the censors, was his banned play *Salomé.* Theda Bara played the role in a 1918 film. Two versions appeared in 1923, starring Diana Allen and Alla Nazimova. The latter was directed by Nazimova's husband, Charles Bryant. Thirty years later, William Dieterle filmed it in a production starring Rita Hayworth and Charles Laughton. A 1961 version starred Brigid Bazlen. Claude D'Anna made a French version in 1985, and in 1987 it was the basis for *Salome's Last Dance*, directed by Ken Russell. Even death did not stop Wilde's censorship problems. The first two biographical films about his life were banned both in the United States and in his native Ireland.

Some of Wilde's wittiest writing can be found in *The Importance of Being Earnest,* directed in 1952 by Anthony Asquith. A short story called *Lord Arthur Savile's Crime* by Wilde is the second (and best) of three tales of the supernatural in Julien Duvivier's *Flesh and Fantasy* (1943). Rounding out the list of Wilde's film credits is *The Birthday of the Infanta*, adapted by William and Marilyn Raban as an avante-garde film called *Black and Silver*, in 1981.

Even more prolific than Wilde was another bisexual English writer, W. Somerset Maugham. Maugham was a compulsive traveler who wrote extensively on the road. Reflecting on his life and sexual orientation, he once said, "I tried to persuade myself that I was three-quarters 'normal' and only a quarter of me was queer whereas really it was the other way round." Amazingly, more than forty of his works have been adapted for film.

Maugham's film career began with a number of plays adapted to the silent screen. The first of these was *The Land of Promise* (1917), based on a play of the same name and remade as *The Canadian* in 1926. In 1919, *The Divorcee* was filmed, based on his play *Lady Frederick*. The play *Caesar's Wife* became the film *Infatuation* in 1925. *The Circle* was filmed as *Strictly Unconventional* in 1925 and again in 1930. *The Charming Sinners* was adapted from *The Constant Wife* in 1929, and *The Sacred Flame* was filmed as *The Right to Live* in 1929 and 1935.

The first of Maugham's novels to reach the screen was *The Magician* in 1926. In it, the sinister Dr. Haddo kidnaps a young woman on her wedding night because he requires the blood of a virgin's heart in order to bring his experiment to life. Directing this film for MGM was Rex Ingram (*The Thief of Bagdad, Adventures of Huckleberry Finn*, and *Elmer Gantry*). According to *Halliwell's Film Guide,* no prints of this film now exist.

In 1928, Gloria Swanson bought the rights to Maugham's short story, *Rain*. She renamed it *Sadie Thompson* and starred along with Lionel Barrymore. Four years later, MGM followed up with a remake starring Joan Crawford and Walter Huston and directed by Lewis Milestone. In 1946, Spencer Williams (the Andy of *Amos 'n' Andy*) directed the "race movie" *Dirty Gertie from Harlem,* an adaptation of *Rain*. Columbia filmed *Rain* as a 3-D musical called *Miss Sadie Thompson* in 1953.

In 1934, MGM filmed *The Painted Veil*, starring Greta Garbo and directed by Richard Boleslawski. This story is based on Maugham's novel about a doctor's wife who gives up her lover to join her husband's fight against an epidemic in China. MGM filmed it again in 1957 under the name *The Seventh Sin*, directed by Ronald Neame. Also in 1934, John Cromwell directed Bette Davis in *Of Human Bondage*, the story of a handicapped medical student who falls in love with a tough cockney waitress. This film was remade by Edmund Goulding in 1946 and again in 1964 by Henry Hathaway, starring Kim Novak.

Maugham's film career was on a roll. A successful young English director by the name of Alfred Hitchcock was the next to bring his work to the screen. *The Secret Agent* was adapted by Hitchcock in 1936 from two of Maugham's *Ashenden* stories. It is about a British intelligence agent who is sent to Switzerland to eliminate an enemy spy, but murders the wrong man. Peter Lorre fans will want to see this one. In 1938, Erich Pommer directed *Vessel of Wrath*, starring Charles Laughton and his wife, Elsa Lanchester. Laughton plays a drunken beachcomber who gradually wins the heart of a missionary's sister. The film was remade as *The Beachcomber* in 1954 by Muriel Box.

The 1940s proved to be as successful for Maugham as the previous decade. William Wyler started things off with an excellent

production of *The Letter*, once again starring Bette Davis. The film takes place in Maugham's beloved Singapore where Leslie, the wife of a rubber plantation owner shoots a man in apparent self-defense. Unfortunately, the ending was modified to provide suitable retribution to placate The Code's sense of justice. An earlier version, filmed in 1929, had remained more true to the novel, with Leslie getting away with the murder by lying on the witness stand. The story was filmed at third time in 1947 as *The Unfaithful*.

The Moon and Sixpence (1943) is loosely based on the life of impressionist artist Paul Gauguin. Director Albert Lewin filmed it mainly in black and white, but used color on occasion to make certain scenes more striking. Deanna Durbin played a New Orleans nightclub hostess in the 1944 film, *Christmas Holiday*. Once again, the censors got in the way of Maugham's work. Durbin's character was supposed to be a prostitute, but that was not allowed under The Code. The substitution ruins the motivation behind her murder and subverts an otherwise good film noir by Robert Siodmak.

The Razor's Edge, published in 1944, was one of Maugham's finest novels. This is the story of a young man returning from the First World War who gives up wealth and comfort in search of spiritual fulfillment. Tyrone Power turns in an excellent performance in Edmund Goulding's 1946 production. In 1984, Bill Murray wanted to play the role and persuaded backers to remake the film. This version was directed by John Byrum.

Maugham himself introduced the 1948 film, *Quartet*, which features four of his short stories. Four different directors brought *The Facts of Life, The Alien Corn, The Kite*, and *The Colonel's Lady* to the screen for this production. The success of this film led to a sequel two years later, called *Trio*, by two of the same directors. Again Maugham introduced his stories, *The Verger, Mr. Knowall*, and *The Sanitarium*. The film industry, always known for doing a good idea to death, followed the identical format in 1952 with Maugham and three more of his stories in a package called *Encore*. The tales this time were *Winter Cruise, The Ant and the Grasshopper*, and *Gigolo and Gigolette*.

Though production of Maugham's works has tapered off since the early 1950s, a new one appears every now and then. The most

recent was *Change of Destiny* (1989), filmed in the Soviet Union and based on a short story by the same name.

D. H. Lawrence is yet another British writer with a string of successful screen adaptations. Never shy about proclaiming his own greatness, Lawrence once mused, "I should like to know why nearly every man that approaches greatness tends to homosexuality, whether he admits it or not . . ." Biographer Richard Adlington reports that, "Lawrence was about 85 percent hetero and 15 percent homo." Whatever the percentages, Lawrence clearly had enough male and female lovers to qualify as bisexual and enough literary success to "approach greatness." He is also one writer who courageously and repeatedly brought bisexual images to the market, despite the legal and financial hardships caused by outraged censors. Many of these bisexual characters and plot lines have subsequently made it to the screen.

Lawrence was involved in a number of legal battles as a result of the uncompromising eroticism of his writings. One of the worst of these took place in October of 1915, when his book *The Rainbow* was banned and he was prosecuted for "uncleanness and pornography." *The Rainbow* contains long erotic passages about a love affair between a female teacher and a girl in her class, both of whom are also attracted to men. Due to the expense of his legal defense, Lawrence lost his London home and was reduced to living in a two-room cottage in Cornwall. There he completed *Women in Love*, which he described as "a sequel to *The Rainbow,* though quite unlike it." This time there was male bisexuality in the story. No publisher in England or the United States would touch it for several years, for fear of prosecution.

Ken Russell directed *Women in Love* in 1970, for which Glenda Jackson won an Academy Award as Best Actress. The nude wrestling scene between Alan Bates and Oliver Reed was considered highly controversial. In 1989, Russell filmed *The Rainbow*, based on Lawrence's earlier book. This one starred Sammi Davis and Amanda Donohoe, with Glenda Jackson as the mother.

Anthony Pelissier was the first director to bring Lawrence to the screen in 1949 in a film called *The Rocking Horse Winner*. It is a strange little story, with Oedipal overtones, about a boy who discovers his ability to predict the winners of horse races by riding his

rocking horse. One of Lawrence's better-known works, *Sons and Lovers*, was filmed in 1960 by Jack Cardiff. Freddie Francis received an Academy Award for his photography and the film was nominated in five other categories.

Lawrence's most frequently banned novel was *Lady Chatterley's Lover*. The story is about an English woman whose husband is paralyzed in the First World War. To fulfill her sexual needs, she takes as a lover the estate's gamekeeper. *Lady Chatterley's Lover* was first filmed in 1955 by French director Marc Allégret, then again in 1981 by Just Jaeckin. Neither version does the story justice. The latter version is little more than a soft-core porn movie.

Mark Rydell directed another Lawrence story with a bisexual character–*The Fox* (1967). In typical 1960s fashion, the bisexual woman falls for a man and the lesbian is killed.

In 1970, Christopher Miles directed *The Virgin and the Gypsy*, based on a Lawrence novella about a Midlands clergyman's daughter who falls in love with a Gypsy played by Franco Nero. Miles later directed a biographical picture called *The Priest of Love*. It stars gay actor Ian McKellan as an aging Lawrence beset with book bannings and tuberculosis.

Kangaroo is Lawrence's semiautobiographical novel about an English writer and his wife who move to Australia in the 1920s and are befriended by neighbors who are not as open as they appear. The film version was directed by Australian Tim Burstall in 1986. It features beautifully photographed exotic Australian settings contrasted with bleak shots of their native England.

Lawrence spent most of his final years in the United States, where a young crop of talented bisexual writers were soon to make their mark on the film industry. One of the most successful and outspoken of these is Gore Vidal, who recently offered the opinion that "Everyone has homosexual and heterosexual desires and impulses and responses."

Since *The Left-Handed Gun* (1958), nearly every film with which Gore Vidal has been associated has had one or more gay, bisexual, or transgendered characters. One of the most famous movie scripts to which he contributed was the 1959 version of *Ben-Hur*. It was Vidal who suggested to director William Wyler that Ben-Hur's rivalry with boyhood friend Messala might best have been motivated by an

old love affair between the two. Wyler instructed Stephen Boyd to play the part of Messala as if he were an ex-lover, but was afraid to let the highly conservative Charlton Heston (Ben-Hur) in on the plot twist. Boyd played the part beautifully and added a whole extra dimension of dramatic tension to the scene when the two meet.

Also that year, Vidal wrote the screenplay for *Suddenly Last Summer*, but did not appear in the credits for having done so. Instead, Tennessee Williams, who wrote the original stage play was credited with the screenplay as well, prompting a major fight between the two writers. Vidal avoided this sort of problem in the 1964 film *The Best Man*, for which he wrote the screen adaptation based on his own stage play.

In 1968, the novel *Myra Breckenridge* became the third of four consecutive best sellers for Vidal. Work soon began on a film version. It was released in 1970 starring Mae West, Raquel Welch, John Huston, film critic Rex Reed, Farrah Fawcett, Jim Backus, John Carradine, Andy Devine, and Tom Selleck. Today the film is mainly considered of interest for its camp value. An even worse disaster for Vidal was the *Penthouse* magazine production of *Caligula* (1977). His script was so gratuitously butchered by director Tinto Brass that Vidal demanded his name be removed from the credits. Vidal appeared in *Fellini's Roma* in 1972.

Carson McCullers is not a household name, but her writing has been the source for some interesting films over the past forty years. In 1953, her Broadway hit play *The Member of the Wedding*, was made into a movie with Julie Harris reprising her role as a twelve-year-old tomboy. *Reflections in a Golden Eye* (1967) is the most influential film based on a McCullers novel. It stars Marlon Brando hyperventilating his way through a role as a closeted military officer, married to Elizabeth Taylor. Two more quality films based on McCullers' work are *The Heart is a Lonely Hunter* (1968) and *The Ballad of the Sad Cafe* (1991).

Science fiction writer Arthur C. Clarke was another bi American to make it to the screen. His *2001: A Space Odyssey* (1968) was a breakthrough film for the sci-fi genre. It received awards all over the globe, including Stanley Kubrick's Academy Award for Best Director. The sequel, made sixteen years later in 1984, was called *2010* and is based on Clarke's novel, *The Sentinel*.

American expatriate Paul Bowles lived and wrote in Morocco, where he claimed to have more freedom and better sex. His circle of friends included such gay, lesbian, and bisexual luminaries as Aaron Copeland, Leonard Bernstein, Gertrude Stein, William S. Burroughs, W. H. Auden, Truman Capote, Virgil Thompson, Allen Ginsberg, and Djuna Barnes. Bernardo Bertolucci directed the film version of Bowles' 1949 novel, *The Sheltering Sky*. An aficionado of anonymous sex, Bowles wrote to documentarist Regina Weinrich, "I think what people really want to know is: With whom have you been to bed? To answer that, it would be necessary to have known their names." Her biopic about the writer/composer is called *Paul Bowles: The Complete Outsider* (1993).

Writers who might be considered by some to be bisexual based on their past behavior might nonetheless identify as gay or straight. Whatever their self-identity, their experience with male and female partners cannot help but influence the way they think and write about issues involving sex, love, and relationships. One such writer is Harold Robbins, who told *People* magazine that he "experimented" with bisexuality to find out what it was like. The Elvis Presley vehicle *King Creole* (1958), directed by Michael Curtiz, was based on Robbins' novel *A Stone for Danny Fisher*. Candice Bergen plays a bisexual character in *The Adventurers* (1970), based on a Robbins novel of the same name. Eight years later, Robbins returned to the screen with *The Betsy*, directed by Daniel Petrie and starring bisexual actor Laurence Olivier. In *The Lonely Lady* (1983), based on another Robbins story, Pia Zadora plays a Hollywood screenwriter who sleeps her way to the top with both men and women. Robbin's most explicitly bisexual novel, *Dreams Die First* has not yet made it to the screen.

One bisexual writer who has also appeared on film is Yukio Mishima. His most famous work to appear on screen was *The Sailor Who Fell from Grace with the Sea* (1976), starring Kris Kristofferson and Sarah Miles. He also wrote the screenplay for a campy Japanese cult film called *Black Lizard* (1968), in which he appears as a stuffed human mannequin in a museum.

Of course, this is not a complete listing of bisexual writers who have contributed to the history of the cinema, nor was Oscar Wilde the first. Many did not have the luxury of being open about their

sexual orientation and their contributions have gone unacknowledged. Others are only now being rediscovered. One example, generally acknowledged to be the greatest playwright in the English language, is William Shakespeare. He was married to Anne Hathaway, but is now believed to have had other lovers of both sexes. Shakespearean scholar Marjorie Garber states that the narrative of his love sonnets is clearly bisexual–including several to a young man, others to a dark lady, and one contrasting his two loves.

At least a dozen different Shakespeare plays have been made into movies, with *Hamlet* having been filmed at least six times and *Romeo and Juliet* nearly as often. In addition, more than twenty other film scripts have been adapted from the works of The Bard. Among these are *Ran, West Side Story, Forbidden Planet,* and *My Own Private Idaho.*

A number of films have drawn on Lord Byron's epic satire, *Don Juan.* The first, and perhaps still most famous is a 1926 silent film of the same name starring John Barrymore and Mary Astor. Byron appears as a character in ten films ranging from *The Bride of Frankenstein* (1935) to *Haunted Summer* (1988). The latter film, set at Lake Geneva in 1816, depicts Byron's relationships with the future Mary Shelley and a homosexual male doctor.

Herman Melville was another writer who died before the word bisexual was recast in its current form. Married with three children, Melville nonetheless is known to have had an unrequited love for fellow writer Nathaniel Hawthorne. Melville was a popular nineteenth century writer of adventure tales of the sea. Three of his stories have been filmed: *Moby Dick* (1956), with Gregory Peck as Captain Ahab; *Billy Budd* (1962), starring a young and beautiful Terrance Stamp, and *Bartleby* (1970).

Given the enormous success of bisexual writers, more will certainly find their way to film. And more who are already there will come out or be discovered as new interviews and biographies are published.

Chapter 15

Conclusion

My primary goal in writing this book was to critically examine the previously unexplored topic of bisexual characters in film. This exploration covers more than two hundred films made in twenty-five countries over a period of eighty years. It is hoped that film viewers, having this material as background, will be better equipped to understand bisexual film characters and the forces that shape them.

Common themes emerge when one views the treatment and history of bisexual characters in the movies alongside the treatment of lesbian, gay, intersexed, transsexual, and transvestite characters, the exploitation of women, and the perpetuation of racial, ethnic, and class stereotypes in film. In his *Ain't I a Queer?* speech at the Creating Change conference in 1995, Dr. Elias Farajajé-Jones states, "Without sexism and gender oppression, heterosexism could hardly exist." His observation on the relationship between these *particular* oppressions points up the interconnectedness of *all* oppressions.

The next time you go to the movie theater, observe the posters and count how many women, as opposed to men, are in "sexual poses." See what percentage of the names in the big bold type are women. Watch the movie trailers and observe how much screen time the female characters are given as opposed to the male characters. Try to find a film in which the female lead was paid more than (or even as much as) the male lead. Pay attention to minor characters who are not conventional, heterosexual, white males. How are they portrayed? What happens to them? Are they treated as sympathetic characters? Who are the heroes in the movies? Who are the victims and who are the villains? Through whose gaze are the characters viewed?

A case in point is the 1995 film *Color of Night*. The rich white male is the hero, the working-class guy is the psychopathic killer, and the cross-dressing bisexual is mentally disturbed. Jane March has, by far, the most difficult role playing the troubled bisexual. Yet it is the two male leads (playing wealthy, middle-aged men—what a stretch!) who receive top billing. This incredibly violent film received an R rating, whereas *When Night is Falling*, which has little violence and about the same amount of sex, received an NC-17. What difference between the two films caused one to receive a rating which automatically reduces the potential audience by one-quarter? Was it because *When Night is Falling* was not a Hollywood film, because it was directed by a woman, or because some of the sex occurs between two women?

Watch the Academy Awards and see whether *any* of the films nominated for Best Picture (or any other award) are stories about people of color in the United States. Check out the children's section of your local video stores and look for a film in which the girl (or in the case of animal stories, the female) is the lead character. Notice the relative skin color, hair color, and accents of the heroes and villains in children's film.

The situation is improving, with independent filmmakers leading the way. But the forces of intolerance and greed make the struggle a slow one. Well-funded bigots, using religion as both club and shield, attempt to turn back the clock in order to reestablish and reinforce the privileged social order. Our struggle is to ensure that the next generation of bisexual, lesbian, gay, intersexed, and transgendered children grow up knowing they are not alone in the world. The film and print media are a powerful tool in that struggle.

Bibliography

Allen, Nancy. *Film Study Collections.* New York: Frederick Ungar Publishing Co., 1979.

Anger, Kenneth. *Hollywood Babylon.* New York: Dell Publishing, 1981.

Anger, Kenneth. *Hollywood Babylon II.* New York: E. P. Dutton, Inc., 1984.

Bad Object Choices. *How Do I Look?* Seattle: Bay Press, 1991.

Bell-Metereau, Rebecca. *Hollywood Androgyny.* New York: Columbia University Press, 1993.

Broughton, James. *Coming Unbuttoned.* San Francisco: City Lights, 1993.

Bryant, Wayne. "Bisexual Film Stars of the 1950s," *Anything That Moves,* No. 8 (Summer 1994).

Bryant, Wayne. "Bisexual Women in Film and Video," *Bi Women,* Vol. 12, No. 2 (April/May 1994).

Bryant, Wayne. "Women Challenging Gender Roles in Silent Film," *femme flicke,* No. 3 (1994).

Cole, Janis and Dale, Holly. *Calling the Shots: Profiles of Women Filmmakers.* Kingston, Ontario: Quarry Press, 1993.

Dyer, Richard. *Gays and Film.* New York: Zoetrope, 1986.

Dyer, Richard. *Now You See It: Studies on Lesbian and Gay Film.* London: Routledge, 1990.

Eastman, John. *Retakes: Behind the Scenes of 500 Classic Movies.* New York: Ballantine Books, 1989.

Facey, Paul W. *The Legion of Decency.* New York: Arno Press, 1974.

Fariello, Griffin. *Red Scare: Memories of the Inquisition.* New York: W. W. Norton and Co., 1995.

Foster, Jeanette H. *Sex Variant Women in Literature.* Tallahassee: The Naiad Press, 1985.

Garber, Marjorie. *Vice Versa.* New York: Simon and Schuster, 1995.

Gardner, Gerald. *The Censorship Papers: Movie Censorship Letters from the Hays Office 1934 to 1968.* New York: Dodd, Mead and Co., 1987.

Geller, Thomas. *Bisexuality: A Reader and Sourcebook.* Ojai: Times Change Press, 1990.

Gever, Martha, Greyson, John, and Parmar, Pratibha. *Queer Looks.* Toronto: Between the Lines, 1993.

Gmünder, Bruno. *Gewalt und Leidenschaft: Das Lexicon Homosexualität in Film und Video.* Berlin: Bruno Gmünder

Grazia, Edward de and Newman, Roger K. *Banned Films: Movies, Censors and the First Amendment.* New York: R. R. Bowker Co., 1982.

Grey, Rudolph. *Nightmare of Ecstasy.* Los Angeles: Feral House, 1992.

Guest, Barbara. *Herself Defined: The Poet H.D. and Her World.* New York: Quill Press, 1984.

Hadleigh, Boze. *Conversations with My Elders.* New York: St. Martin's Press, 1986.

Hadleigh, Boze. *The Lavender Screen.* New York: Citadel Press, 1993.

Hadleigh, Boze. *Hollywood Lesbians.* New York: Barricade Books, 1994.

Halliwell, Leslie. *Halliwell's Film Guide: Seventh Edition.* New York: Harper and Row, 1989.

Hayman, Ronald. *Fassbinder: Filmmaker.* New York: Simon and Schuster, 1984.

Hetze, Stefanie. *Happy-End für Wen? Kino und lesbische Frauen.* Frankfurt: Tende, 1986.

Hoberman, J. "The Big Heat," *The Village Voice,* Vol. 36, No. 46 (1991).

Hoskyns, Barney. *Montgomery Clift: Beautiful Loser.* New York: Grove Weidenfeld, 1991.

Howes, Keith. *Broadcasting It.* London: Cassell, 1993.

Huffhines, Kathy Schulz. *Foreign Affairs.* San Francisco: Mercury House, 1991.

Hutchins, Loraine and Kaahumanu, Lani. *Bi Any Other Name: Bisexual People Speak Out.* Boston: Alyson Publications, 1991.

Hyams, Jay. *James Dean: Lost Little Boy.* New York: Warner Books, 1992.

Isherwood, Christopher. *The Berlin Stories*. New York: New Directions Publishing Company, 1935 (Isherwood), 1945, 1954.

Isherwood, Christopher. *Christopher and His Kind*. New York: Michael di Capua Books, 1976.

Ives, John G. *John Waters*. New York: Thunder's Mouth Press, 1992.

Katz, Jonathan. *Gay American History*. New York: Avon Books, 1976.

Kiernan, Thomas. *Sir Larry: The Life of Laurence Olivier*. New York: Times Books, 1981.

Klein, Fritz. *The Bisexual Option: Second Edition*. Binghamton, NY: Harrington Park Press, 1993.

Klein, Fritz, Sepekoff, Barry, and Wolf, Timothy J. "Sexual Orientation: A Multivariable Dynamic Process," *The Journal of Homosexuality*, Vol. 11 (1985).

Knight, Julia. *Women and the New German Cinema*. London: Verso, 1992.

Kuhn, Annette. *Cinema, Censorship and Sexuality 1909-1925*. London: Routledge, 1988.

Kuhn, Annette. *The Women's Companion to International Film*. London: Virago Press, 1990.

Lee, Walt. *Reference Guide to Fantastic Films*. Los Angeles: Chelsea-Lee Books, 1972.

Leff, Leonard L. and Simmons, Jerold L. *The Dame in the Kimono*. New York: Anchor Books, 1990.

Limbacher, James L. *Sex in World Cinema*. Metuchen, New Jersey: Scarecrow Press, 1983.

Lyon, Christopher. *The International Dictionary of Films and Filmmakers: Directors/Filmmakers*. Chicago: St. James Press, 1984.

Madsen, Axel. *The Sewing Circle*. New York: Birch Lane Press, 1995.

Mayne, Judith. *Kino and the Woman Question: Feminism and Soviet Silent Film*. Columbus: Ohio State University Press, 1989.

Mayne, Judith. *The Woman at the Keyhole: Feminism and Women's Cinema*. Bloomington: Indiana University Press, 1990.

McDonald, Boyd. *Cruising the Movies: A Sexual Guide to "Oldies" on TV*. New York: Gay Presses of New York, 1985.

McGavin, Patrick Z. *Facets Gay and Lesbian Video Guide*. Chicago: Facets Multimedia Inc., 1993.

McGilligan, Patrick. *A Double Life: George Cukor*. New York: Harper Collins, 1992.

Mellen, Joan. *Women and Their Sexuality in the New Film.* New York: Dell Publishing Co., 1973.

Miller, Frank. *Censored Hollywood.* Atlanta: Turner Publishing, 1994.

Milne, Tom. *The Time Out Film Guide.* London: Penguin Books, 1989.

Milner, Michael. *Sex on Celluloid.* New York: MacFadden Books, 1964.

Mungenast, E. M. *Asta Nielsen.* Stuttgart: Walter Hädecke Verlag, 1928.

Murray, Raymond. *Images in the Dark.* Philadelphia: TLA Publications, 1994.

Palumbo, Donald. *Eros in the Mind's Eye: Sexuality and the Fantastic in Art and Film.* New York: Greenwood Press, 1986.

Paris, Barry. *Louise Brooks.* New York: Doubleday, 1989.

Parish, James Robert. *Gays and Lesbians in Mainstream Cinema.* Jefferson: McFarland and Co., 1993.

Perry, Danny. *Cult Movie Stars.* New York: Simon and Schuster/Fireside, 1991.

Petro, Patrice. *Joyless Streets.* Princeton: Princeton University Press, 1989.

Philbert, Bertrand. *L'Homosexualite a L'Ecran.* Paris: Henri Veyrier, 1984.

Phillips, Klaus. *New German Filmmakers.* New York: Frederick Ungar Publishing Co., 1984.

Ramsaye, Terry. *A Million and One Nights.* New York: Simon & Schuster, 1926.

Roen, Paul. *High Camp.* San Francisco: Leyland Publications, 1994.

Russo, Vito. *The Celluloid Closet: Homosexuality in the Movies.* New York: Harper and Row, 1987.

Rust, Paula. *Bisexuality and the Challenge to Lesbian Politics.* New York: New York University Press, 1995.

Shipman, David. *Judy Garland: The Secret Life of an American Legend.* New York: Hyperion, 1992.

Slide, Anthony. *The American Film Industry.* New York: Limelight Editions, 1990.

Smith, Paul Julian. *Laws of Desire: Questions of Homosexuality in Spanish Writing and Film 1960-1990.* Oxford: Oxford University Press, 1992.

Spoto, Donald. *Blue Angel.* New York: Doubleday, 1992.

Spoto, Donald. *Laurence Olivier.* New York: Harper Collins, 1992.

Steven, Peter. *Jump Cut: Hollywood, Politics, and Counter-Cinema.* Toronto: Between the Lines, 1985.

Stewart, Steve. *Gay Hollywood Film and Video Guide.* Binghamton, NY: Harrington Park Press, 1995. *2nd Edition.* Laguna Hills: Companion Publications, 1994.

Sullivan, Kaye. *Films For, By, and About Women.* Metuchen: Scarecrow Press Inc., 1980.

Sullivan, Kaye. *Films For, By, and About Women Series II.* Metuchen: Scarecrow Press Inc., 1985.

Tucker, Naomi. *Bisexual Politics: Theories, Queries, & Visions.* Binghamton, NY: Harrington Park Press, 1995.

Tyler, Parker. *Screening the Sexes.* New York: Holt, Rinehart and Winston, 1972.

Tyler, Parker. *Sex Psyche Etcetera in the Film.* New York: Horizon Press, 1969.

Tyler, Parker. *Underground Film: A Critical History.* New York: Grove Press, 1969.

Vale, V. and Juno, Andrea. *Incredibly Strange Films.* San Francisco: RE/SEARCH Publications, 1986.

VideoHound. *Cult Flicks and Trash Pics.* Detroit: Visible Ink Press, 1996.

VideoHound. *VideoHound's Golden Movie Retriever.* Detroit: Visible Ink Press, 1996.

Vogel, Amos. *Film as a Subversive Art.* New York: Random House, 1974.

Wallace, Irving, Wallace, Amy, and Wallechinsky, David. *The Intimate Sex Lives of Famous People.* New York: Dell Publishing, 1981.

Weaver, Kathleen. *Film Programmer's Guide to 16mm Rentals.* Albany, CA: Reel Research, 1980.

Weiner, David J. *The Video Source Book Tenth Edition 1989.* Detroit: Gale Research Inc., 1991.

Weiss, Andrea. *Vampires and Violets.* New York: Penguin Books, 1993.

Weldon, Michael. *The Psychotronic Encyclopedia of Film.* New York: Ballantine Books, 1983.

Yacowar, Maurice. *The Films of Paul Morrissey.* Cambridge: Cambridge University Press, 1993.

Film Index

General Index

Academy Awards, 33,36,37,39,49, 57,111,114,132,141,143, 144,148,149,150,154
Accord, Art, 22
Acosta, Mercedes de, 131,132,144
Adlington, Richard, 148
Advise and Consent (Drury), 38
Aftonbladet, 137
Ahab, Captain, 152
Aherne, Brian, 29
AIDS, 46,46-47,66,71-72,76,129
Ain't I a Queer? (Farajajé-Jones), 153
Alabama, 132
Alaska, 39
Albee, Edward, 105
Aldrich, Robert, 69
Alexander the Great, ix,51
Alien Corn, The (Maugham), 147
All Girl Action (Bright), 123
Allégret, Marc, 149
Allen, Diana, 145
Allen, Lewis, 50
Allyson, June, 69
Almodóvar, Pedro, 62,71,95,107
Alternate Current, 136
Altman, Robert, 7,51,64
America, Paul, 91
American Mutoscope Company, 10
Amos 'n' Andy, 146
Amsterdam, 94,95
Amsterdam Gay and Lesbian Film Festival, 94
Anderson, Brig, 67
Anderson, Eddie, 139
Anderson, Judith, 131
Anderson, Robert, 54
Andrew, Geoff, 31

Anger, Kenneth, 41,133
Ant and the Grasshopper, The (Maugham), 147
Apartheid, 118
Araki, Gregg, 69,75
Archbishop Ritter, 142
Argentina, 64,77
Arizona, 93
Arbuckle, Fatty, 19-20
Armstrong, Louis, 141
Arquette, Alexis, 76-77
Arthur, George, K., 30
Arzner, Dorothy, 14-15,137
Asher, Betty, 131
Asia the Invincible, 64
Asquith, Anthony, 145
Astor, Mary, 152
Atlanta, 37,103
Auckland, 105
Auden, W. H., 151
Audience Prize for Best Film, 77
Audrey, Jacqueline, 6,143
Augustine, Saint, 89
Australia, 74,87,103,108,124,149
Avery, Margaret, 57
Avery, Shug, 57-58,78

Babenco, Hector, 94
Bacall, Lauren, 34
Backstage Passes: Life on the Wild Side with David Bowie (Bowie), 124
Backus, Jim, 150
Bacon, Kevin, 91,92
Bad Seed, The (March), 55
Baker, Dorothy, 34
Baker, Josephine, 126

Chabrol, Claude, 63,68,143
Chamberlain, Richard, 102
Chancellor, Olive, 114
Chaplin, Charlie, 23,132
Chapman, Graham, 125
Cher, 117
Chicago, 17,24,60
Child Manuela, The (Winsloe), 144
Children's Hour, The (Hellman), 30,
 38,53
China, 146
Christ. *See* Jesus of Nazareth
Christian, 25
Christianity, 84
Christie, Julie, 39
Christina, Queen (of Sweden),
 68,131
Cimino, Michael, 131
Circle, The (Maugham), 145
Clarke, Arthur C., 150
Claudine á l'École (Colette), 142
Clift, Montgomery, 71,128
Closer To Home (Weise, ed.), 47
Clover, Daisy, 40,74
Cobain, Kurt, 124
Coburn, James, 69,74
Cocteau, Jean, 41
Code, The. *See* Motion Picture
 Production Code
Cohn, Harry, 27,28
Cohn, Roy, 47-48
Colette, 135,142-144
Colonel's Lady, The (Maugham),
 147
Columbia Pictures, 27,28,146
Coming Unbuttoned (Broughton),
 140
Commission on Obscenity
 (President Johnson's), 40
Committee for the First Amendment,
 129
Communists, 35,48,79
Congress, United States, 20,27,67
Consenting Adult (Hobson), 59
Constant Wife, The (Maugham), 145

Cooper, Gary, 126,131
Copeland, Aaron, 151
Cornell, Katharine, 131
Cornwall, 148
Cosmopolitan, 46
Costello, Elvis, 124
Cottis, Jane, 4
Courtney, Jo, 39
Crassus, 37,56,66,129
Crawford, Joan, 132,138,146
Creating Change conference, 153
Crisp, Quentin, 144
Cromwell, John, 146
Cronenberg, David, 53
Crosby, Bing, 129,142
Cross dressing, 10,25,97,154. *See
 also* Drag; Transvestites
Crowley, Aleister, 41
Crowley, Mart, 75
Cukor, George, 46,127,132
Curram, Roland, 39
Curry, Tim, 99-100
Curtis, Tony, 37
Curtiz, Michael, 34,151

D'Agostino, Lisa, 117
Dall, John, 60
Dallamano, Massimo, 145
Dallas, 129
Dallesandro, Joe, 6,91,103
Daly's Theater, 10
Damita, Lily, 126
Daniels, Billy, 139
D'Anna, Claude, 145
Darling, Candy, 92
Davies, Marion, 23
Davion, Alex, 40
Davis, Bette, 34,146-147
Davis, Brad, 50,104
Davis, Sammi, 148
Day, Doris, 34,129
Dean, James, 7,51-52,71,127-128,
 129
Deathwatch (Genet), 56

Maggenti, Maria, 136-137
Magician, The (Maugham), 146
Magick, 41
Mahin, John Lee, 55
Malle, Louis, 110
Mallett, Richard, 50
Maloney, Leo, 22
Mamoulian, Rouben, 27
Mankiewicz, Joseph, 34
Manhattan, 105,111. *See also* New
 York City
Manila, 96-97
Maori, 117
March, Frederic, 15
March, Jane, 154
March, William, 55
Marcos, Ferdinand, 96
Marcos, Imelda, 96
Marcos government, 96
Markopoulos, Gregory, 42
Martin, Steve, 112
Maruyama, Akihiro, 104
Maura, Carmen, 107
Marx, Karl, 84
Maryland, 34
Mason, James, 60-61
Massachusetts, 19
Massachusetts Legislature, 18
Massey, Edith, 100
Mastroianni, Marcello, 68
Matachine Society, 18
Mattes, Eva, 141
Maugham, W. Somerset, 138,
 145-148
Maurier, Daphne du, 54,144
Mazursky, Paul, 56
McCarthy, Joseph, 47-48,53
McCarthy witch-hunts, 35,53,132,
 139,141. *See also* Red Scare
McCullers, Carson, 150
McDowall, Roddy, 86
McHenry, Mole, 100
McKellan, Ian, 149
McMurray, Lillita, 23
Mead, Taylor, 43,102

Meier, Armin, 140
Meininger, Al, 17
Mekas, Jonas, 42
Melville, Herman, 55,152
Member of the Wedding, The
 (McCullers), 150
Metro-Goldwyn-Mayer, 27,137,
 139,146
Metzger, Randy, 86
Mexico, 93,96
Meyer, Russ, 63,100-101,106
MGM. *See* Metro-Goldwyn-Mayer
Miami, 89,107
Michelangelo, 51
Mikaël (Bang), 12
Millais-Scott, Imogen, 101
Milan, 85
Miles, Christopher, 149
Miles, Sarah, 151
Milestone, Lewis, 146
Miller, Henry, 133
Miller, June, 133
Milles, Carl, 12
Milstead, Glenn, 100
Mind's I, The (Redgrave), 130
Minne (Colette), 143
Minnelli, Vincente, 131,143
Mineo, Sal, 127-128,129
Minter, Mary Miles, 20
Miou-Miou, 65,79
Mishima, Yukio, 52,71,104-105,151
Mommie Dearest (Crawford), 132
Monroe, Marilyn, 36,37,128
Montgomery Clift: Beautiful Loser
 (Hoskyns), 128
Monthly Film Bulletin, 92
Monty Python's Flying Circus, 125
Moore, Dennie, 29
Moorehead, Agnes, 121,133
Moreau, Jeanne, 104
Morocco, 108,151
Morrison, Marion. *See* Wayne, John
Morrissey, Paul, 6,83,90-91,
 102-103,140
Morrow, Vic, 56

Order Your Own Copy of
This Important Book for Your Personal Library!

BISEXUAL CHARACTERS IN FILM
From Anaïs to Zee

_____ in hardbound at $24.95 (ISBN: 0-7890-0142-X)

_____ in softbound at $17.95 (ISBN: 1-56023-894-1)

COST OF BOOKS_____

OUTSIDE USA/CANADA/
MEXICO: ADD 20%_____

POSTAGE & HANDLING_____
(US: $3.00 for first book & $1.25
for each additional book)
Outside US: $4.75 for first book
& $1.75 for each additional book)

SUBTOTAL_____

IN CANADA: ADD 7% GST_____

STATE TAX_____
(NY, OH & MN residents, please
add appropriate local sales tax)

FINAL TOTAL_____
(If paying in Canadian funds,
convert using the current
exchange rate. UNESCO
coupons welcome.)

☐ **BILL ME LATER:** ($5 service charge will be added)
(Bill-me option is good on US/Canada/Mexico orders only;
not good to jobbers, wholesalers, or subscription agencies.)

☐ Check here if billing address is different from
shipping address and attach purchase order and
billing address information.

Signature_____

☐ **PAYMENT ENCLOSED: $**_____

☐ **PLEASE CHARGE TO MY CREDIT CARD.**

☐ Visa ☐ MasterCard ☐ AmEx ☐ Discover

Account #_____

Exp. Date_____

Signature_____

Prices in US dollars and subject to change without notice.

NAME _____

INSTITUTION _____

ADDRESS _____

CITY _____

STATE/ZIP _____

COUNTRY _____ COUNTY (NY residents only) _____

TEL _____ FAX _____

E-MAIL_____
May we use your e-mail address for confirmations and other types of information? ☐ Yes ☐ No

Order From Your Local Bookstore or Directly From
The Haworth Press, Inc.
10 Alice Street, Binghamton, New York 13904-1580 • USA
TELEPHONE: 1-800-HAWORTH (1-800-429-6784) / Outside US/Canada: (607) 722-5857
FAX: 1-800-895-0582 / Outside US/Canada: (607) 772-6362
E-mail: getinfo@haworth.com
PLEASE PHOTOCOPY THIS FORM FOR YOUR PERSONAL USE.

BOF96